Musikraphics

Visualizing the rhythm of music

Musikraphics

First published and distributed by
viction:workshop ltd.

viction:ary™

Unit C, 7th Floor, Seabright Plaza, 9-23 Shell Street,
North Point, Hong Kong
URL: www.victionary.com
Email: we@victionary.com

Edited and produced by viction:workshop ltd.

Book design by viction:workshop ltd.
Concepts & art direction by Victor Cheung
Cover image by Irana Douer

ISBN 978-988-98229-7-2

EUR edition
Printed and bound in China

Content

Nowadays, music graphics has leapt from print to film, record sleeves to animations.

We are sure you have heard the tagline 'No Music, No Life' a thousand times. It is about time to throw this broken record away. We have a new one: 'No Music Graphics, No Life.' Not only does it help us to visualize music, it can transport us to the stories behind it. It expresses what music can't and fills in the pauses in the tunes. But above all, it is like water, which just goes with the flow of the songs.

Nowadays, when asked which new record he/she would like to have, a kid's answer would most likely be, "I need to pay for it?" With free entertainment just a mouse-click away, even adults, who grew up with vinyl records, cassette tapes or MDs and CDs, have become reluctant to buy music. We are more likely to enter record

Introduction

stores, listen to the latest CDs, and emerge empty-handed than ever before. So what cards are music labels playing as record sales dwindle? One of them must be wicked music graphics. As the old saying goes, a little beauty goes a long way.

Even before the dawn of graphics, record sleeves have always been as memorable as the best-selling CDs they accompany, if not even more so. The cover of Madonna's album 'True Blue,' shot by the late American fashion photographer Herb Ritts, is arguably one of her most iconic images. Along a similar vein, the cover of Nirvana's album 'Nevermind,' which features a baby swimming merrily towards a US dollar bill on a fishhook, is as famous as the band's song 'Smells Like Teen Spirit.' Not to mention the cover artwork of David Bowie's studio album 'Aladdin Sane,' which features him with a Z adorning his face and blurs the line between him and his alter ego Ziggy Stardust.

Nowadays, music graphics has leapt from print to film, record sleeves to animations. It is used to build or maintain the identity of musicians or music events and put them in the best light possible. Take Madonna, who succeeded in striking a chord with the younger audience with her animated music video for her single 'Get Together,' which portrayed her as a diva rocking the dance floor and having a good time.

When MIKA cut his musical teeth in 2007, his image — fun, energetic, childlike — already shone through, thanks to Airside's campaign for his debut album 'Life in Cartoon Motion.' The London-based design company joined forces with the musician's sister Yasmine, who drew the

characters that lived in MIKA's wonderland. The result was a typeface tailor made for the Lebanese singer, web animations, packaging, window display, installation, posters and music promos. The highlight was the whimsical installation, which featured lots of lollipops and made the audience feel like a child in a candy store. What Airside created was beyond a visual identity — it was a world that MIKA's fans and music lovers could rock and roll to when they need a little cartoon motion in their lives.

Music graphics is not just all glitz and no substance, it can be used to make a social commentary too. Yellow Brain Co., LTD, creatively helmed by Kouki Tange, has been churning out thought-provoking music artworks since 1999. Among them is their DVD jacket for 'Mr. Children HOME TOUR 2007,' a collaboration between Tange and designer Yuhei Urakami. A record sleeve and jigsaw puzzle rolled into one, it features elements like aeroplanes, footballs and christmas trees, as though saying that home is where we can lay our heads down. "All things, good and bad, are connected and linked like this puzzle. The missing piece can also symbolize people who have lost their way. Everyone is looking for that missing piece on their own," Tange says.

The 'Mr. Children HOME TOUR 2007' DVD also comes with a simple yet powerful poster, which features a house made of rubberbands. Various hands, from senile to infantile, white to black, tug on the ends of the house. Ideally, home is earth, where people from all age brackets and races play an equally important role and live together harmoniously. On a negative note, the poster can also be read as a commentary on the segregrated state of the world, where many of us are voluntarily participating in the tug of war, be it the battle between the sexes, or countries.

Other design studios use the most unlikely materials to make record sleeves. Sopp, a design studio based in Sydney and London whose portfolio stretches from album artwork to music videos to interactive installations, is always looking for a new way to express music visually. Their record sleeve for The Falls' 'Long Time Coming' features a portrait of the band members made of real leaves. And it doesn't stop here. Sopp collected leaves and sorted them by colour to make a 2x3m floor installation for the acoustic-based pop duo.

Record sleeves can also be used to change the public's deeply entrenched attitudes towards up-and-coming and established musicians. Hong Kong's Benny Luk, aka Sixstation, famed for his unique blend of contemporary and tradition Asian elements, did just that. His design and illustration for Nicholas Tse's 'Yellow' is a departure from the celebrity's edgy image and portrays him as a martial master. The singer is seen flaunting his kung fu skills in a swirl of ink, looking intense. Using red and black as the main colours, the record is a testament to Tse's transformation from pretty boy to macho man, singer to film star, son to father.

Music is a funny thing, it either elicits feelings of love or hatred. There's simply no middle ground. An album you can't stop listening to is the soundtrack to someone else's nightmare. Even a song as popular as John Lennon's 'Imagine' has its own share of opponents, who objects it because of its contradictions. Likewise, music graphics either strikes a chord with you or it doesn't. And when it does, we hope it includes the works we feature in this volume.

Music graphics is not just all glitz and no substance, it can be used to make a social commentary too.

Title:
1. HELL/ALAN VEGA -
Listen to the Hiss
2. HELL - The Final
Countdown

Year:
1. 2004
2. 2005

Contributed by:
Elisabeth Arkhipoff

Design:
Elisabeth Arkhipoff

Client:
Gigolo Records

Description:
Music artwork for
HELL. Its typogra-
phy seems to glow
in the pitch dark-
ness.

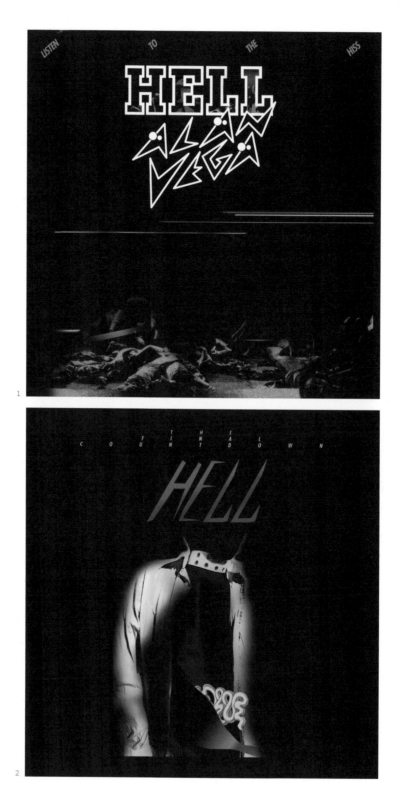

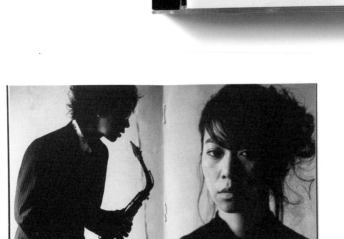

Title:
UA x Naruyoshi
kikuchi/curejazz

Type of Work:
CD packaging

Year:
2006

Contributed by:
Tetsuya Nagato

Art Direction:
Tetsuya Nagato

Design:
Tetsuya Nagato

Client:
Victor Entertain-
ment speedstar

Musician(s):
UA x Naruyoshi
kikuchi

Description:
Modern jazz in
2006. Emotional
photograph by
Yuriko Takagi.

Title:
Love Attack

Type of Work:
CD sleeves

Year:
2007

Contributed by:
Grandpeople

Art Direction:
Grandpeople

Design:
Grandpeople

Client:
Kompakt Records

Musician(s):
Skatebård

Description:
Love Attack is the second 12" release by techno artist Skatebård on the German label Kompakt. The visual expression is a prolongation of Skatebård's 2006 debut album 'Midnight Magic.' The visual references are 80s horror movies and heavy metal. It is dark, but has details with warmer colours: Love.

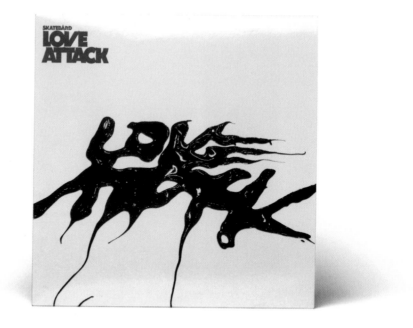

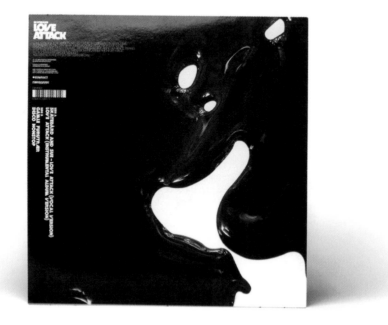

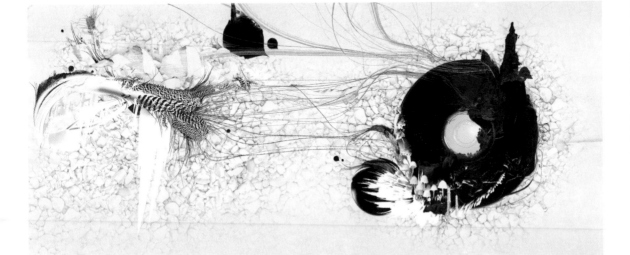

Title:
'Boards Awards

Type of Work:
Style frame,
Packaging

Year:
2007

Contributed by:
Kim Dulaney

Art Direction:
Alan Bibby

Design:
Kim Dulaney

Client:
'Boards Magazine

Description:
The idea is to
show the growth of
motion graphics in
a visual form, and
also showing off
all technologies of
what motion graph-
ics has become.

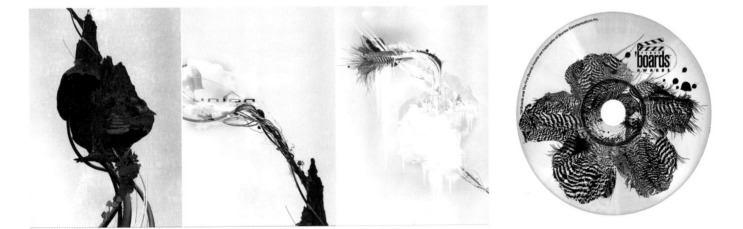

Title:
Travel Sickness

Type of Work:
Graphic concept,
Photography, Illus-
tration, Layout,
Packaging design

Year:
2006

Contributed by:
BombTheDot

Art Direction:
Stefan Alt

Design:
Stefan Alt, Okres
Patlary

Client:
Hymen Records

Musician(s):
8 bands in total:
Lusine Icl, Solarx,
Lowfish, Gridlock,
Psi Spy, Snog,
Hecq, Mad Ep

Description:
Travel sickness is
a common cultural
illness, a virus
found in the heart,
mind, and body of
people. It makes
them become very
ignorant gradually.
Human beings can be
infected by: will-
ingly engaging in
meaningless move-
ments spawned by
corporate inter-
ests; purchasing
and consuming prod-
ucts intended to
curb creativity and
independent think-
ing; and accepting
as facts any disin-
genuous and unin-
formed concepts,
often conveyed by
parents, education
systems, and peers.
The metamorphosis
of men is part of
the release's con-
cept and symbolised
by the transforma-
tion of butter-
flies.

Extra heavy wooden
boxset with 8x
3"cds and inlay.

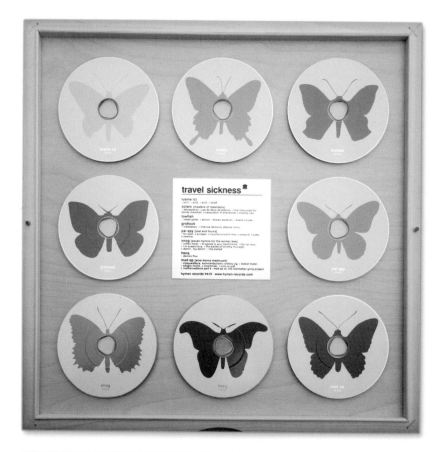

travel sickness 1

lusine icl · solarx · lowfish · gridlock · psi spy · snog · hecq · mad ep
hymen records ¥410 · www.hymen-records.com

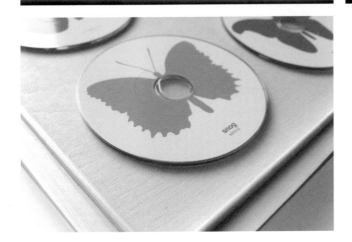

Title:
The Light Will Be

Type of Work:
CD cover

Year:
2005

Contributed by:
Christophe Remy

Design:
Christophe Remy

Client:
Tommy Donald Colin

Musician(s):
Tommy Donald Colin

Description:
Album artwork for
Tommy's first album
'The Light Will Be.'

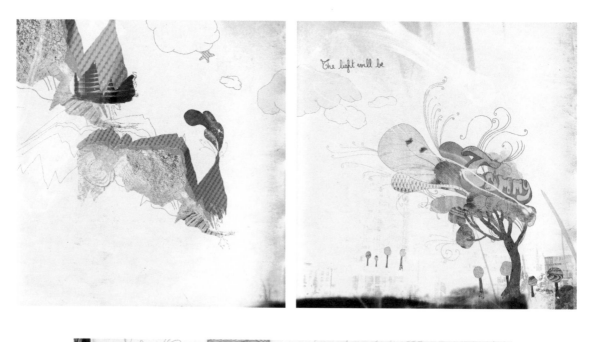

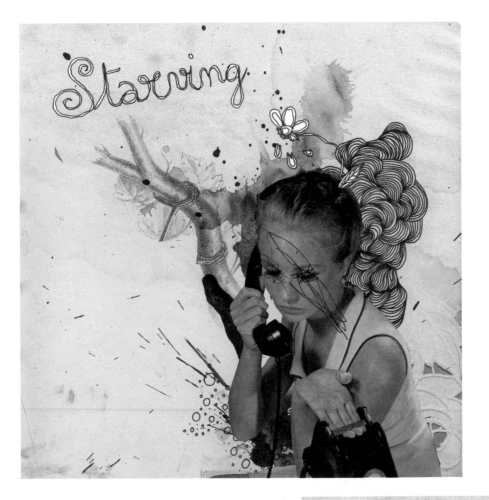

Title:
Starving

Type of Work:
CD cover

Year:
2007

Contributed by:
Christophe Remy

Design:
Christophe Remy

Client:
Starving

Musician(s):
Starving

Description:
Album artwork for
Starving's last EP.

Title:
NICHIKA's Debut
Single

Type of Work:
CD, Poster, Flyer,
Press kit, Bag

Year:
2007

Contributed by:
RADIO

Art Direction:
Yoshi Tajima

Design:
Yoshi Tajima

Client:
R and C Ltd.(Japan)

Musician(s):
NICHIKA

Description:
This is Japanese
pop duo NICHIKA's
debut single.
Tajima tried to
visualize their
melancholic style
and Brit pop fla-
vour.

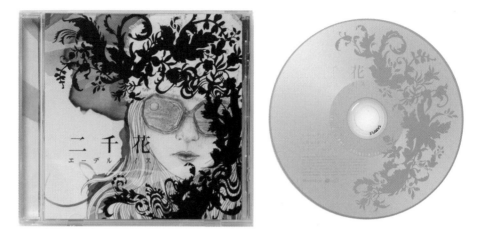

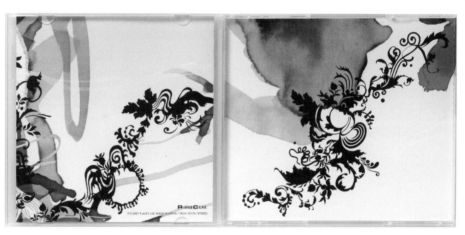

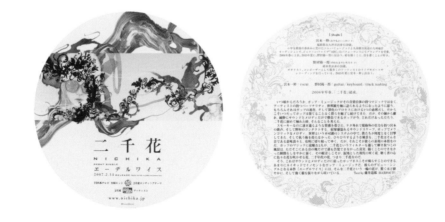

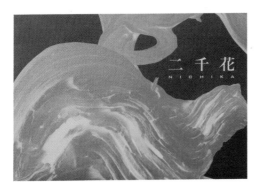

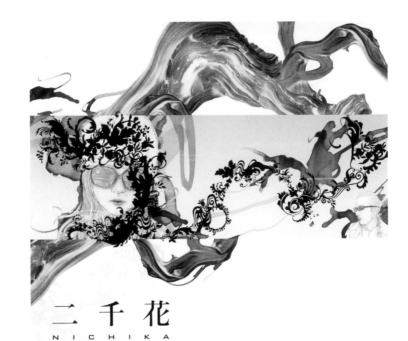

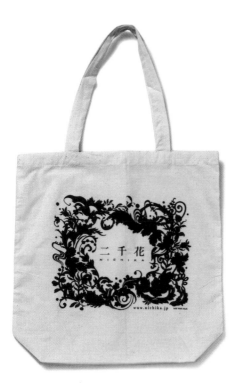

二千花
NICHIKA

DEBUT SINGLE

エーデルワイス

2007.2.14
RELEASE YRCN-10173 ¥1,260 (INCLUDING TAX)

TBS系テレビ全国ネット 2月度エンディングテーマ

www.nichika.jp

R and C Ltd.

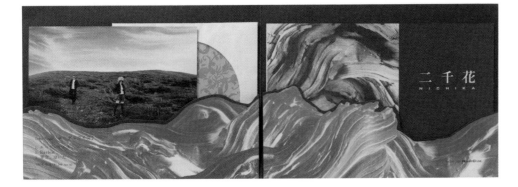

Title:
NICHIKA's Second
Single

Type of Work:
CD, Poster, Flyer,
Press kit, Bag

Year:
2007

Contributed by:
RADIO

Art Direction:
RADIO

Design:
Yoshi Tajima

Photography:
Yumiko Inoue
(D-cord)

Client:
R and C Ltd.(Japan)

Musician(s):
NICHIKA

Description:
This is Japanese
pop duo NICHIKA's
second single.
Tajima tried to
visualize their
melancholic style
and Brit pop fla-
vour.

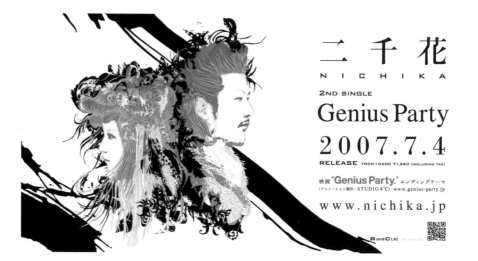

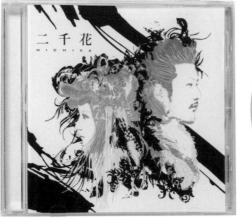

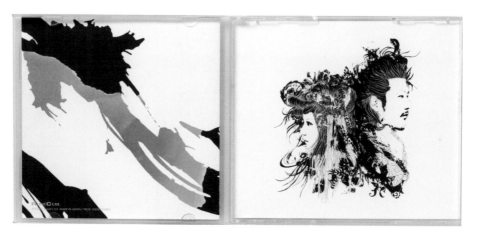

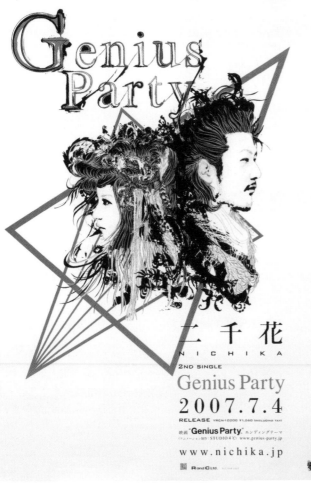

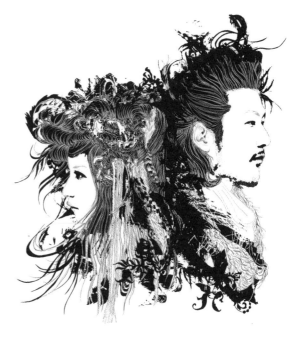

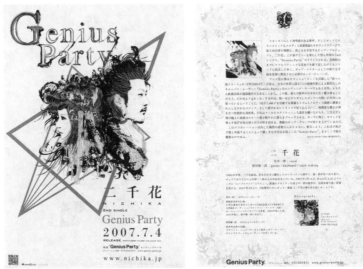

Title:
Himawari's CD

Type of Work:
Packaging, Print, Promotion

Year:
2005

Contributed by:
Santos&Karlovich™

Art Direction:
Virgilio Santos

Design:
Virgilio Santos

Photography:
Koichiro Shiiki

Client:
Himawari

Musician(s):
Himawari

Description:
A series of illustration done for the Japanese performing musical artist Himawari. The illustration then be used for all collateral promotions as well as the LP and CD packaging. Also a handmade typographic solution was constructed for this project. (Himawari is under the Pid Recording Label.)

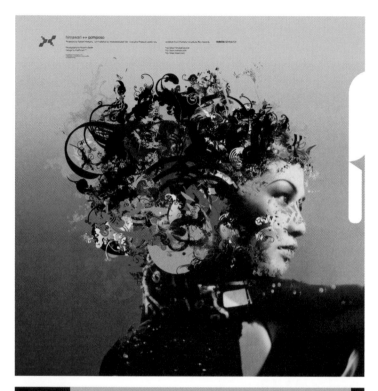

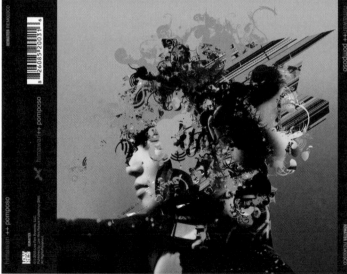

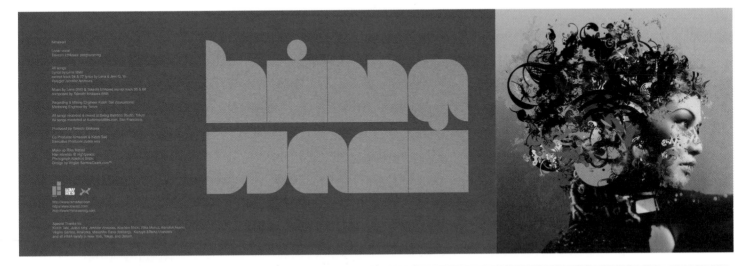

himawari

Lead vocal
Takeshi Ishikawa: programming

All songs
Lyrics by Lena Ishii
except track 04 & 07 lyrics by Lena & Jeni Q, 'q'
Prologue: Jennifer Andrews

Music by Lena (2ND & Takeshi Ishikawa) except track 06 & 08
composed by Takeshi Ishikawa (2ND)

Recording & Mixing Engineer Kotch Taki (loscurrone)
Mastering Engineer by Twins

All songs recorded & mixed at Swing Bamboo Studio, Tokyo
All songs mastered at Audiosociatiés.com, San Francisco

Produced by Takeshi Ishikawa

Co-Produce himawari & Kotch Taki
Executive Producer Junko Way

Make-up Rika Matsui
Hair Hirohiko @ nightglavor
Photograph Kotchiro Shiibil
Design by Virgilio Santos/Ozark.com™

http://www.remixitel.com
http://www.lowres.com
http://www.himawarirog.com

Special Thanks to:
Kotch Taki, Junko Way, Jennifer Andrews, Kotchiro Shiibil, Rika Matsui, Kenshin Asami,
Virgilio Santos, Ainworks, Masuhiro Sano (loobang), Kazuya & Reino Ishikawa
and all HMA family in New York, Tokyo, and Detroit.

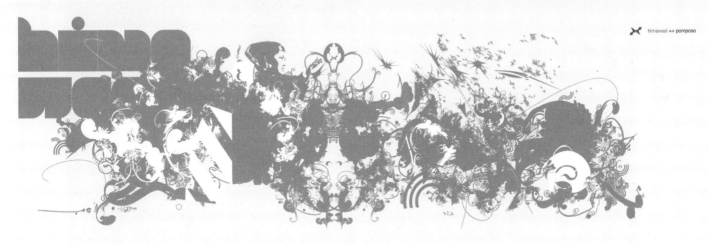

himawari ++ pomposo

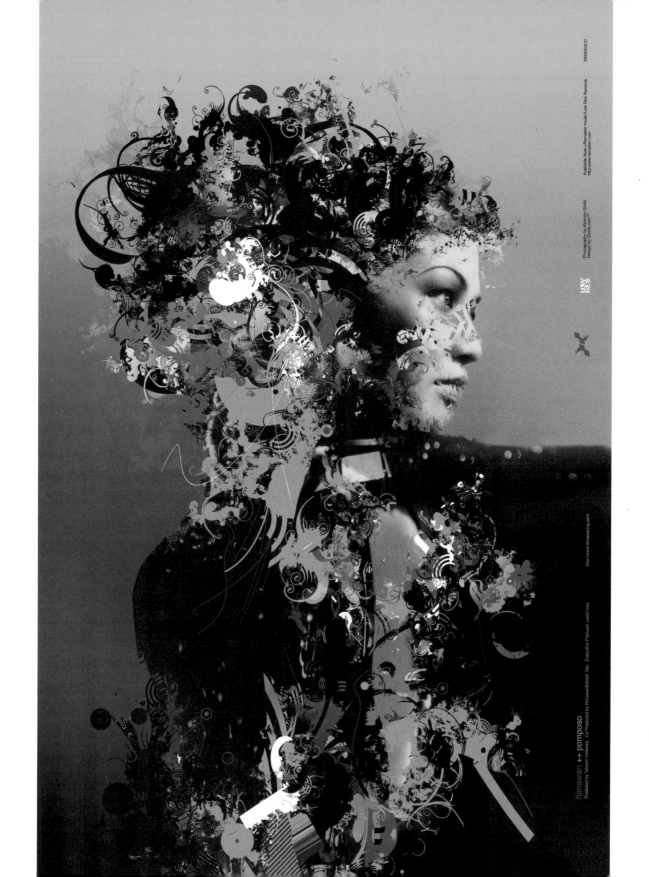

himawari ++ pomposo

Produced by Takeshi Ichikawa Co Produced by Himawari&Kidoh Taki Executive Producer Justin Ivey

Photography by Koichiro Shiiki
Design by Dzark.com™

Available Now >Rematter music/Low Res Records

REMATTER REM003CD

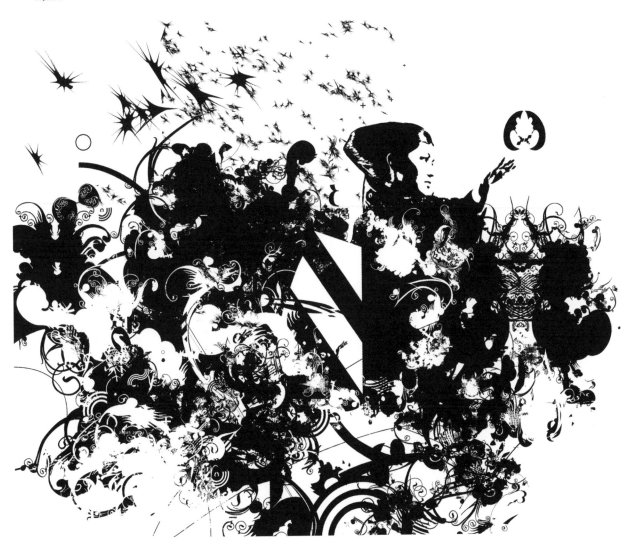

Title:
花無雪

Type of Work:
CD

Year:
2007

Contributed by:
Kabo

Art Direction:
Joel Chu

Design:
Perry Cheng

Client:
Emperor Entertain-
ment Hong Kong Ltd.

Musician(s):
Vincy

Description:
Design for Vincy's
second album - 花無雪.

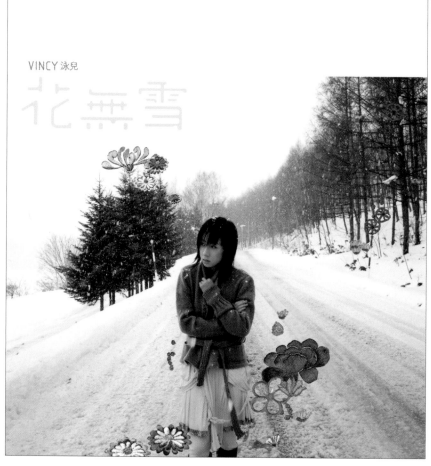

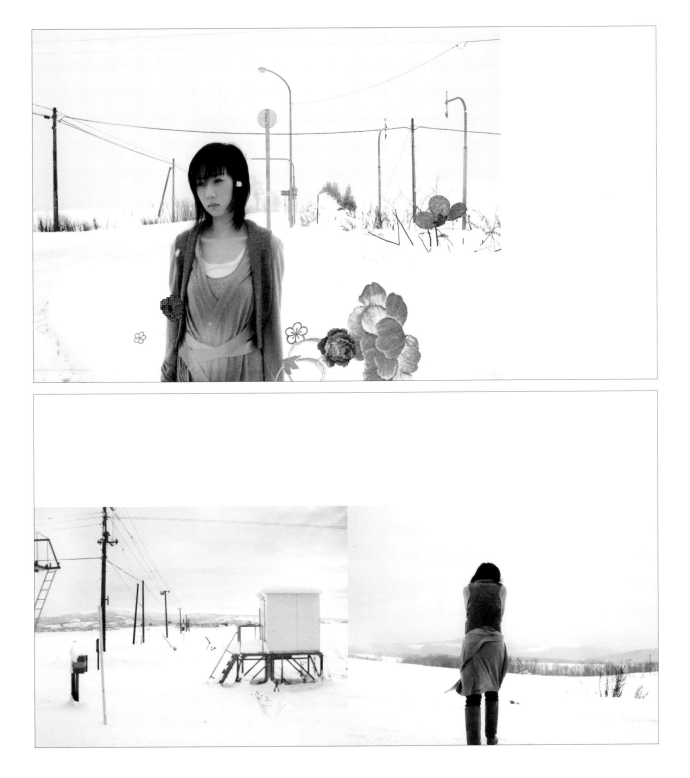

Title:
Lo-Fi-Fnk
"...And the JFG?"

Type of Work:
CD cover

Year:
2005

Contributed by:
PMKFA

Art Direction:
PMKFA

Design:
PMKFA

Photography:
Anders Neuman

Client:
La Vida Locash

Musician(s):
Lo-Fi-Fnk

Description:
An illustration of
typography and the
band in a situation
where they look
like giants.

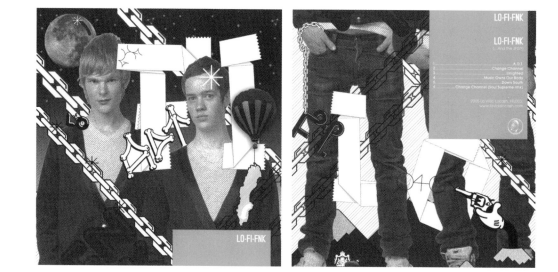

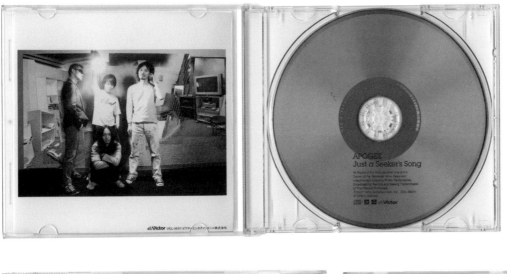

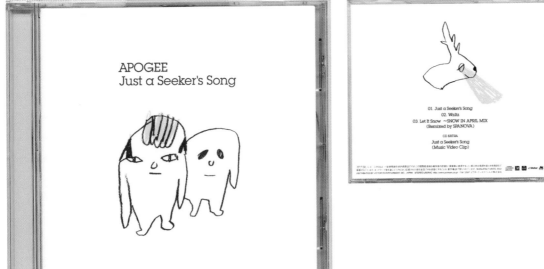

Title:
Just a Seeker's
Song

Type of Work:
CD

Year:
2007

Contributed by:
cucumber

Art Direction:
Miki Rezai

Design:
Miki Rezai

Photography:
Zoren Gold and
Minori

Client:
Victor Entertain-
ment, Inc.

Musician(s):
APOGEE

Description:
These 2 characters
were just doodles
at the corner of a
rough sketch that
Miki was working
on at the time. He
felt attached to
them so he put them
on the wall for a
while and some-
times use them for
his private works.
It turned out that
APOGEE and their
record company
loved them too and
wanted to make an
animated PV featur-
ing them for their
new single.

Title:
Coward (Premium Edition)

Type of Work:
CD artwork

Year:
2006

Contributed by:
Enlightenment

Art Direction:
Enlightenment

Design:
Enlightenment

Client:
Johnnys Entertainment

Musician(s):
Endlicheri Endlicheri

Description:
Enlightenment made a work with the analog that the corrugated cardboard depends on not graphics with the computer.

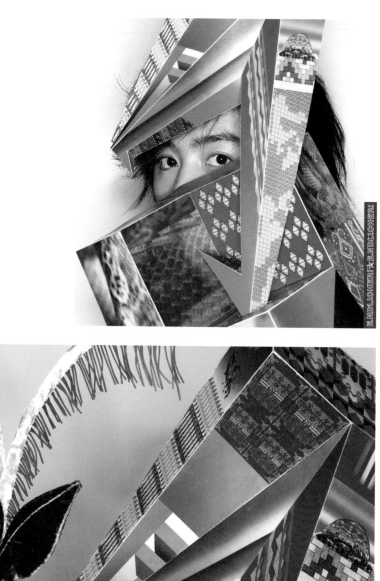

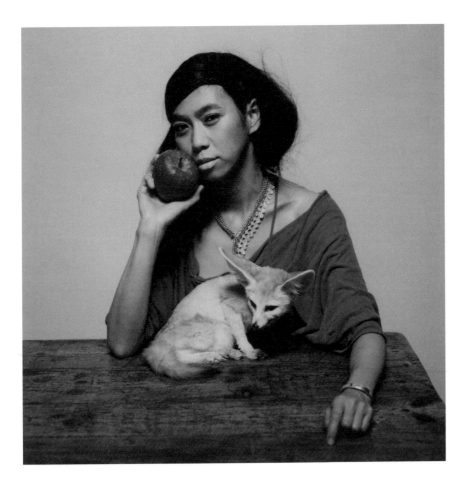

Title:
UA/GoldenGreen

Type of Work:
CD package

Year:
2007

Contributed by:
Tetsuya Nagato

Art Direction:
Tetsuya Nagato

Design:
Tetsuya Nagato

Client:
Victor Entertain-
ment Speedstar

Musician(s):
UA

Description:
A combination of
new and old paint-
ings.

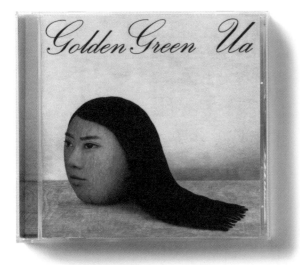

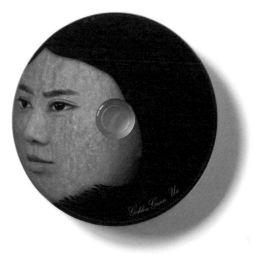

Title:
Digitaria - Anti

Type of Work:
CD artwork

Year:
2005

Contributed by:
Misprinted Type

Art Direction:
Eduardo Recife

Design:
Eduardo Recife

Client:
Gigolo Records

Musician(s):
Digitaria

Description:
Eduardo made several vector illustrations to go along with the whole album cover. Then it was shaped like an old book since the CD packaging would be made entirely out of paper.

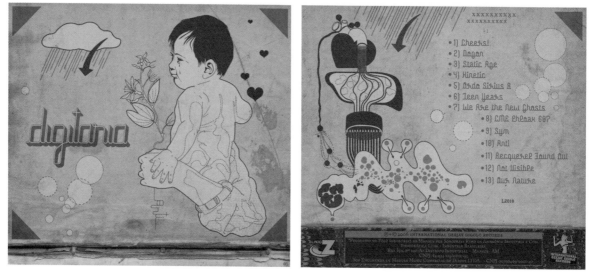

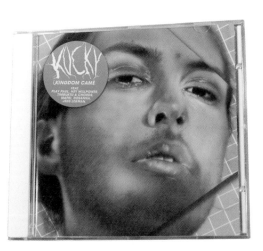

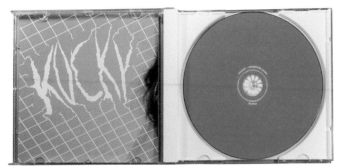

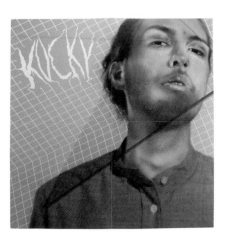

Title:
Kingdom Came

Type of Work:
CD cover

Year:
2007

Contributed by:
PMKFA

Art Direction:
PMKFA

Design:
PMKFA

Client:
La Vida Locash

Musician(s):
Kocky

Description:
The designer wanted
to make people feel
uncertain of when
the graphics were
from by mixing both
old and new ele-
ments.

Title:
HAIL SOCIAL -
Warning Sign

Type of Work:
CD artwork

Year:
2006

Contributed by:
Michael Perry

Art Direction:
Michael Perry

Design:
Michael Perry

Client:
Poly Vinyl Records

Musician(s):
Hail Social

Description:
Using drawn cal-
ligraphic elements
to build a land-
scape to lead you
through the design
that reflects the
landscape the music
made.

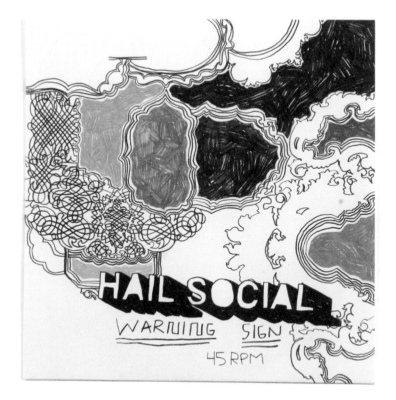

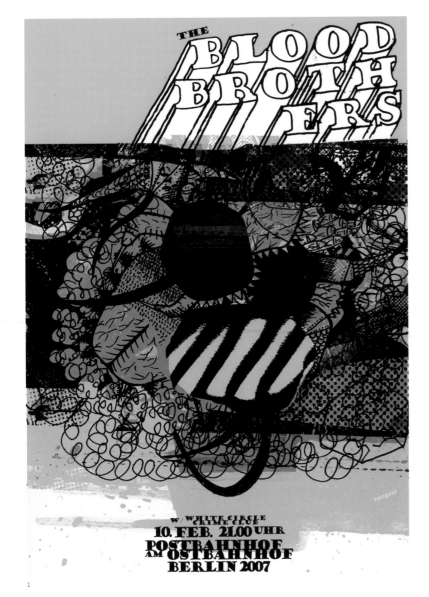

1

Title:
1. The Blood Brothers
2. Boredoms

Type of Work:
Silkscreen concert poster

Year:
1. 2007
2. 2006

Contributed by:
Bongoût

Art Direction:
Meeloo Gfeller, Anna Hellsgard

Design:
Meeloo Gfeller, Anna Hellsgard

Client:
1. The Blood Brothers (USA)
2. Twisted Robots (Berlin)

Musician(s):
1. The Blood Brothers
2. Boredoms (Japan)

Description:
1. 3 colours limited edition hand printed silkscreen on 300gr paper. The band gave the designers total freedom for the visuals.
2. Bongoût was very honoured to do this limited edition poster for their favourite noise band, Boredoms. The idea was to do something similar to Yamatsuka Eyes creations and at the same time, in their own style, to fit the band's psychedelic, and chaotic aesthetic. The text part was done out of Jean Dubuffet's hand-writting samples.

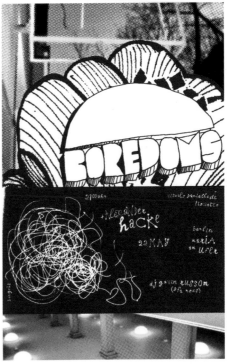

2

Title:
フェイク
Type of Work:
CD jacket
Year:
2006
Contributed by:
Yellow Brain Co.,
LTD
Art Direction:
Kouki Tange
Design:
Yuhei Urakami
Client:
TOY'S FACTORY
Musician(s):
Mr. Children

Description:
The cover of this CD shows the real world while the reverse side is a mirrored world, where all words are inverted. There are 2 stories in the pictures. One is about a love doll in a mirrored world who desires to become human and has made herself look real. As for the other story, you think the cover is a real woman, but she is actually the love doll. The theme is 'you can't judge a book by its cover.' The designers like the first story better.

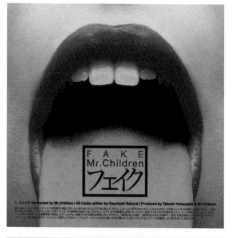

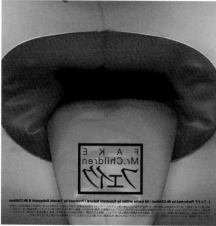

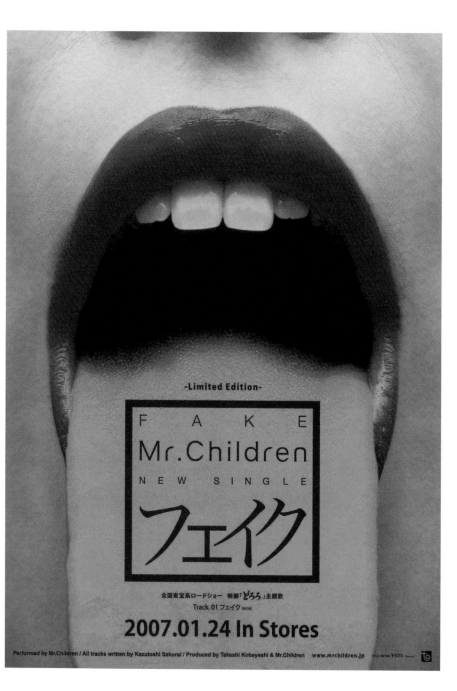

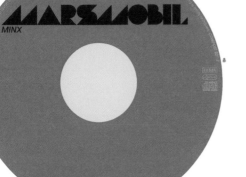

Title:
Marsmobil

Type of Work:
CD artwork

Year:
2006

Contributed by:
C100 Studio

Design:
C100 Studio

Client:
Compost Records

Musician(s):
Marsmobil

Description:
CD Cover for the
band Marsmobil.

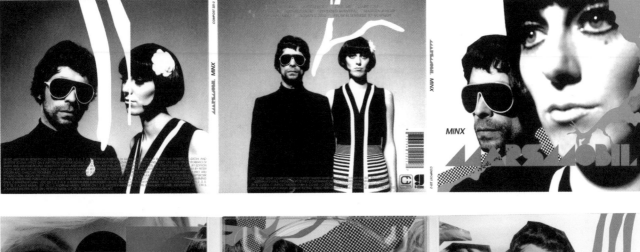

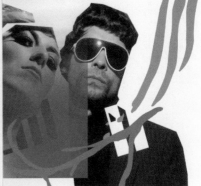

Title:
Pomelo 1994-2007:
13 Years

Type of Work:
CD artwork

Year:
2007

Contributed by:
dextro.org

Art Direction:
dextro.org

Design:
dextro.org

Client:
Pomelo Records

Musician(s):
Various

Description:
CD artwork for
'Pomelo 1994-2007:
13 Years,' a compi-
lation CD present-
ing tracks from the
past 13 years.

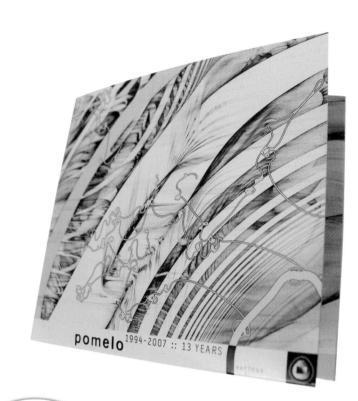

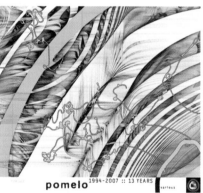

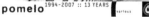

Title:
Laceration

Type of Work:
CD artwork

Year:
2007

Contributed by:
C100 Studio

Design:
C100 Studio

Client:
58 Beats

Musician(s):
Glam

Description:
CD cover for the
musician 'Glam.'

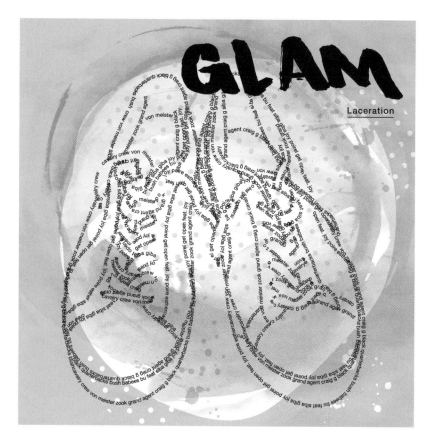

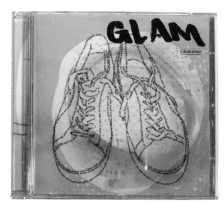

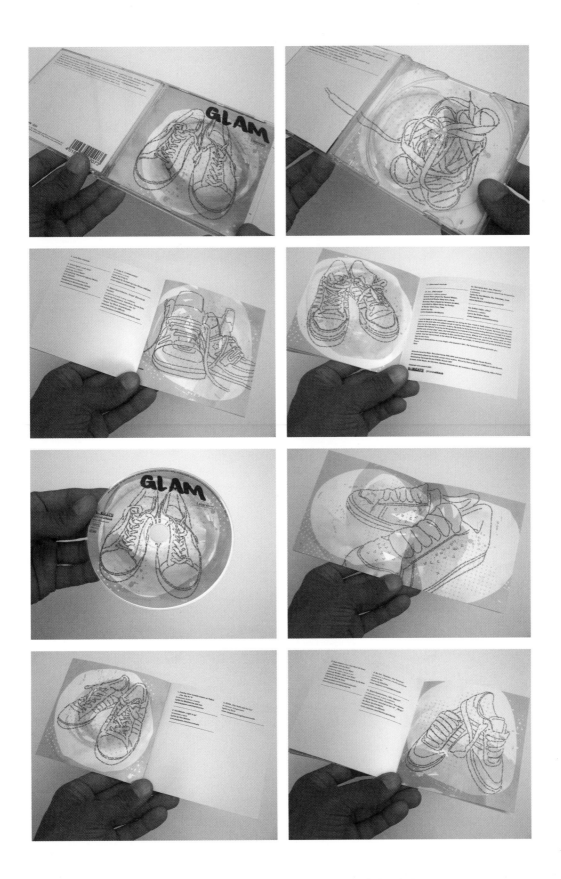

Title:
沿志奏逢2

Type of Work:
CD jacket

Year:
2008

Contributed by:
Yellow Brain Co., LTD

Art Direction:
Kouki Tange

Design:
Yuhei Urakami

Client:
TOY'S FACTORY

Musician(s):
Bank Band

Description:
This band was funded by a non-profit environment activist group. 'SOUSHISOUAI2' means 'love each other' in Japanese. The designers change these 4 characters to mean 'energetic musicians perform.' The jacket puts 'SOUSHISOUAI2' into shape with symmetry. It opens from a centre binding where the writing can be read normally. Upon expansion the writing can only be read from the moon's reflection, which features cranes flying across it. This is an interactive system which helps the user feel more harmonious with 'SOUSHISOUAI2' and the environment.

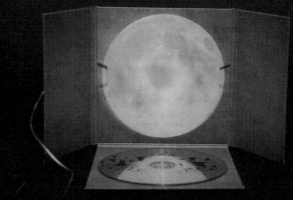

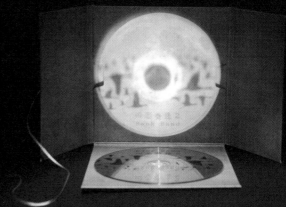

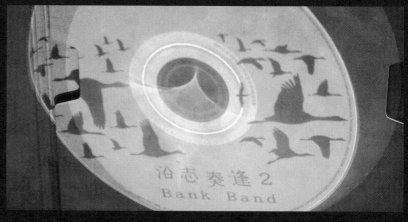

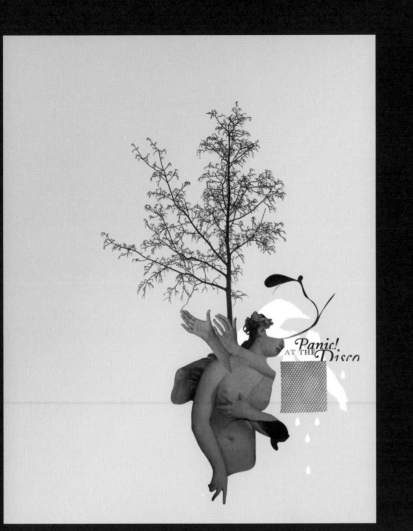

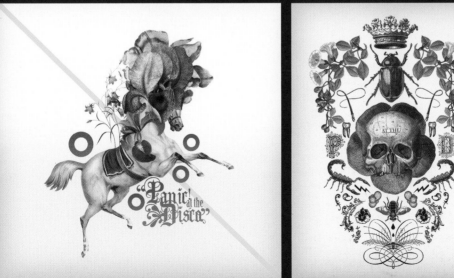

Title:
Panic! At the Disco

Type of Work:
T-shirt design

Year:
2007

Contributed by:
Misprinted Type

Art Direction:
Eduardo Recife

Design:
Eduardo Recife

Client:
Warner Music

Musician(s):
Panic! At the Disco

Description:
There was no brief
so Eduardo could
pretty much go
crazy with it and
create anything
that he wanted. But
somehow he tried
to incorporate the
feel of their music
into the design.

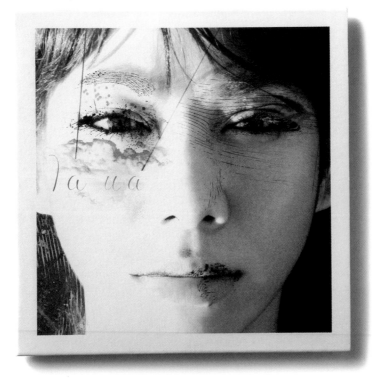

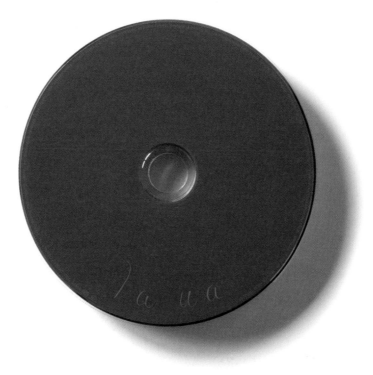

Title:
UA/Laua

Type of Work:
CD package

Year:
2004

Contributed by:
Tetsuya Nagato

Art Direction:
Tetsuya Nagato

Design:
Tetsuya Nagato

Client:
Victor
Entertainment
Speedstar

Musician(s):
UA

Description:
Silence. Photo
illustration by
Tetsuya Nagato.

Title:
Miho murmur

Type of Work:
CD cover

Year:
2005

Contributed by:
IKKAKUIKKA Co.,Ltd

Art Direction:
Keiko Itakura

Design:
Keiko Itakura

Client:
Victor
Entertainment
Speedstar

Musician(s):
Miho

Description:
The CD cover mirrors Miho's songs, which are fancy and tender.

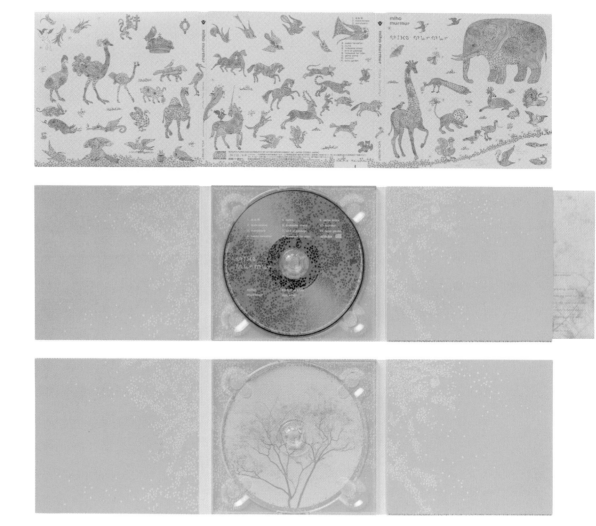

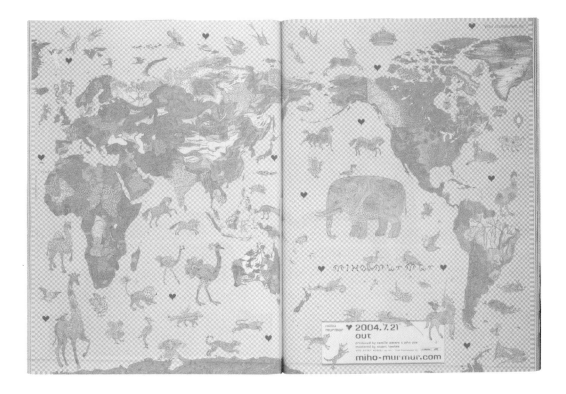

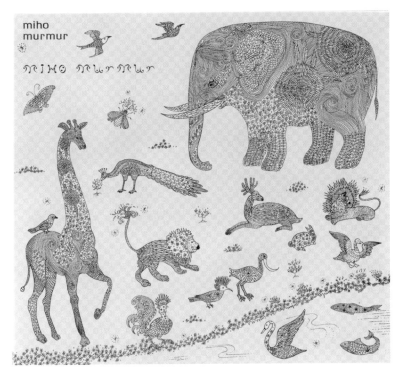

Title:
Saalschutz Machts
Moeglich!

Type of Work:
Vinyl Cover

Year:
2006

Contributed by:
Voegeli JTV

Art Direction:
Jonas Voegeli

Design:
Jonas Voegeli

Client:
Saalschutz

Musician(s):
Saalschutz

Description:
A vinyl cover for
the electro music
duo Saalschutz.
Their aim was to
irritate the listen-
ers and make them
think. The theme
colours are dark,
shiny, spooky mete-
orite and stone.
Even the typogra-
phy is set in the
shape of a stone.
For the release
party they created
an 8-page newspaper
which worked as a
flyer and a poster
at the same time. 4
posters were actu-
ally put together
to form a newspaper
flyer.

PASCAL FUHLBRUEGGE / DJ CHIRI MOYA SONNTAG: 24.12.2006 / 23:00H
RELEASE PARTY SAALSCHUTZ
IM STALL6 MACHT'S MOEGLICH
GESSNERALLEE ZUERICH FREE ENTRY

"ÜBER
SIEBEN
BRÜCKEN MUSST
DU GEHN UM SAALSCHUTZ
SAALSCHUTZ PROFITIEREN
ZU VERSTEHN" VON DEM HYPE
MIT: STINA GALAXINA LIVE ON STAGE
JANE FOXXXY, LOLITA
DEFEKT, PHANTWO, OUT NOW
STRIKK, BIG ZIS, ON VINYL
PLEMO TINGUELY DA AND CD
CHNACHT, G.I.JOHN,
LUGNER, KNARF RELLÖM
UND VIELE MEHR...
RELEASE PARTY 24.12.06

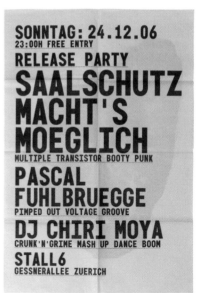

SONNTAG: 24.12.06
23:00H FREE ENTRY
RELEASE PARTY
SAALSCHUTZ
MACHT'S
MOEGLICH
MULTIPLE TRANSISTOR BOOTY PUNK
PASCAL
FUHLBRUEGGE
PIMPED OUT VOLTAGE GROOVE
DJ CHIRI MOYA
CRUNK'N'GRIME MASH UP DANCE BOOM
STALL6
GESSNERALLEE ZUERICH

RELEASE PARTY 24.12.06
UND VIELE MEHR...
LUGNER, KNARF RELLÖM
CHNACHT, G.I.JOHN,
PLEMO TINGUELY DA
STRIKK, BIG ZIS,
DEFEKT, PHANTWO,
JANE FOXXXY, LOLITA
MIT: STINA GALAXINA
ZU VERSTEHN" VON DEM HYPE
LIVE ON STAGE
SAALSCHUTZ PROFITIEREN
DU GEHN UM SAALSCHUTZ
BRÜCKEN MUSST
SIEBEN
"ÜBER
OUT NOW
ON VINYL
AND CD
spex

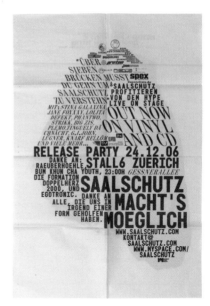

"ÜBER
SIEBEN
BRÜCKEN MUSST
DU GEHN UM SAALSCHUTZ
SAALSCHUTZ PROFITIEREN
ZU VERSTEHN" VON DEM HYPE
MIT: STINA GALAXINA LIVE ON STAGE
JANE FOXXXY, LOLITA
DEFEKT, PHANTWO, OUT NOW
STRIKK, BIG ZIS, ON VINYL
PLEMO TINGUELY DA AND CD
CHNACHT, G.I.JOHN,
LUGNER, KNARF RELLÖM
UND VIELE MEHR...
RELEASE PARTY 24.12.06
DANKE AN: STALL6 ZUERICH
RAEUBERHOEHLE GESSNERALLEE
BUM KHUN CHA YOUTH, 23:00H
DIE FORMATION
DOPPELHERZ SAALSCHUTZ
2000, UND
EGOTRONIC. DANKE AN MACHT'S
ALLE, DIE UNS IN
IRGEND EINER MOEGLICH
FORM GEHOLFEN
HABEN.
WWW.SAALSCHUTZ.COM
KONTAKT@
SAALSCHUTZ.COM
WWW.MYSPACE.COM/
SAALSCHUTZ

.......
estival
y/Flyer
r

007

uted by:
phe Remy

phe Remy

re
acoustik
ts
t circuit
aison des
s

2. Flyer for a contest involving emerging Belgian rock bands.

3. Flyer for an indie/rock festival at la maison des musiques in Brussels. 'Maison' meaning house in English, it's where the main theme is taken from.

CONCOURS
CIRCUIT
2005 ROCK DUR

WWW.COURTCIRCUIT.BE

2

WE ARE
ELECTROACOUSTIK
ACCIDENTS

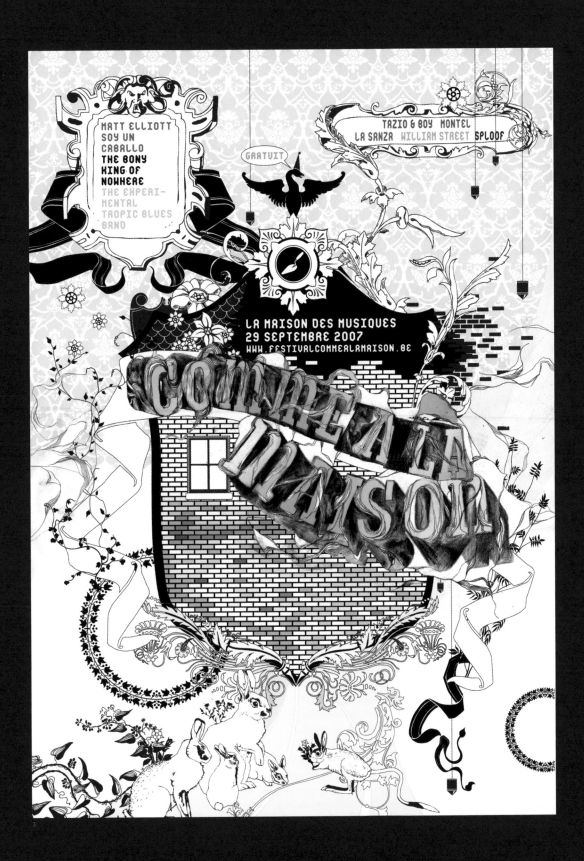

Title:
Regina

Type of Work:
Illustration

Year:
2007

Contributed by:
Maija Louekari

Art Direction:
Maija Louekari

Design:
Maija Louekari

Client:
Regina

Musician(s):
Regina, Iisa Pykäri,
Mikko Pykäri, Mikko
Rissanen

Description:
Illustrated cover
design for an Indie
band called Regina
from Finland.

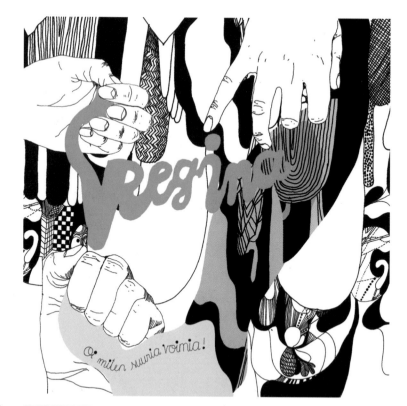

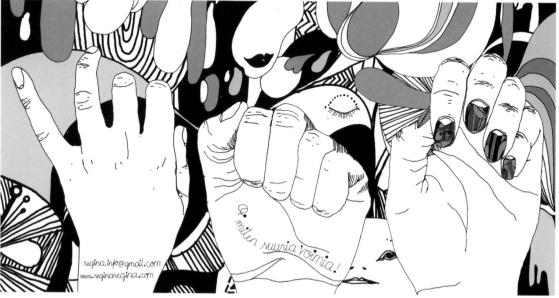

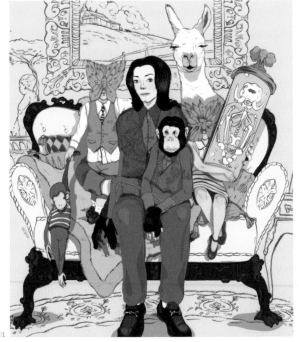

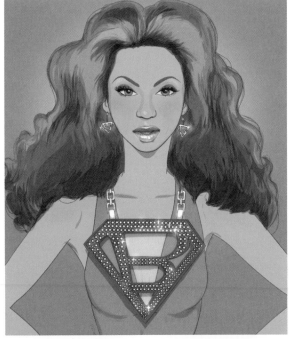

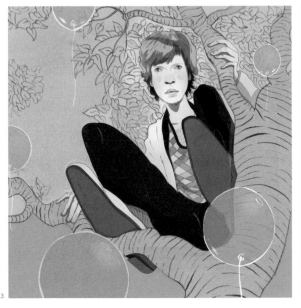

Title:
1-3. Nil
4. Yoko Ono: Yes
I'm a Witch

Type of Work:
Magazine
illustration

Year:
1. 2005
2-3. 2006
4. 2007

Contributed by:
Marcos Chin

Art Direction:
1, 3. Devin
Petzwater
2. Wyatt Mitchell
4. José Reyes

Design:
1, 3. Devin
Petzwater
2. Wyatt Mitchell
4. José Reyes

Client:
1, 3. Spin
2. Vibe
4. Paste

Musician(s):
1. Michael Jackson
2. Beyonce
3. Beck
4. Yoko Ono

Description:
1. The illustra-
tion is a sarcas-
tic portrayal of
Michael Jackson; it
is essentially his
family portrait.
2. This illus-
tration was for
an article about
Beyonce's ubiquity
in the music indus-
try and mass media.
3. Illustration for
Beck's new album
Guaro that was
published in Spin
magazine.
4. This illustra-
tion was for an
article in Paste
magazine about Yoko
Ono's new album,
entitled, 'Yes, I'm
A Witch.'

Title:
Javier Punga's EP

Type of Work:
CD cover
illustration

Year:
2007

Contributed by:
Irana Douer

Art Direction:
Javier Punga

Design:
Irana Douer

Client:
Javier Punga

Musician(s):
Javier Punga

Description:
The idea was to
make 2 images like
silkscreen prints.
The cover features
a girl listening to
the artist's music
and the back cover
is just the pro-
file of a girl with
a patterned back-
ground.

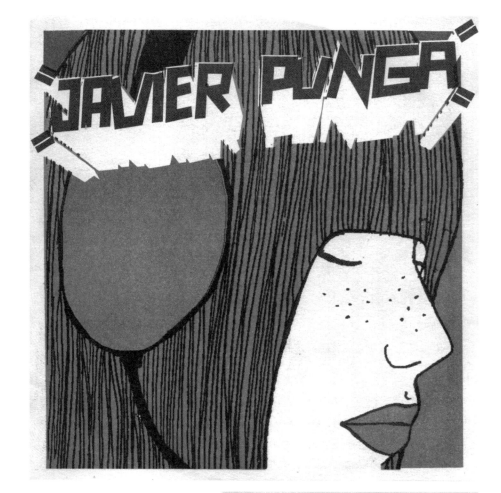

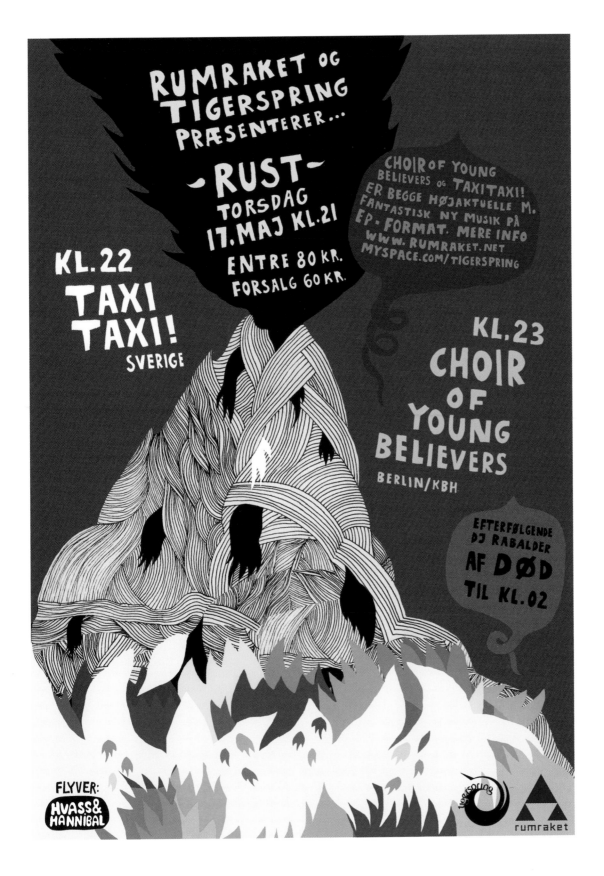

Title:
Rumraket and
Tigerspring

Type of Work:
Flyer

Year:
2007

Contributed by:
Hvass&Hannibal

Design:
Hvass&Hannibal

Client:
Rumkraket and
Tigerspring

Description:
Flyer for a concert
night at Rust in
Copenhagen orga-
nized by Rumraket
and Tigerspring
record labels.

Title:
Dour

Type of Work:
Festival identity

Year:
2007

Contributed by:
Christophe Remy

Art Direction:
Christopher Remy

Design:
Christophe Remy,
Amandine Dupont

Client:
Dour festival

Description:
Visual identity
for the well-known
Belgian summer fest
Dour.

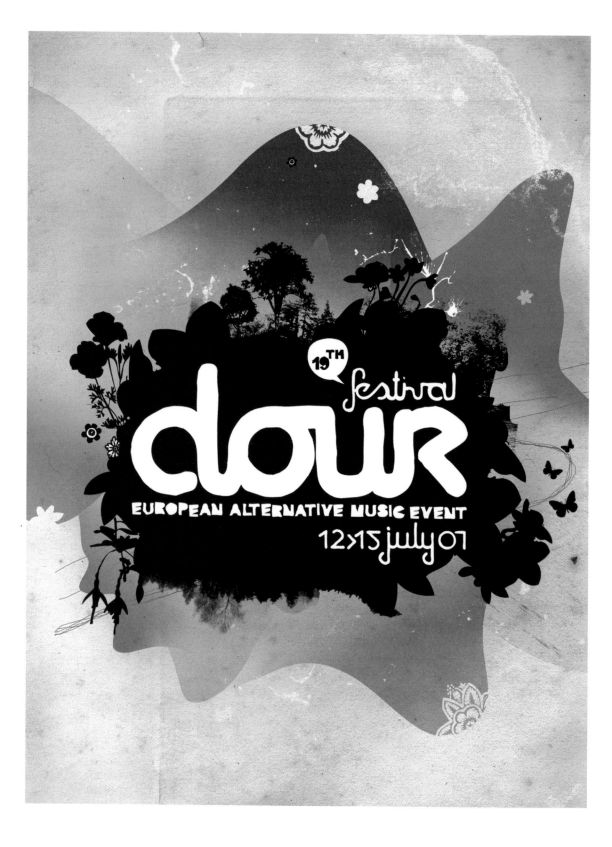

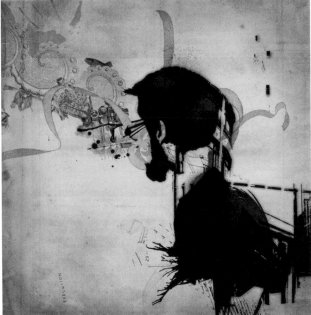

Title:
Gri

Type of Work:
CD cover

Year:
2006

Contributed by:
Christophe Remy

Design:
Christophe Remy

Client:
Gri

Musician(s):
Gri

Description:
CD cover for a
little independent
experimental music
project from
Brussels.

Title:
Mika: Various

Type of Work:
Graphic design,
Animation, Music
packaging, Exhibi-
tion design

Year:
2006-07

Contributed by:
Airside

Art Direction:
Airside, Yasmine

Design:
Airside, Yasmine

Client:
Mika, Island
Records and Machine
Management

Musician(s):
Mika

Description:
Mika and his sister
Yasmine came to
Airside with plenty
of ideas and draw-
ings, but the chal-
lenge of turning
these into a full
visual identity for

Mika's music was
too daunting for
them alone. Enter
Airside, stage
left. The visual
world of Mika is
colourful and
naive, and reflects
his personality.
Using elements and
characters drawn
by Yasmine, Air-
side created a
world for them all
to inhabit in, as
well as develop-
ing a typeface
unique to Mika.
They developed a
visual language and
identity that was
then applied across
the entire campaign
including web ani-
mations, packaging,
posters and music
promos.

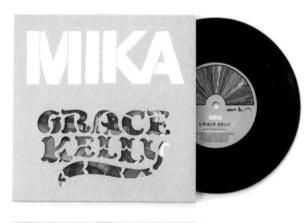

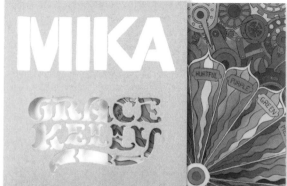

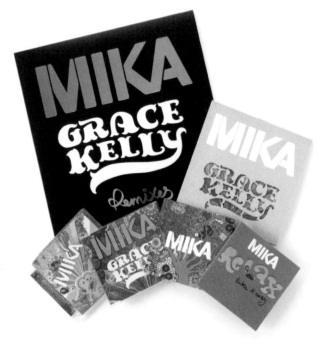

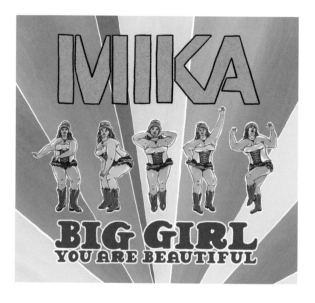

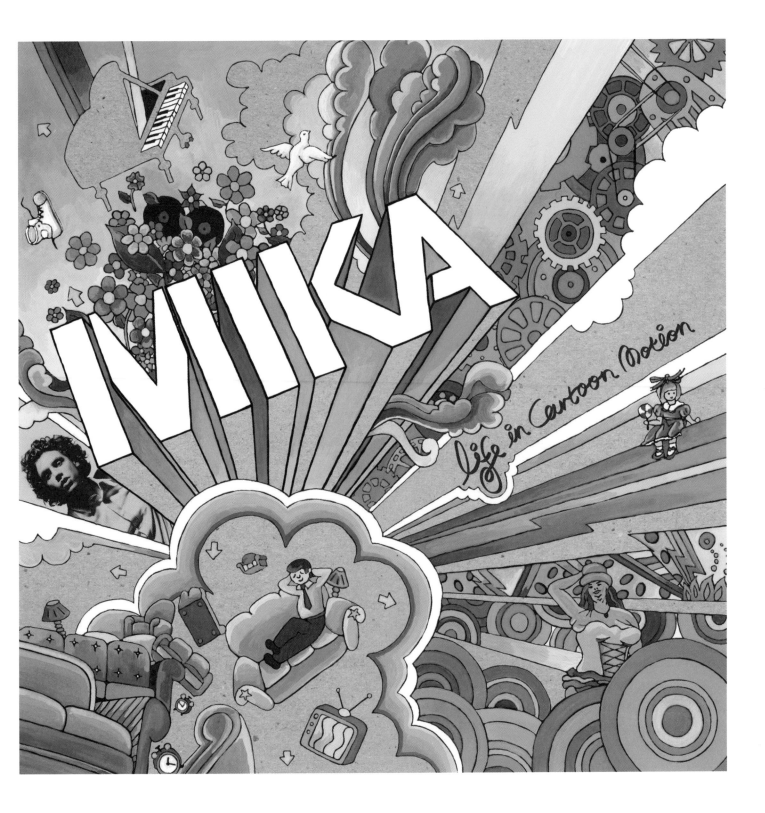

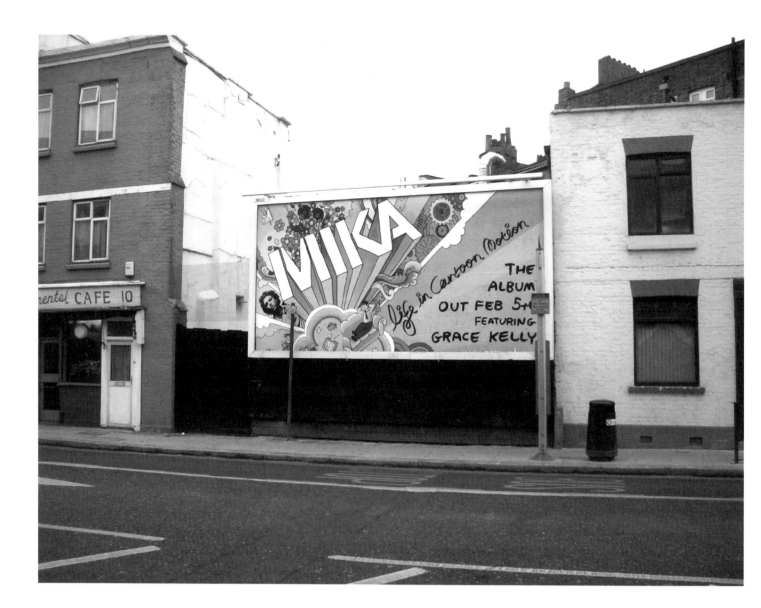

Title:
Southern Sessions

Type of Work:
Flyer

Year:
2005-06

Contributed by:
Purple Haze Studio

Art Direction:
Clemens Baldermann

Design:
Clemens Baldermann

Client:
Southern Sessions

Musician(s):
Various

Description:
Flyer design, illustration and title type design for a drum and bass club night series. Printed in various spot colours, metallic and fluorescent inks.

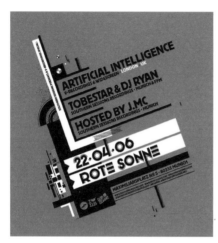

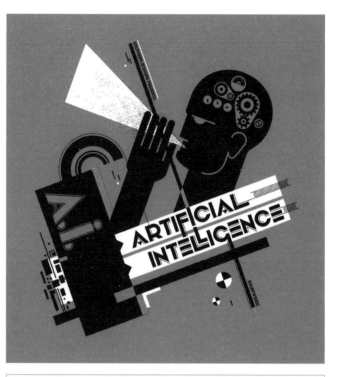

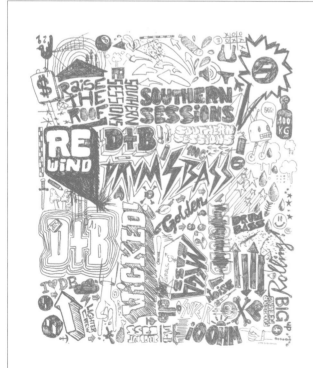

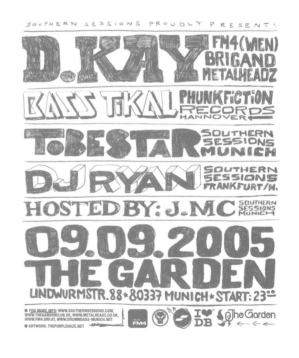

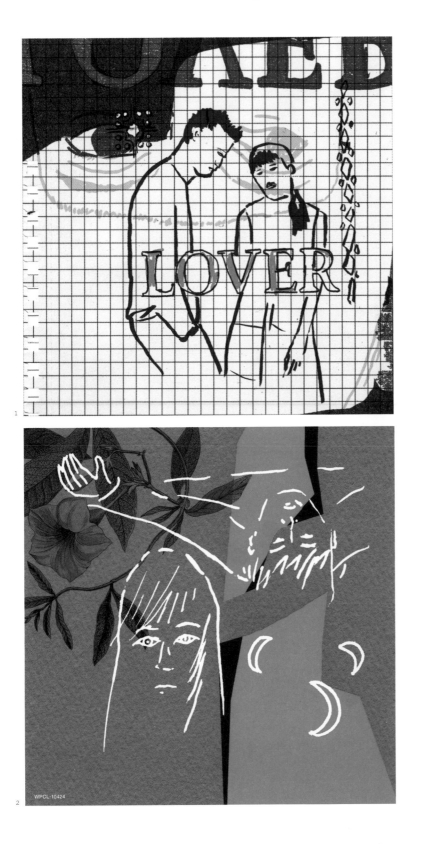

Title:
1. Lover
2. Koiwazurai

Type of Work:
CD artwork

Year:
2007

Contributed by:
Enlightenment

Art Direction:
Enlightenment

Design:
Enlightenment

Client:
Warner Music Japan

Musician(s):
Tsubakiya Quartette

Description:
1. Enlightenment
expressed an insane
love story of 2
people who were in
love by collage of
the soft psyche-
delic drawing.
2. Enlightenment
expressed love
before being morbid
by crimson and col-
lage of soft psy-
chedelic drawing.

Title:
Jerome and Sylvie
- Vacinar EP

Type of Work:
CD artwork,
Packaging

Year:
2007

Contributed by:
D412 Architectural
Design Group

Art Direction:
Luis Iturra M.

Design:
Luis Iturra M.

Client:
Noseyo Records,
Jerome and Sylvie

Musician(s):
Jerome and Sylvie

Description:
Vacinar was a new
musical path in
Jerome and Sylvie's
music. The graphics
is a series of nice
drawings of dots
and lines that form
a new drawing. The
9 drawings are used
for the cover and
are separated at
the back. Inside,
all parts are
separated, like the
loops in the music.

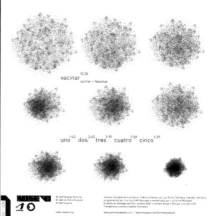

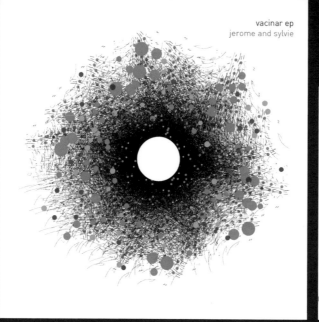

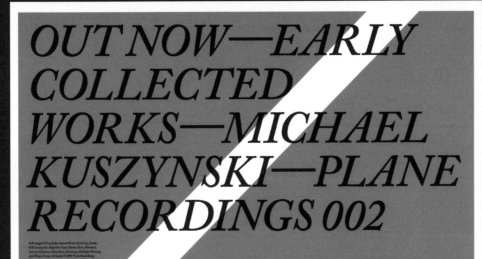

OUT NOW—EARLY
COLLECTED
WORKS—MICHAEL
KUSZYNSKI—PLANE
RECORDINGS 002

Full-length CD includes Smooth Break, Dark City, Gritch,
Still Loving You, Royal Fox Court, Techno Siren, Who am I,
Learn to Compress, Fairy Dust, Constancy, Midnight Morning,
and Wango Drums. All tracks © 2007 Plane Recordings.
Written, recorded, and produced by Michael Kuszynski.
Design by Ken Meier. Mastered by Nathan Jones at Jaguar
Sound, NY. Track order arrangement by Luis Gabriel
Aguilera. For bookings and ordering information, please
visit planerecordings.com.

ael Kusz

Collected

© 2007 Plane Recordings
planerecordings.com

Michael Kuszynski / Early Collected Works / Plane Recordings 002

Smooth Break 11:40:04
Dark City 06:10:12
Gritch 05:43:38
Still Loving You 06:40:08
Royal Fox Court 05:51:50
Techno Siren 06:41:38
Who am I? 05:52:55
Learn to Compress 08:41:03
Fairy Dust 06:41:10
Constancy 09:40:07
Midnight Morning 10:41:09
Wango Drums 06:41:43

Michael Kuszynski
Early Collected Works

Written, recorded, and produced by Michael Kuszynski. Design by Ken Meier.
Mastered by Nathan Jones at Jaguar Sound, NY. Track order arrangement by
Luis Gabriel Aguilera. All tracks © 2007 Plane Recordings. All rights reserved.
Unauthorized duplication is a violation of applicable laws.

Title:
Early Collected
Works

Type of Work:
CD artwork, Poster

Year:
2006

Contributed by:
Ken Meier

Art Direction:
Ken Meier

Design:
Ken Meier

Client:
Plane Recordings

Musician(s):
Michael Kuszynski

Description:
Independent elec-
tronic music from
New York.

Title:
ReEdits 01-03

Type of Work:
CD artwork

Year:
2006-07

Contributed by:
desres design group

Art Direction:
Michaela Kessler

Design:
Michaela Kessler,
Dirk Schrod

Client:
pooledmusic,
Ian Pooley

Musician(s):
Ian Pooley

Description:
Design for Ian's
latest releases.
The 'returned-
series' consists
of 3 12-inch with
re-edits of tracks,
originally released
in the mid 90s.

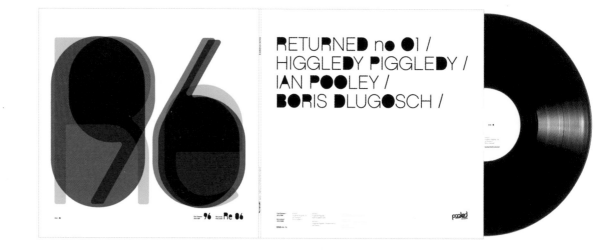

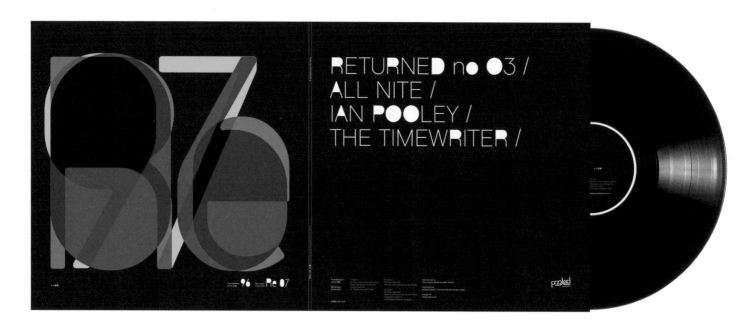

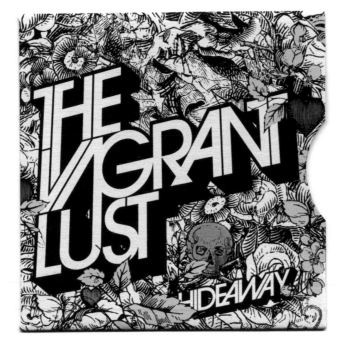

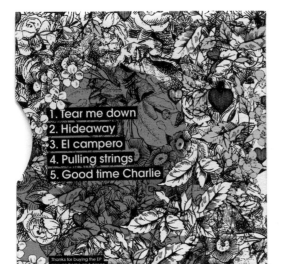

1. Tear me down
2. Hideaway
3. El campero
4. Pulling strings
5. Good time Charlie

Thanks for buying the EP
now go home and dance

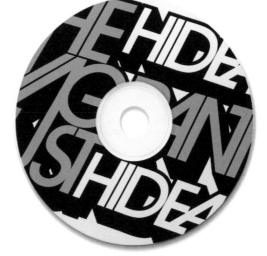

Title:
The Vagrant Lust CD
Packaging

Type of Work:
CD packaging

Year:
2006

Contributed by:
S E I Z

Art Direction:
Gui Seiz

Design:
Gui Seiz

Client:
S E I Z

Musician(s):
The Vagrant Lust

Description:
The Vagrant Lust's
EP is a mix of
melancholic songs
that deal with the
usual teenage angst
issues of breakups,
missed chances and
hidden feelings.
The idea for the
cover was to create
a hectic environ-
ment in which love
(hearts) and heart-
break (skulls) were
present, although
hidden away. There
are also hidden
references to songs
in the artwork that
become clearer the
more you listen to
the CD. All art-
work is silkscreen
printed in limited
edition, varied
coloured batches.

Title:
Talib Kweli -
Eardrum

Type of Work:
CD artwork

Year:
2006

Contributed by:
KARBORN

Design:
KARBORN

Client:
The KDU

Musician(s):
Talib Kweli

Description:
2 high-resolution
illustrations cre-
ated on commission
from NY collective,
the KDU for Talib
Kweli. A well-known
and well respected
veteran of U.S. Hip
Hop, collaborating
with Mos Def on the
Blackstar releases.

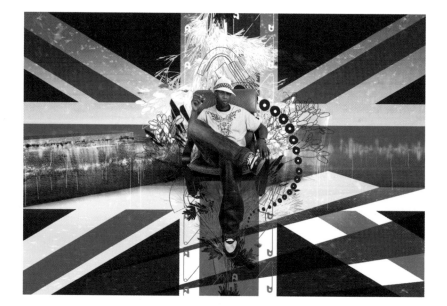

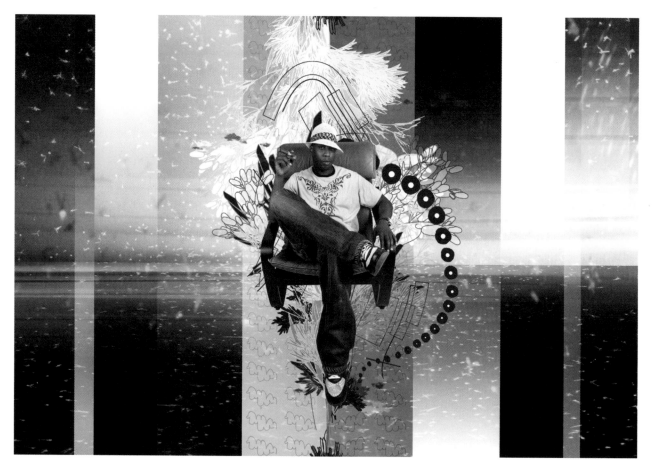

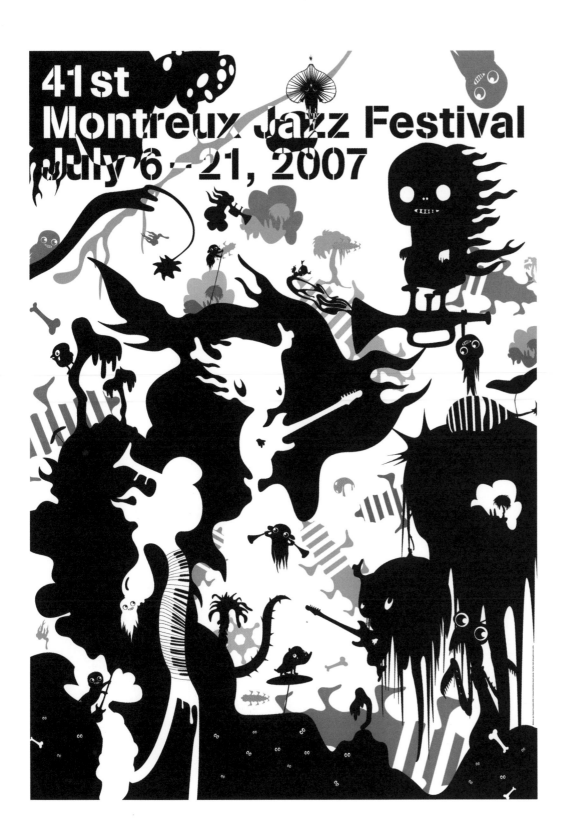

Title:
Poster for the 41st
Montreux Jazz fes-
tival, Switzerland
2007

Type of Work:
Illustration

Year:
2007

Contributed by:
KATRIN OLINA

Design:
Katrin Olina

Client:
Foundation Montreux
Jazz festival,
Switzerland

Description:
The vast collec-
tion of posters
for the Festival
include art work
by such highlights
as Andy Warhol,
Keith Haring, David
Bowy, Robert Combas
and Nicki de Saint
Phalle.

Title:
Same Man

Type of Work:
12" vinyl

Year:
2006

Contributed by:
Zion Graphics

Art Direction:
Ricky Tillblad

Design:
Ricky Tillblad

Client:
Refune Recordings

Musician(s):
Till West, DJ
Delicious

Description:
The silver foiled
typography on this
cover is a modified
Charlet.

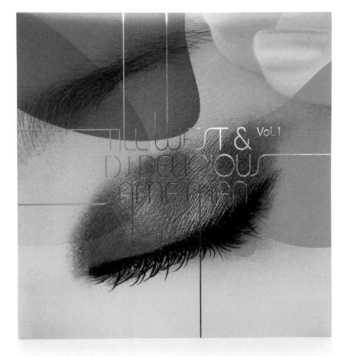

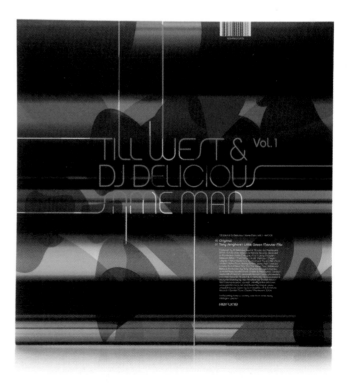

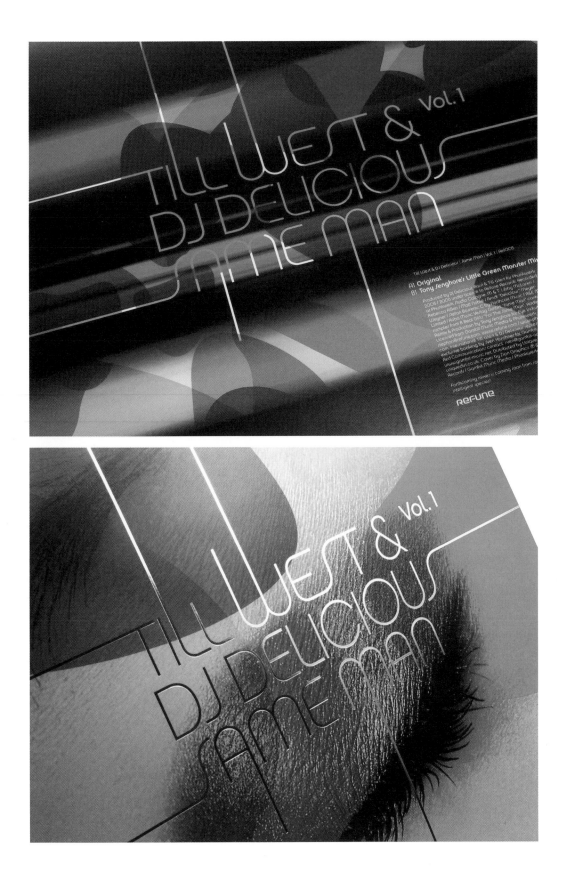

Title:
La Messe

Type of Work:
CD artwork

Year:
2007

Contributed by:
ATOMIKE STUDIO

Art Direction:
Mike Stefanini

Design:
Mike Stefanini

Client:
ARGOS

Musician(s):
PUSH

Description:
Album cover and art
direction for PUSH.

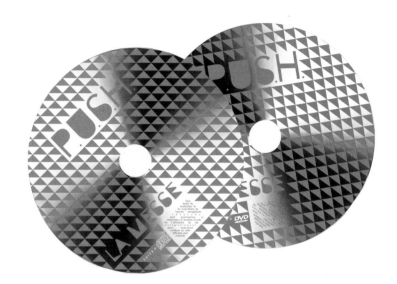

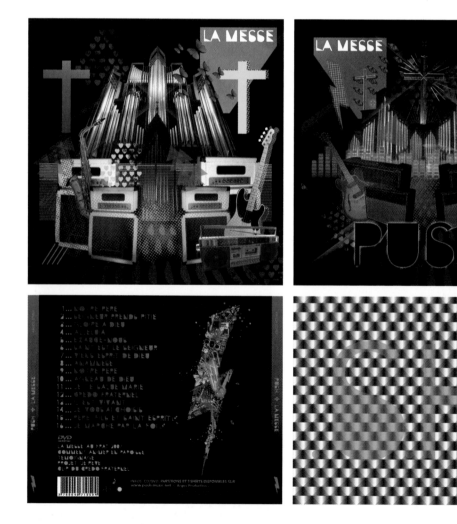

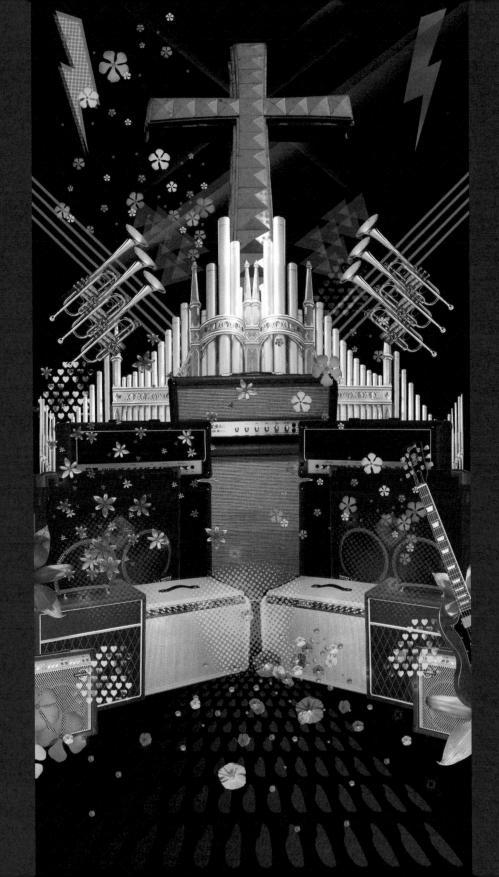

Title:
1. Passchendale
2. Leni
3. The Illness

Type of Work:
CD cover
illustration

Year:
1, 3. 2007
2. 2006

Contributed by:
Julien Pacaud

Art Direction:
Julien Pacaud

Design:
Steve Stacey

Client:
Columbia/Sony BMG

Musician(s):
GoodBooks

Description:
Digital collage
and photo manipula-
tion using vintage
images found in old
magazines.

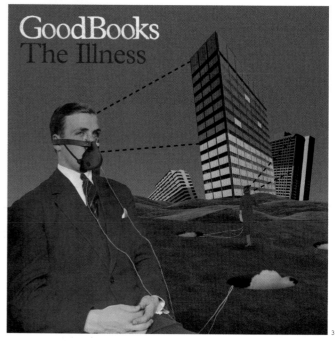

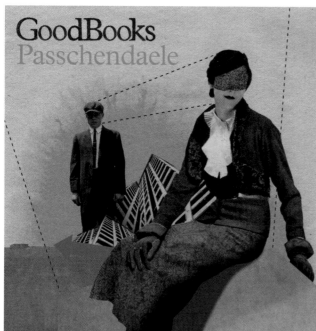

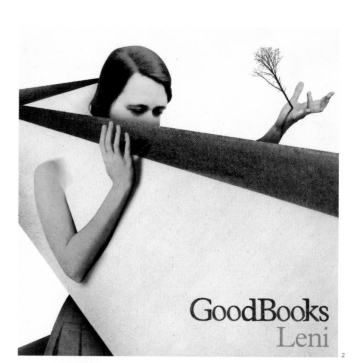

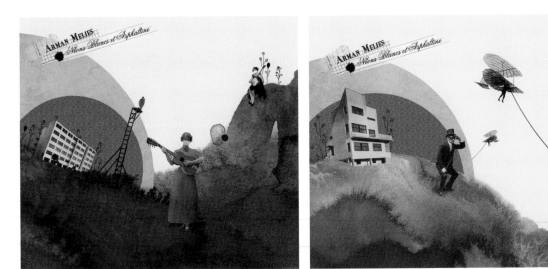

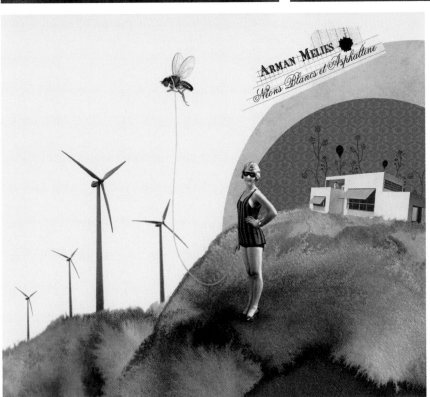

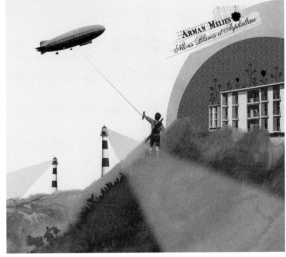

Title:
Néons Blancs et
Asphaltine
Type of Work:
CD cover
illustration
Year:
2004
Contributed by:
Julien Pacaud
Art Direction:
Julien Pacaud
Design:
Julien Pacaud
Client:
Bizarrre K7
Musician(s):
Arman Méliès
Description:
Digital collage
and photo manipula-
tion using vintage
images found in old
magazines. There
are 4 different
illustrations for 4
different possible
covers, printed on
cards, which can be
changed in the CD
case.

Title:
1. Les Tortures
Volontaires
2. Judith Judith

Type of Work:
CD cover
illustration

Year:
2006

Contributed by:
Julien Pacaud

Art Direction:
Julien Pacaud

Design:
Julien Pacaud

Client:
1. Remark Records/
Warner
2. P 572

Musician(s):
1. Arman Méliès
2. Death Polka

Description:
Digital collage and
photo manipulation
using vintage
images found in
old magazines.

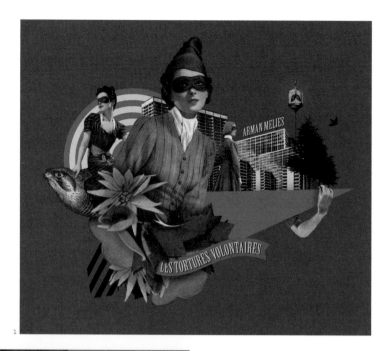

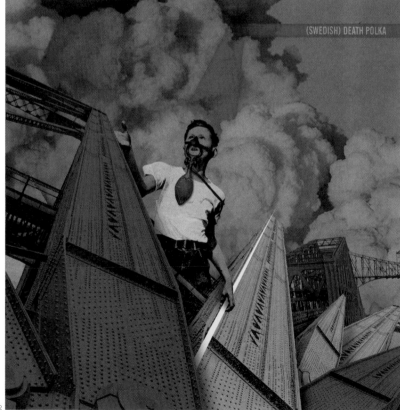

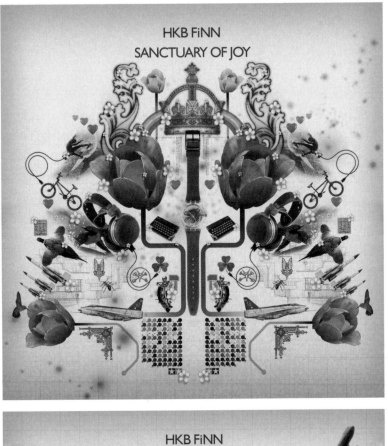

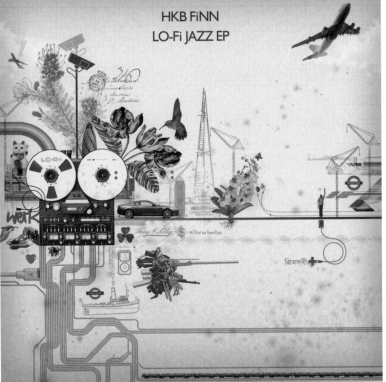

Title:
1. Sanctuary of Joy
Covers
2. Lo-Fi Jazz EP

Type of Work:
CD cover

Year:
2007

Contributed by:
Aeriform Viscom

Art Direction:
Sean Rodwell

Design:
Sean Rodwell

Client:
Alter Native
Studios

Musician(s):
HKB FiNN

Description:
These covers draw
reference from the
artist's dusty hip
hop poetry and the
times gone by that
it evokes. Visual
references to
both artist and
designer's past are
included to ensure
the covers are a
perfect meeting
point between music
and illustration.

Title:
1. 'Who said that
we need to be
strong?'
2. Super Bug
3. Senses

Type of Work:
Digital collage,
Fine art

Year:
2007

Contributed by:
HANDIEDAN

Design:
HANDIEDAN

Client:
1. FEFÈ Project
– Visual Magazine
Music, Luigi Ver-
nieri

Description:
1. Under the acro-
nym FEFÈ, a group
of Italian profes-
sionals has cre-
ated an interna-
tional magazine. In
each issue 25 'free
entry' guests and 1
child are invited
to enter into the
creative process
of the magazine
itself, interpret-
ing the leading
theme of the maga-
zine.
2, 3. The artworks
HANDIEDAN creates
are accessible,
playful and full of
layered little sto-
ries. It is a digi-
tal cut and paste
mixture of classic
pin ups and hand-
made fine arts and
doodles.

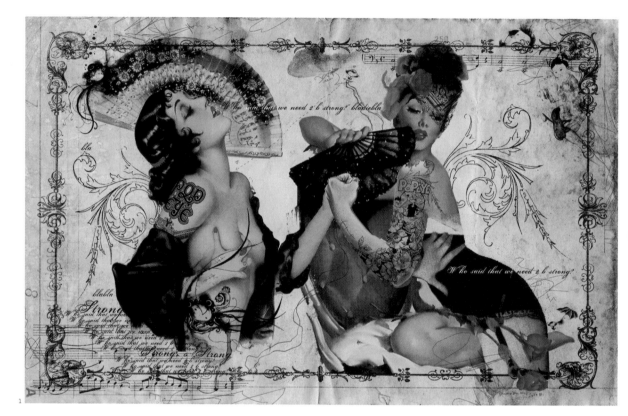

1

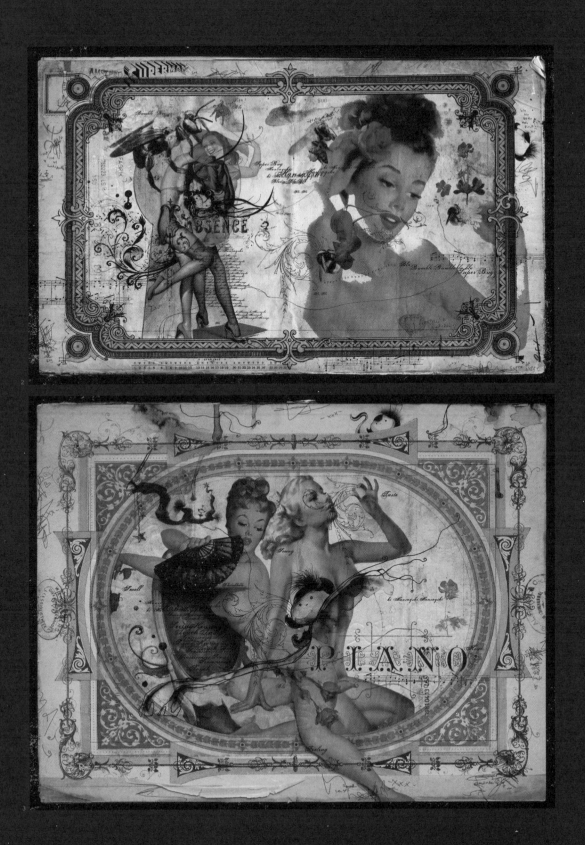

Title:
1. 15
2. Paradise
3. Pin Up

Type of Work:
Digital collage,
Fine art

Year:
2007

Contributed by:
HANDIEDAN

Design:
HANDIEDAN

Client:
1. IdN Magazine

Description:
1. Create an art-
work in the theme
'15' for IdN Maga-
zine's 15th anni-
versary.

2, 3. The artworks
HANDIEDAN creates
are accessible,
playful and full of
layered little sto-
ries. It is a digi-
tal cut and paste
mixture of classic
pin ups and hand-
made fine arts and
doodles.

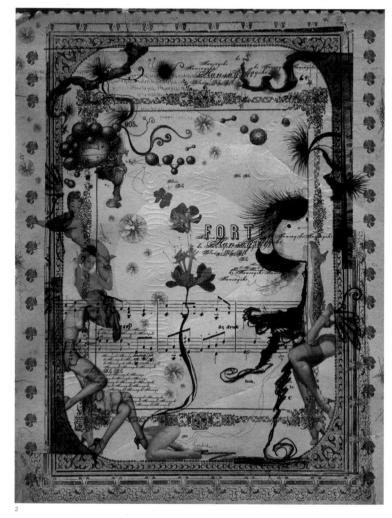

2

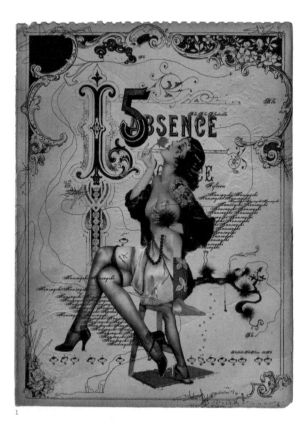

1

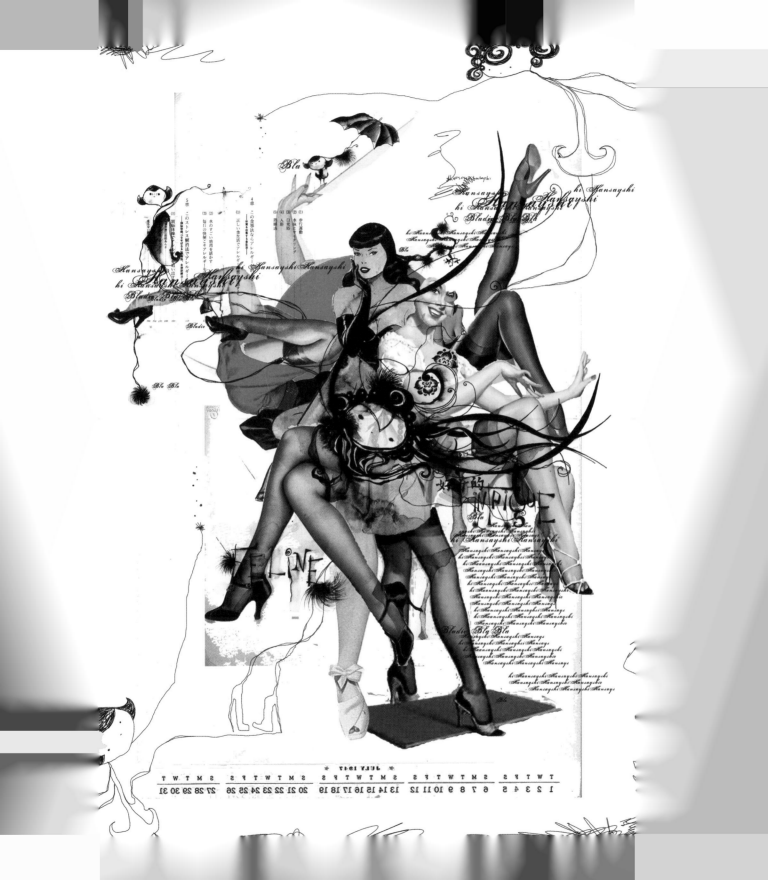

Title:
Big Jama

Type of Work:
Music event, Communication, Poster, Flyer, Program

Year:
2002-07

Contributed by:
Arkétype Création Graphique

Art Direction:
Gérald Jay

Design:
Gérald Jay

Client:
ADMD Cantal. Haute-Loire, Allier, Region Auvergne

Musician(s):
Various

Description:
Big Jama is a device created to put regional music artists under the spotlight and help them in their artistic expansion. He was free to create the universe spinning around these events. So he has chosen to work with old stuff and show the effect of time on objects and some metaphorical images. It was one of the works that allowed him to win a kind of recognition.

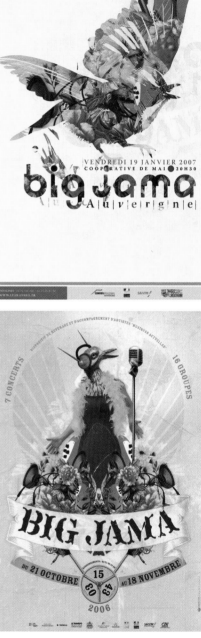

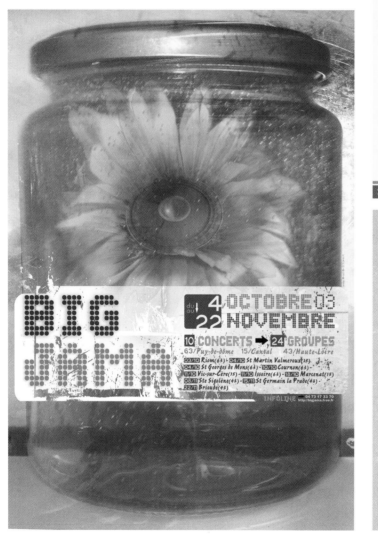

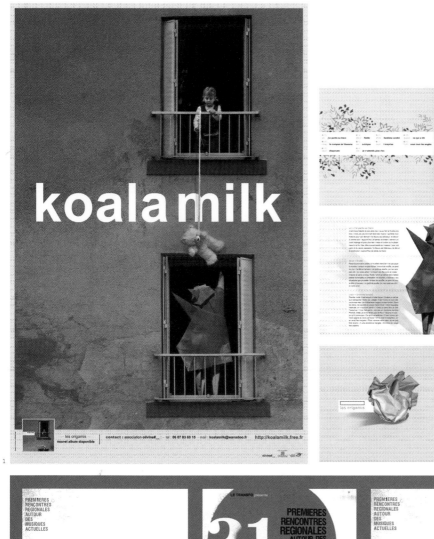

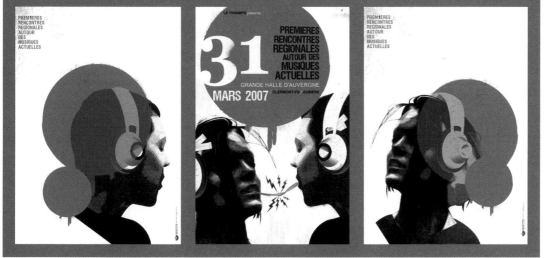

Title:
1. Koala Milk -
Les Origamis
2. 1ere Rencontre
autour des Musiques
Actuelles en
Auvergne

Type of Work:
1. CD packaging,
Poster, Booklet
2. Poster, Flyer,
Merchandising,
Communication

Year:
1. 2005
2. 2007

Contributed by:
Arkétype Création
Graphique

Art Direction:
Gérald Jay

Design:
Gérald Jay

Client:
1. olivine
2. Le Transfo,
Region Auvergne

Musician(s):
1. Koala Milk

Description:
1. Koala Milk is
a pop-rock band.
They wanted to
give an impres-
sion of sweetness,
something like the
childhood, remem-
brance of the
innocence. Jay used
some origami for
this work and he
realized that it's
really harder than
simply creating
images!
2. Jay made this
work for the first
concert in Auvergne,
his region. He was
very proud that
they asked him to
create this. They
wanted something
very powerful and
rock'n'roll. So he
decided to use 2
flashing colours
against a white
backdrop. For the
little story, he
found the idea of
'the electric chew-
ing-gum' while he
was sleeping.

Title:
Lake Toba

Type of Work:
CD cover

Year:
2007

Contributed by:
Madebymade

Art Direction:
Robin Snasen
Rengård

Design:
Robin Snasen
Rengård

Client:
Tuba Records

Musician(s):
Lukestar

Description:
7-inch vinyl single
taken from Luke-
star's 'Lake Toba'
album.

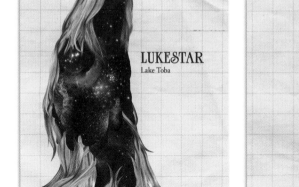
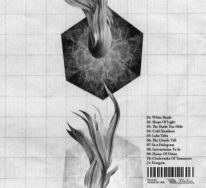

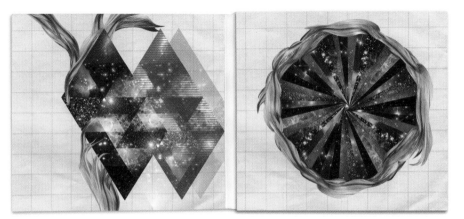

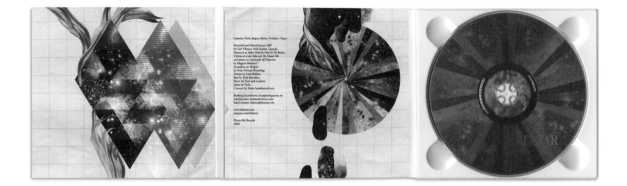

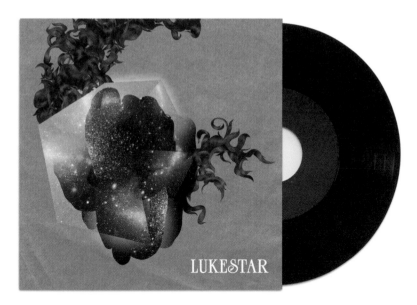

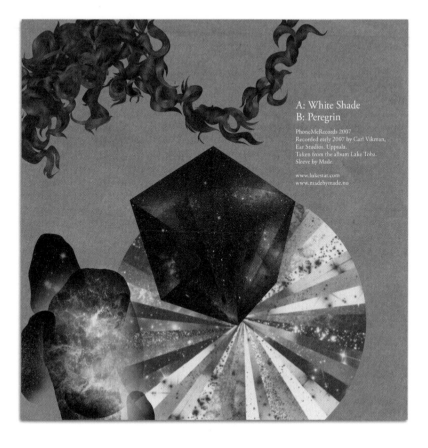

A: White Shade
B: Peregrin

PhoneMeRecords 2007
Recorded early 2007 by Carl Vikman,
Ear Studios. Uppsala.
Taken from the album Lake Toba.
Sleeve by Made.

www.lukestar.com
www.madebymade.no

Title:
White Shade 7"

Type of Work:
Record Cover

Year:
2007

Contributed by:
Madebymade

Art Direction:
Robin Snasen
Rengård

Design:
Robin Snasen
Rengård

Client:
Phone Me Records

Musician(s):
Lukestar

Description:
Design for an indie
pop group from
Norway. Printed on
reversed digipak.

Title:
1. -0°C
2. Rewind

Type of Work:
1. Poster
2. Flyer

Year:
1. 2007
2. 2006

Contributed by:
Khaki Creative
& Design

Art Direction:
Nod Young

Design:
Nod Young

Client:
1. Khaki Creative
& Design
2. Cargo Club

Musician(s):
2. DJ Pitch In and
MC Taiwan

Description:
1. This is a sad
artwork like
Young's favourite
music. Music has
been influencial to
Young, it gives and
encourages him cre-
ative inspirations.
He is not sure for
whom this artwork
is done, perhaps
for music, perhaps
for environment.
2. This is a flyer
for the Cargo
Club's Drum and
Bass party. The
Cargo Club is a
famous club in
Beijing. Young was
doing a lot of
advertising and
packaging for them
in 2006.

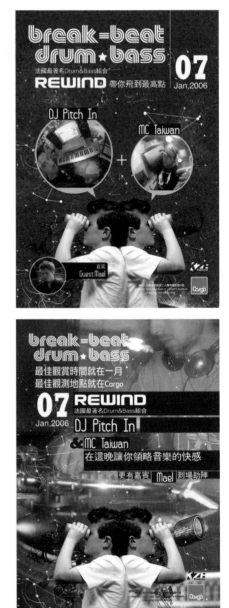

2

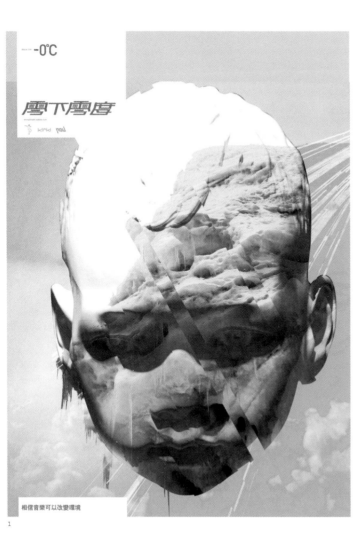

1

I AM ROBOT AND PROUD

WE HAVE ORGANIZED THIS OLD-FASHIONED STEREO EQUIPMENT INTO A NEW FORM TO CREATE THIS COUPLE OF ROBOTS. WE THINK THE AGED PLASTIC AND METAL ARE WAY COOLER THAN OUR MODERN ELECTRONIC STANDARD. THIS PIECE REPRESENTS THE SPIRIT OF THE LAST GENERATION -- THE TIMES WE MISS AND THE CULTURE WE HAVE LOST. WE ARE MOST CONCERNED ABOUT LOSING OUR CULTURE AND FIND IT TO BE A HIGH PRICE TO PAY FOR "MODERN LIFE."

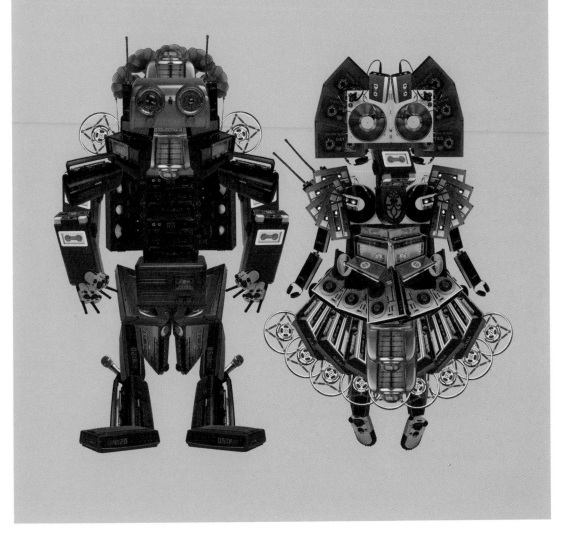

Title:
I am Robot and Proud

Type of Work:
Poster

Year:
2005

Contributed by:
Khaki Creative & Design

Art Direction:
Nod Young

Design:
Nod Young

Description:
Khaki Creative & Design has organized this old-fashioned stereo equipment into a new form to create these robots. They think the aged plastic and metal are way cooler than the modern electronic standard. This piece represents the spirit of the last generation: the times we missed and the culture we lost. The group is most concerned about losing our culture and find it to be a high price to pay for modern life.

Title:
You are the next
project: SONY walk-
man 'Ippei Gyoubu
model'

Type of Work:
Walkman artwork,
Exhibition

Year:
2005

Contributed by:
Ippei Gyoubu

Art Direction:
Yoshihiro Taniguchi

Design:
Kazuhiro Imai

Clients:
SONY Japan,
digmeout

Description:
This project was
a collaboration
between illustra-
tion agency digme-
out and SONY Japan.
The artwork adorned
SONY Japan's lim-
ited edition Walk-
man and the exhibi-
tion was held in
celebration of it.
The entire wall of
the exhibition hall
was covered with a
huge artwork.

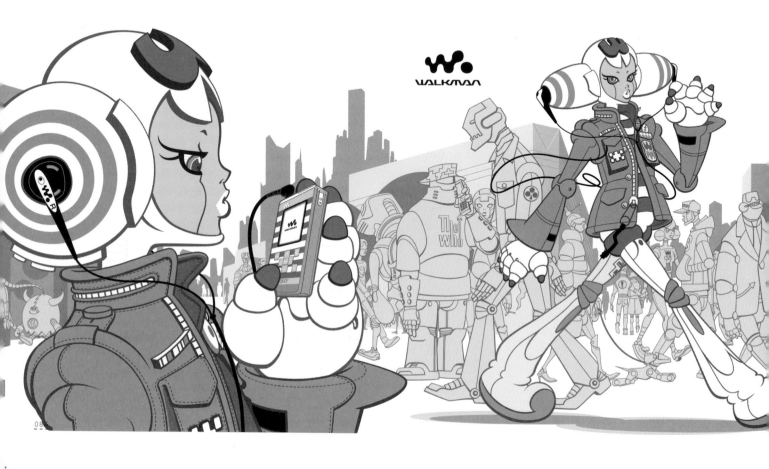

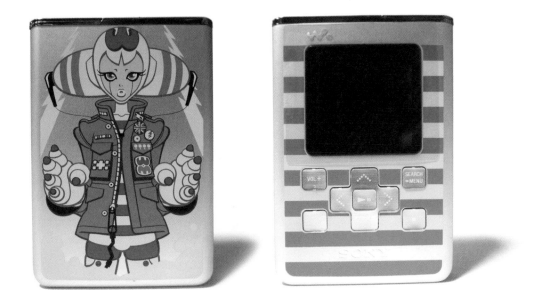

Title:
Husky Rescue

Type of Work:
CD artwork

Year:
2005-07

Contributed by:
Kustaa Saksi
(Unit CMA)

Art Direction:
Kustaa Saksi

Design:
Kustaa Saksi

Client:
Catskills Records

Musician(s):
Husky Rescue

Description:
Art direction and
illustrations for
Husky Rescue's
releases.

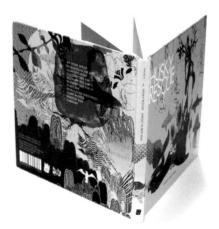

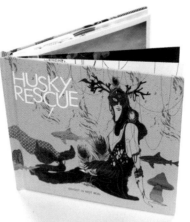

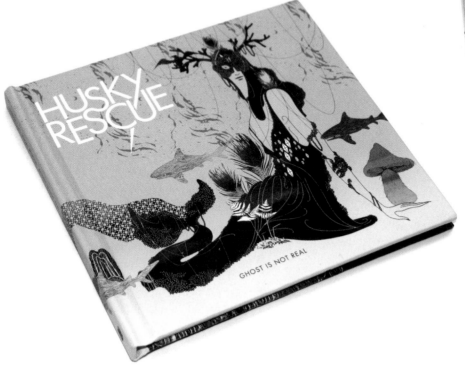

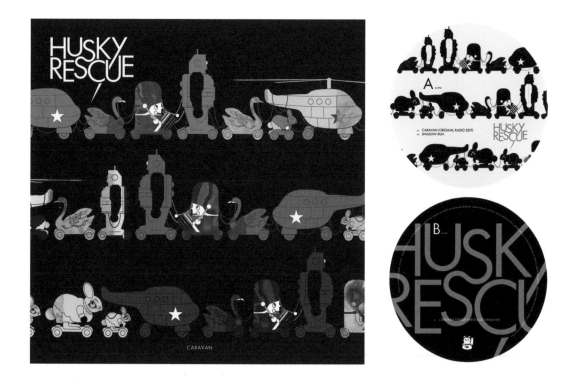

CARAVAN

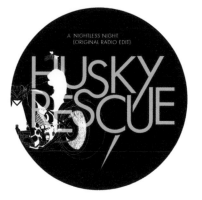

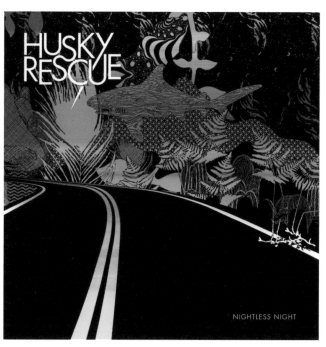

NIGHTLESS NIGHT

Title:
1. Quebexico: Relationship with a Man, Relationship with a Man CD spread
2. The New Pollution Anniversary poster
3. Frog Eyes/Books on Books poster

Type of Work:
1. CD packaging
2, 3. Print

Year:
1. 2006
2, 3. 2007

Contributed by:
King Trash

Design:
Michael DeForge

Client:
1. Quebexico, La Maison Du Bruit
2. The New Pollution
3. Mocking Music

Musician(s):
1. Quebexico
2. A/V, The Carps, Ultra Magnus
3. Frog Eyes, Books on Books

Description:
1. This is a spread of the art DeForge made for the album. It includes the front and back covers, and the inside spread for the liner notes. The illustrations were designed to all connect together.
2. It's Twiggy! The 11x17 silkscreen print was printed by Toronto's Les Robots group.
3. A poster (11x17 offset print) commissioned for Mocking Music's first annual Capital Idea! Festival in Ottawa, Ontario. Bolton's very proud of how the series turned out, and this one is his favourite of the lot.

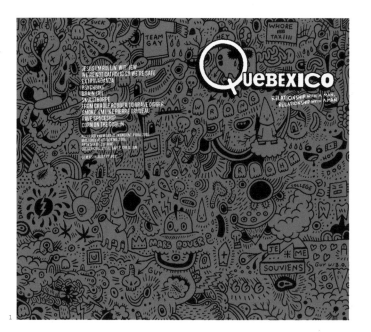

1

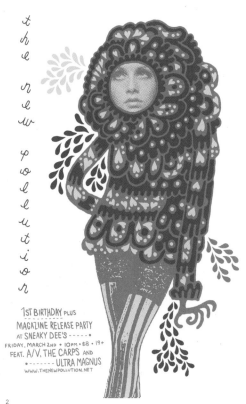

2

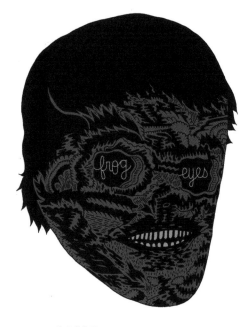

3

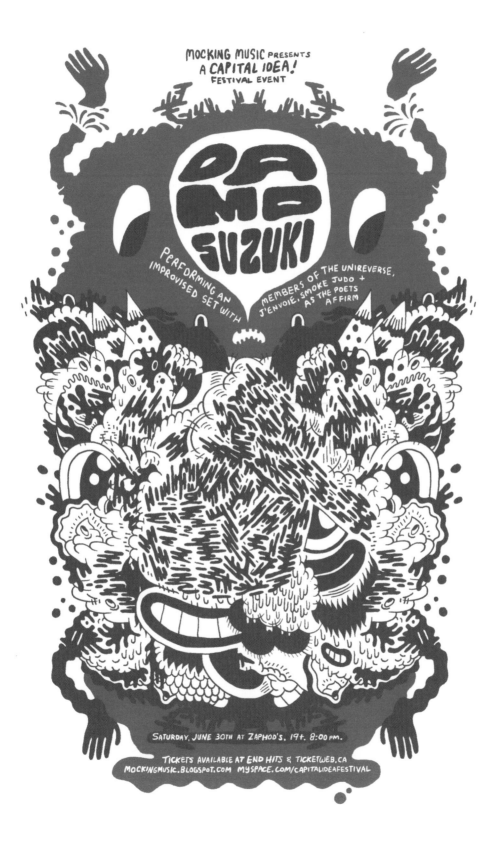

Title:
Damo Suzuki poster

Type of Work:
Print

Year:
2007

Contributed by:
King Trash

Design:
Michael DeForge

Client:
Mocking Music

Musician(s):
Damo Suzuki, Uni-
reverse, j'envoie,
Smoke Judo, As the
Poets Affirm

Description:
It's a 11x17 offset
print. Damo's con-
certs all involve
improvised collabo-
rations, so DeForge
made most of the
poster as a sort of
spontaneous draw-
ing while listening
to one of his live
recordings.

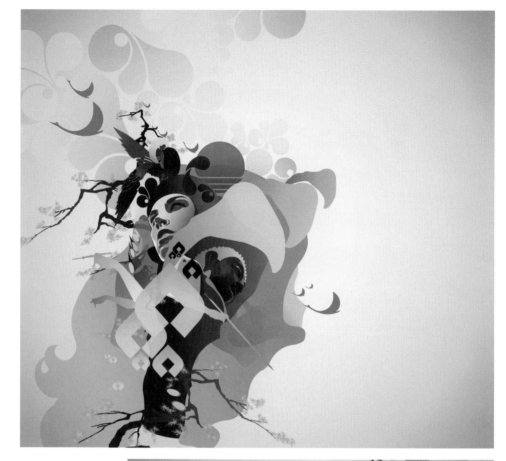

Title:
Reborn

Type of Work:
Motion graphics

Year:
2004

Contributed by:
SixStation

Art Direction:
Benny Luk

Design:
Benny Luk

Client:
MTV Asia

Description:
Broadcast motion to
promote the brand
of MTV Asia.

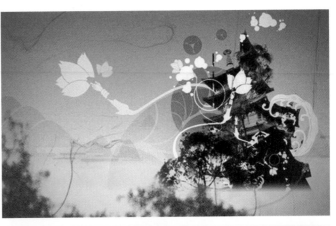

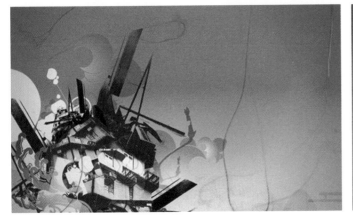

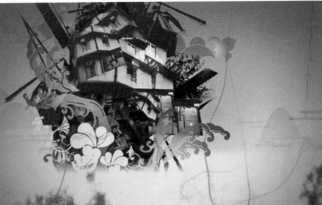

Title:
TCG Sun + Void

Type of Work:
CD artwork

Year:
2007

Contributed by:
Qian Qian

Art Direction:
Qian Qian

Design:
Qian Qian

Client:
The Current Group

Musician(s):
The Current Group

Description:
CD design for The
Current Group. The
cover image is a
collage based on
elements from band
members' artwork.

THE CURRENT GROUP
IMPROVISATIONAL ORCHESTRA
CD RELEASE SHOW

+

THE OUTLAND BALLROOM
221 PARK CENTRAL SOUTH STREET
SATURDAY, NOVEMBER 11TH
9:00 P.M.
W/ MACKENZIE MOORE

THE
CURRENT
GROUP
SUN + VOID

WWW.CLOSE-FAR.COM

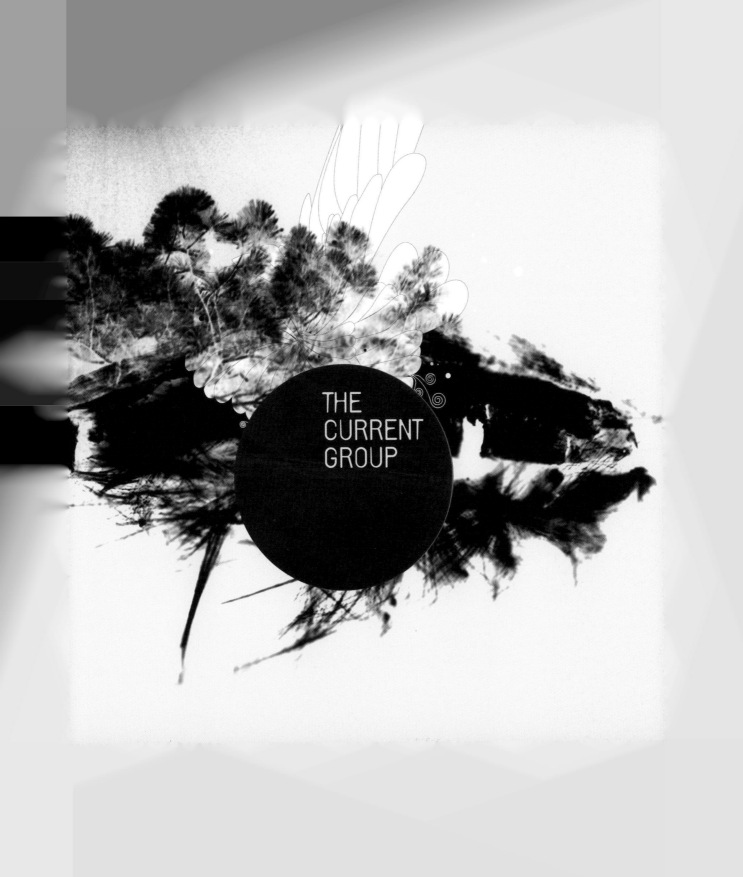

Title:
感應

Type of Work:
CD artwork

Year:
2006

Contributed by:
Kabo

Art Direction:
Joel Chu

Design:
Helen Yeung

Client:
Emperor Entertain-
ment Hong Kong Ltd.

Musician(s):
Vincy Chan

Description:
Music album for
Vincy Chan.

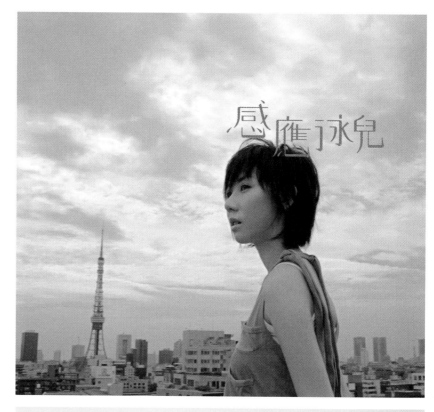

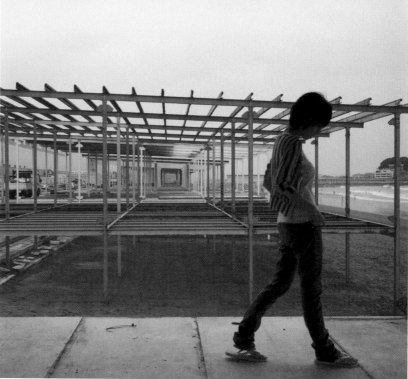

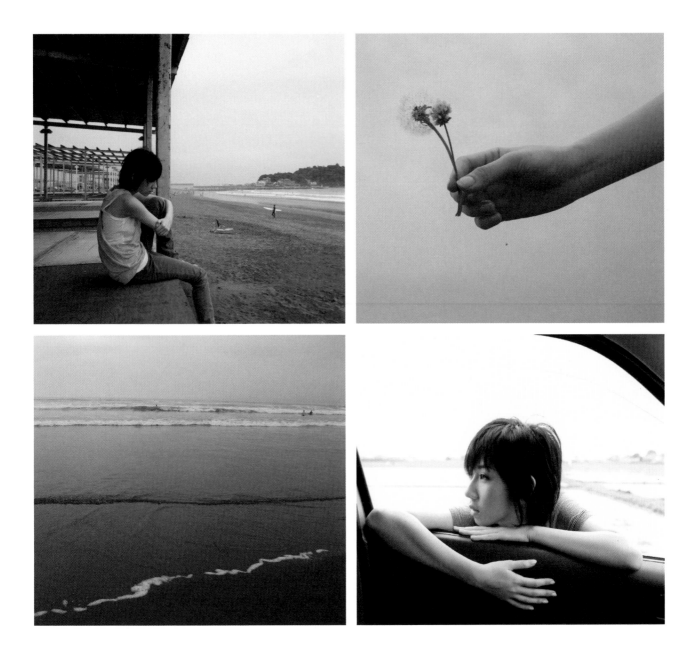

Title:
Futari

Type of Work:
CD cover, CD ad

Year:
2005

Contributed by:
IKKAKUIKKA Co.,Ltd

Art Direction:
Keiko Itakura

Design:
Keiko Itakura

Client:
BMG Japan

Description:
'Futari' means a
man and a woman
in love.

Title:
Agoria - Baboul
Hair Cutting

Type of Work:
CD artwork

Year:
2006

Contributed by:
Benjamin Brard

Art Direction:
Benjamin Brard

Design:
Benjamin Brard

Client:
Different Records/
Pias

Musician(s):
Agoria

Description:
Benjamin Brard
loves Post-it. This
artwork is a patch-
work with Post-it,
photography and
illustration that
tell the story of
the song.

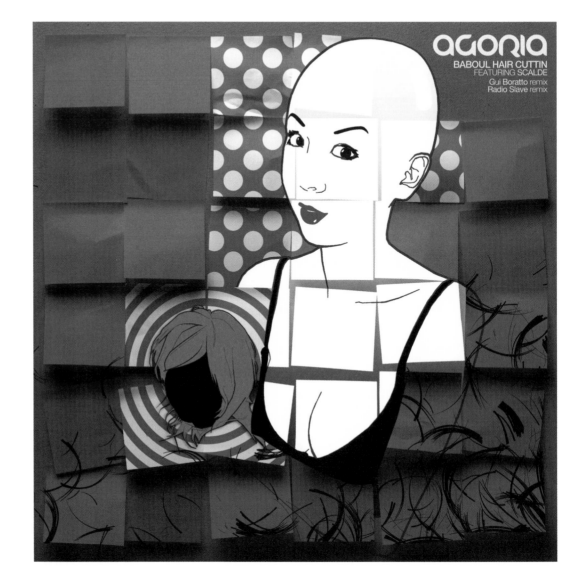

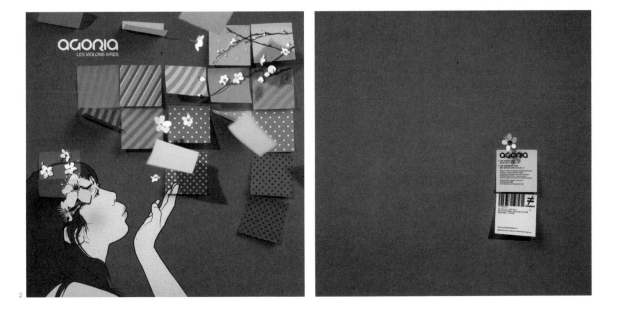

Title:
1. Agoria - Code 1026
2. Agoria - Les Violons Ivres

Type of Work:
CD artwork

Year:
1. 2006
2. 2007

Contributed by:
Benjamin Brard

Art Direction:
Benjamin Brard

Design:
Benjamin Brard

Client:
Different Records/ Pias

Musician(s):
Agoria

Description:
Benjamin Brard loves Post-it. This artwork is a patchwork with Post-it, photography and illustration that tell the story of the song.

Title:
Agoria - The Green
Armchair

Type of Work:
CD artwork

Year:
2006

Contributed by:
Benjamin Brard

Art Direction:
Benjamin Brard

Design:
Benjamin Brard

Client:
Different Records/
Pias

Musician(s):
Agoria

Description:
Benjamin Brard
loves Post-it. This
artwork is a patch-
work with Post-it,
photography and
illustration that
tells the story of
the song.

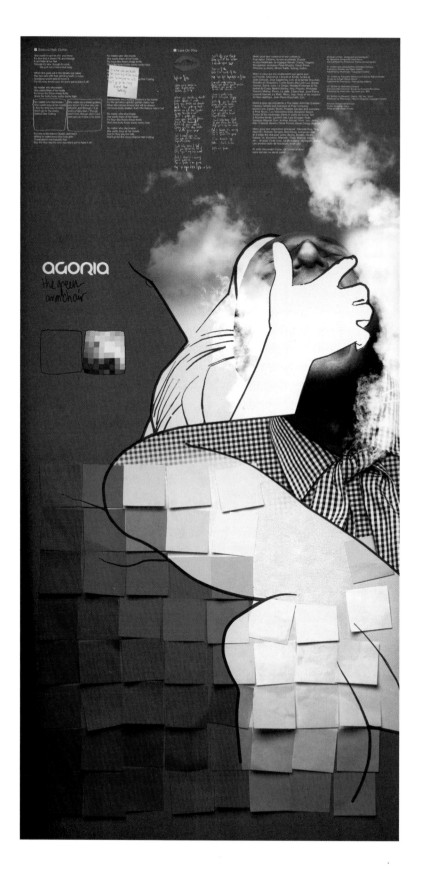

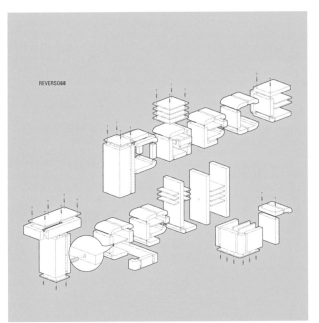

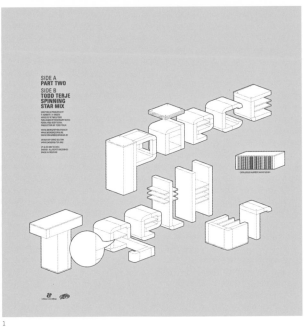

1

2

Title:
1. Reverso 68 'Piece Together'
2. Reverso 68 'Tokyo Disko' and 'Especial'

Type of Work:
CD sleeve

Year:
1. 2007
2. 2006-07

Contributed by:
Chris Bolton

Art Direction:
Chris Bolton

Design:
Chris Bolton

Client:
Eskimo Recordings/ N.E.W.S.

Musician(s):
Reverso 68

Description:
1. Lettering created directly from the 12inch release title track, piece togther. Ikea instruction manual like furniture forms are created to form the words. Legiable in both the 'pre fabricated' stage and 'fabricated' stage. Colouration comes directly from ikea's coporate identity colour palette of yellow, blue and white.
2. The 12-inch sleeve solution came straight from the name of the group itself. Bolton thought somehow it was such a strong name and wanted to express it typographically. The use of the symbols/arrows forming the outlines of the letters was a result of this. It happened by shear luck that there was an even amount of characters in the name to form a 3x3 grid of letters/ numbers. The backside of the sleeve shows also a more simplified version of the main cover typography. These graphic letters make up the names of the tracks and which side they can be found on. The image that is used is an idea based upon reflection or reversed image seen in a mirror. Also helping to this was that are 2 guys forming the group.

Title:
WEA smack CD

Type of Work:
CD sampler cover

Year:
2006

Contributed by:
Yuko Shimizu

Art Direction:
Richard Thomas
Jennings

Design:
Michelle Masi

Client:
Warner Elektra
Atlantic

Description:
It is truly a plea-
sure for Shimizu to
work with Rich-
ard. He is full of
ideas, really good
ones. For this, he
started out with a
concept of 'this
sampler is full of
good music' that
led to this concept
of a music snob
getting smacked,
in 2 panel comics
of front and back
covers with the
title of CD SMACK!
written as the word
'bubble.' The duo
received really
good feedbacks, and
now they are work-
ing on the second
version called The
Smack Down.

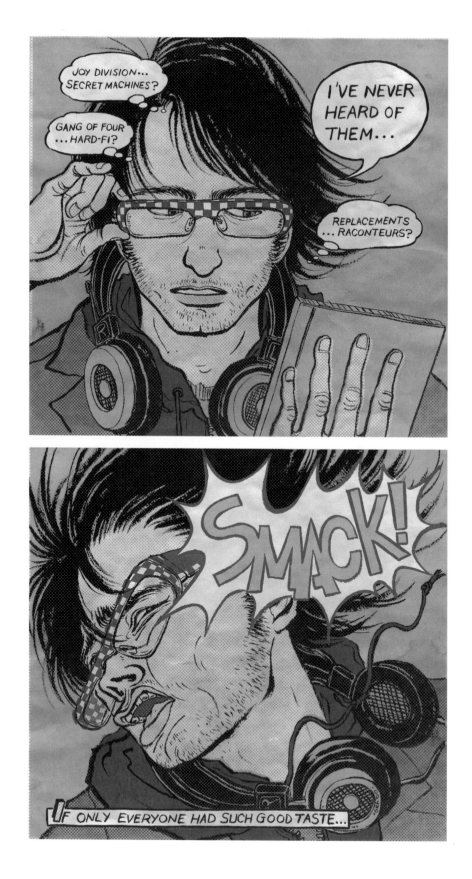

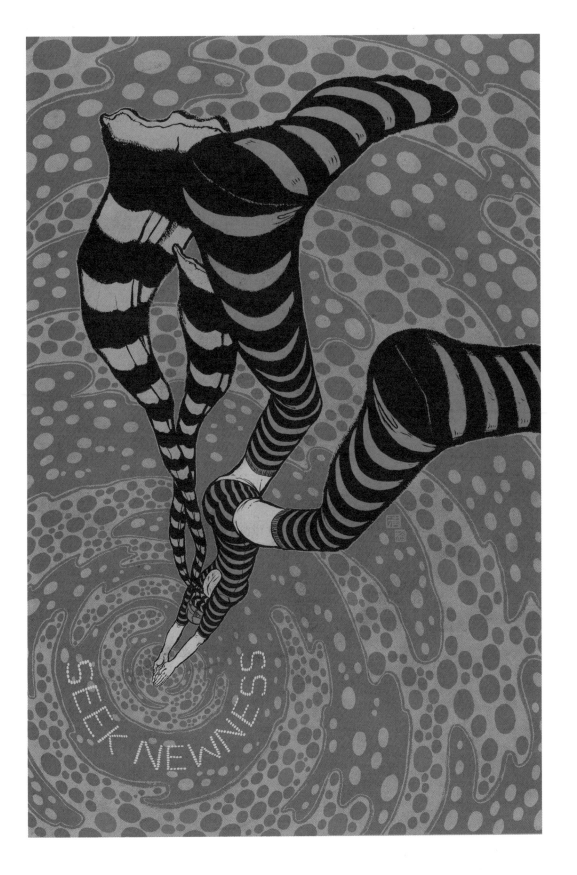

Title:
Microsoft Zune
poster advertising

Type of Work:
Advertising poster

Year:
2006

Contributed by:
Yuko Shimizu

Art Direction:
John Boiler,
Rob Abeyta

Design:
Yuko Shimizu

Client:
Microsoft,
72andSunny

Description:
When Microsoft put
out ZUNE to compete
with iPod, 72and-
Sunny came up with
a campaign to con-
nect music and art.
Artists working in
different mediums
were invited to
create posters with
the keyword they
provided. Shimizu's
was 'Seek Newness.'
There were no
restrictions other
than that keyword.
This was what she
came up with.

Title:
Portraits

Type of Work:
Magazine Illustration, Portrait

Year:
2007

Contributed by:
Yuko Shimizu

Art Direction:
Jose Reyes

Design:
Yuko Shimizu

Client:
Paste Magazine

Description:
As an illustrator, Shimizu draws a lot of portraits, from really famous artists to super obscure ones. Part of a job as an editorial illustrator is to research the subject matter fully before coming up with ideas. So, drawing figures in music is always fun for her. She gets to be introduced to music she wouldn't listen to otherwise. She ends up buying lots of CDs and does iTunes downloads because she ends up loving her subject matter.

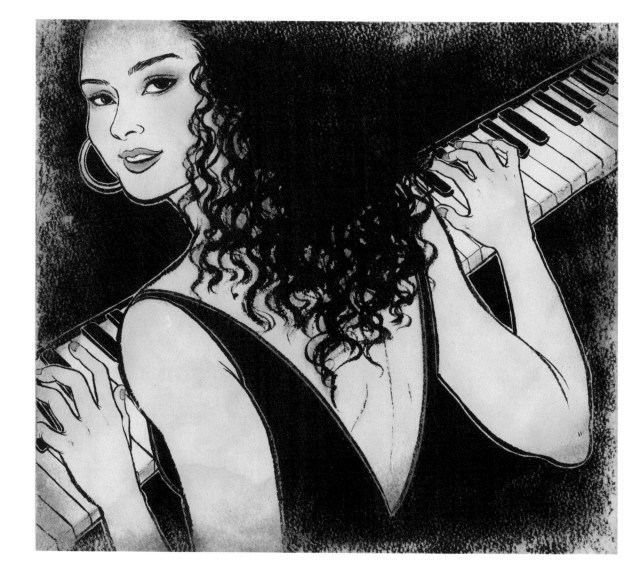

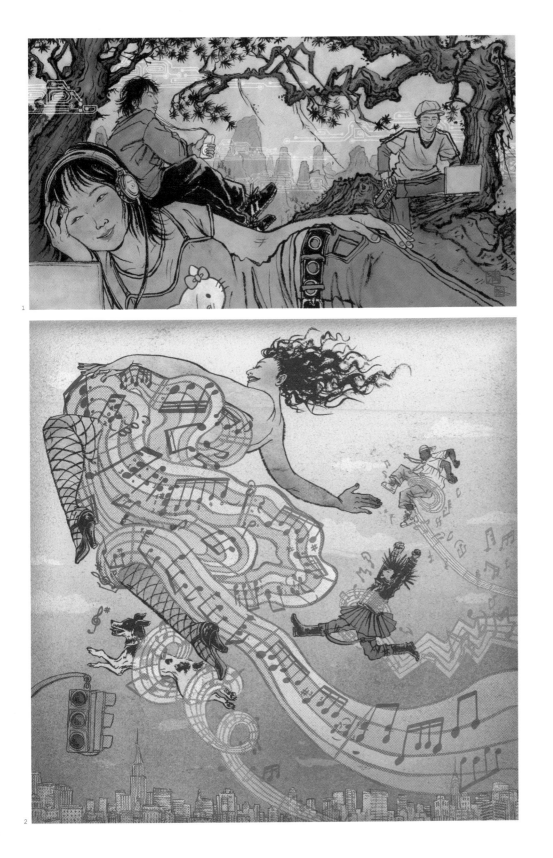

1

2

Title:
1. Digital Asia
2. Musical City

Type of Work:
Magazine
illustration

Year:
2006

Contributed by:
Yuko Shimizu

Art Direction:
1. Christine Bower
2. Deanna Lowe

Design:
Yuko Shimizu

Client:
1. Billboard
Magazine
2. Absolute
Magazine

Description:
1. This illustra-
tion accompanied an
article about how
everything about
music got super
digitalized in
Asia. After speak-
ing with the art
director on what
direction to go,
they decided to
make it look very
old-fashioned and
contemporary at the
same time. Asian
hipster kids in an
old Chinese scroll
type of environment
was what they went
for.
2. This was for a
story about how New
York City is filled
with music, dif-
ferent music, but
lots of fun, and
how it feels like
the whole city is
filled with music
when the long win-
ter is gone and
spring is finally
here.

Title:
The Word/Now Hear
This

Type of Work:
CD artwork illus-
tration

Year:
2007

Contributed by:
Yuko Shimizu

Art Direction:
Matthew Ball, Jona-
than Sellers

Design:
Yuko Shimizu

Client:
The Word magazine
(UK)

Description:
The client, British
music magazine for
grownups called The
Word has a monthly
CD supplement
with great music
called Now Hear

This! And they
were looking for a
new image to go on
this cover during
their magazine
redesign. Matthew
was in charge of
redesigning, and
Shimizu had known
him for years ever
since he first
hired her to do
an illustration
for Rolling Stone
magazine. They
worked on ideas
to make it catchy
and grab viewers'
attention at the
newsstands. He
liked her Asian
imageries and that
was how it started.
Now she works with
Jonathan every
month having lots
of fun and freedom.

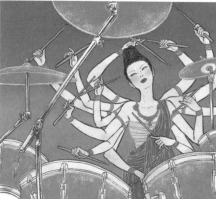

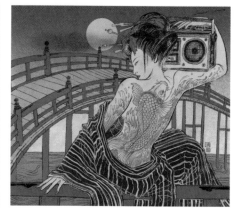

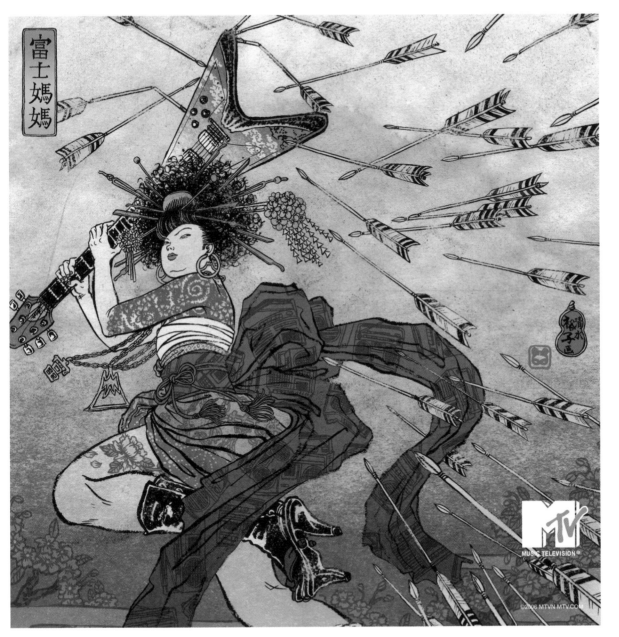

Title:
MTV Calendar

Type of Work:
Advertising calendar

Year:
2005

Contributed by:
Yuko Shimizu

Design:
Chie Araki

Client:
MTV

Description:
Shimizu got a call from MTV to make a calendar image. They wanted something rock'n'roll. After she started talking with designer Chie, who told her the reason she picked her was her personal works of powerful Asian women drawn in traditional woodblock print style. This was the result the illustrator came up with.

Title:
Kaela

Type of Work:
CD jacket

Year:
2004

Contributed by:
Giottographica

Art Direction:
Yoshihiro Inoue,
Yukinko

Design:
Yoshihiro Inoue,
Yukinko

Client:
Columbia Music
Entertainment

Musician(s):
Kaela Kimura

Description:
CD artwork for
Kaela Kimura's
first album, which
is a cross between
the flat and 3-
dimensional motifs.
This symbolizes
Kimura's unique
place in the music
industry.

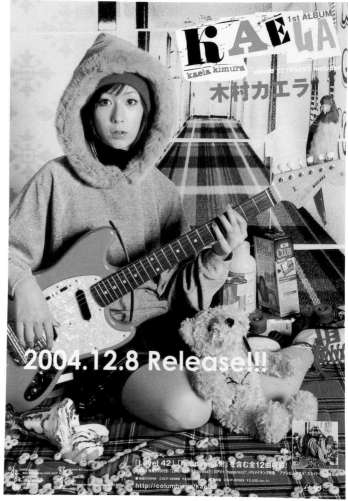

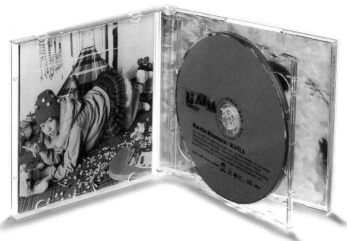

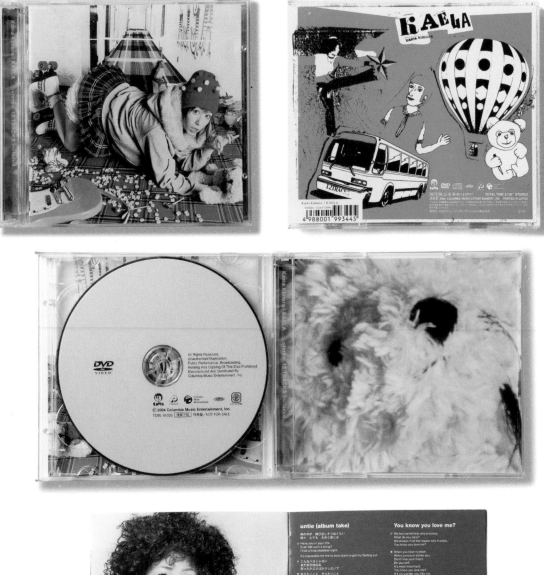

Title:
Namie Amuro So Crazy Tour Featuring BEST singles 2003-2004 Tour Pamphlet

Type of Work:
Concert accessories

Year:
2004

Contributed by:
SUNDAY VISION

Art Direction:
Shinsuke Koshio

Design:
Miki Shimizu

Client:
VISION FACTORY

Musician(s):
Namie Amuro

Description:
A tour pamphlet of Namie Amuro held in Japan in 2004. SUNDAY VISION is in charge of the art direction of the poster and T-shirt, any goods other than a pamphlet by this tour.

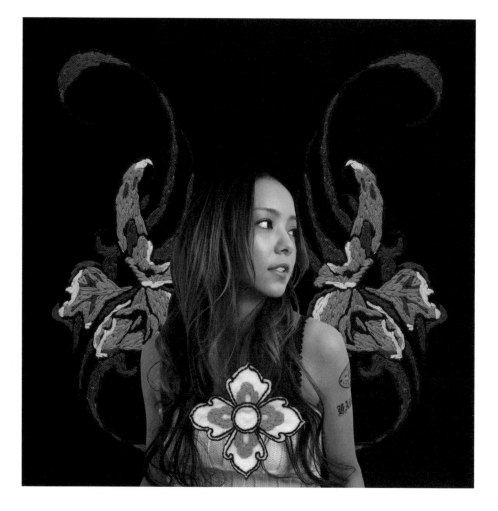

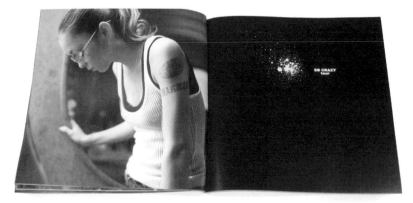

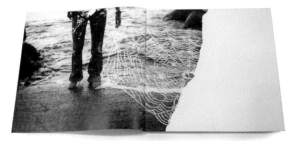

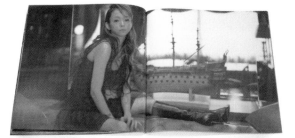

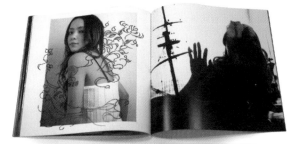

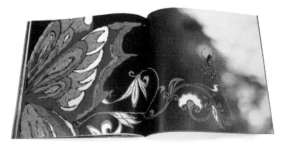

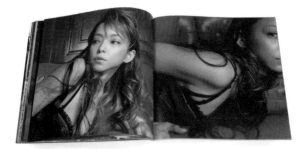

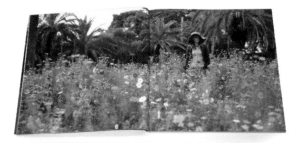

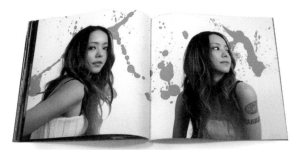

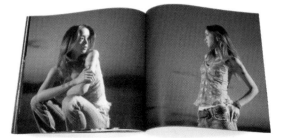

Title:
Gary Tsao –
Superman

Type of Work:
CD packaging

Year:
2006

Contributed by:
Aaron Nieh Workshop

Art Direction:
Aaron Nieh

Design:
Aaron Nieh

Photography:
Kris Shao

Client:
Rock Records
Co.,Ltd.

Musician(s):
Gary Tsao

Description:
The work fits the
concept 'grid' (the
singer's Chinese
name means 'grid')
with abstract grid
elements. Nieh
cropped the photog-
raphy to strengthen
the album's name
'Superman.'

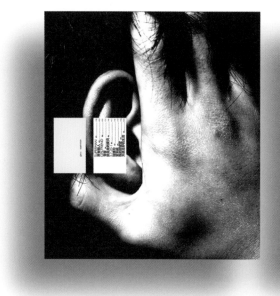
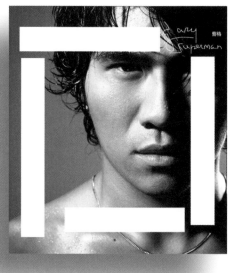

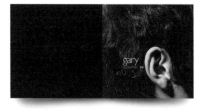

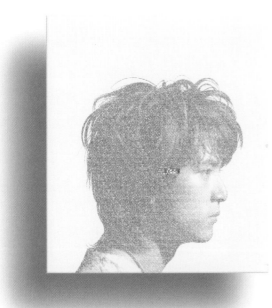

Title:
Roy Chiu -
Incomprehension

Type of Work:
CD packaging

Year:
2003

Contributed by:
Aaron Nieh Workshop

Art Direction:
Aaron Nieh

Design:
Aaron Nieh

Photography:
Leslie Kee

Client:
Skyhigh Entertain-
ment Co., Ltd.

Musician(s):
Roy Chiu

Description:
The feel this album
wants is: murky
but young, rock but
tailored, dark but
pure. So Nieh used
a black and white
tone and splash-
ink painting to run
through the image.

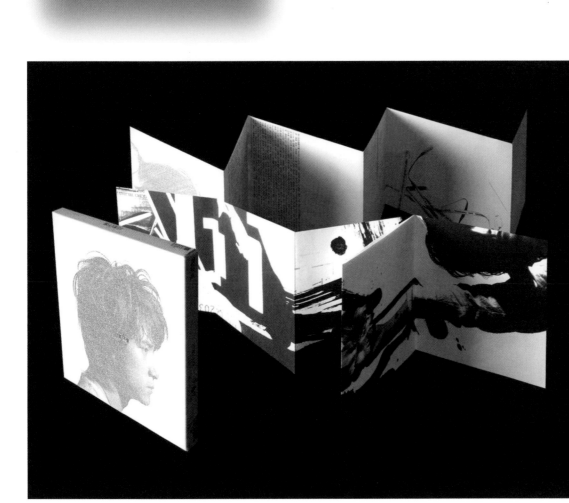

Title:
Gary Tsao –
Grid • Blue

Type of Work:
CD packaging

Year:
2005

Contributed by:
Aaron Nieh Workshop

Art Direction:
Aaron Nieh

Design:
Aaron Nieh

Photography:
Kris Shao

Client:
Rock Records
Co.,Ltd.

Musician(s):
Gary Tsao

Description:
Fits the con-
cept 'grid' with
abstract grid ele-
ments and quadrate
images.

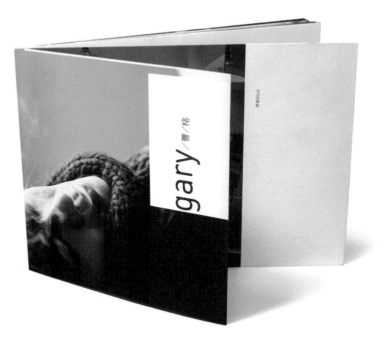

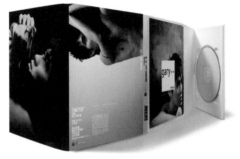

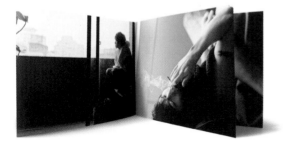

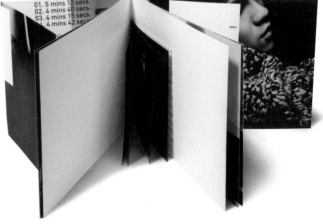

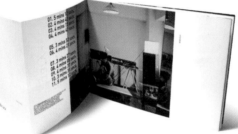

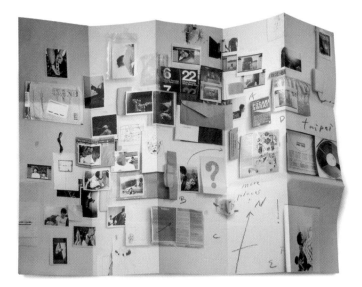

Title:
2moro -
2 more loves

Type of Work:
CD packaging

Year:
2006

Contributed by:
Aaron Nieh Workshop

Art Direction:
Aaron Nieh

Design:
Aaron Nieh

Photography:
Sam Hu

Client:
Rock Records
Co.,Ltd.

Musician(s):
2moro

Description:
Images inspired by
nature, liberty and
freedom. The left-
hand and right-
hand sides of the
page finally could
be connected in a
circle.

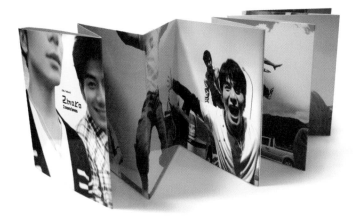

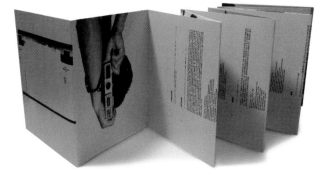

Title:
Otherwize Then

Type of Work:
CD artwork

Year:
2006

Contributed by:
Zion Graphics

Art Direction:
Ricky Tillblad

Design:
Ricky Tillblad

Client:
Refune

Musician(s):
Steve Angello,
Laidback Luke

Description:
This 12" vinyl
sleeve for Refune
shows pillars with
the title and art-
ist name in a Tel-
etubbies- inspired
landscape. The lawn
and pillars are
printed in glossy
UV varnish on a
matt background.

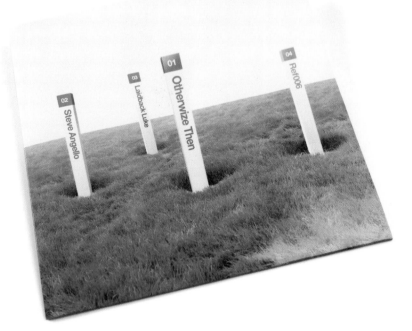

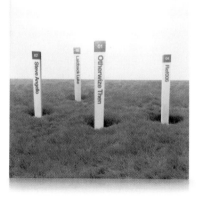

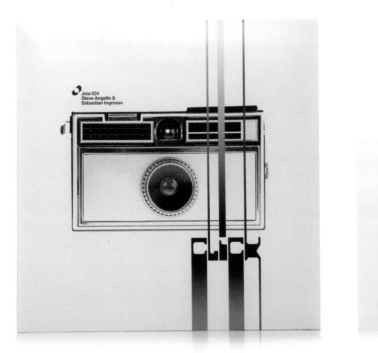

Title:
Joia 024/Click

Type of Work:
CD artwork

Year:
2006

Contributed by:
Zion Graphics

Art Direction:
Ricky Tillblad

Design:
Ricky Tillblad

Client:
Joia Records

Musician(s):
Steve Angello,
Sebastian Ingrosso

Description:
The 12" single is
called 'Click.' So,
why not a camera
on the sleeve? It's
an absolute no-
no to be obvious
within the field
of graphic design,
but Zion Graphics
decided to do the
opposite.

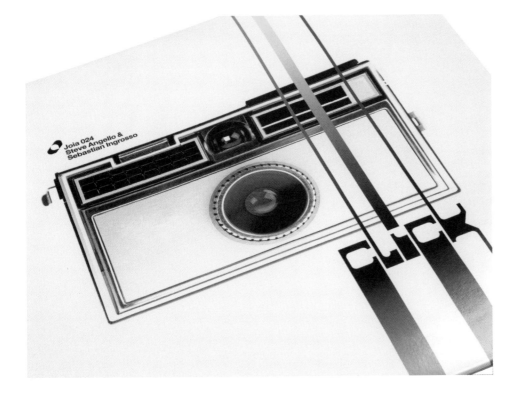

Title:
A Compilation
called Underducks

Type of Work:
T-Shirt design

Year:
2007

Contributed by:
Bionic Systems

Design:
Doris Fürst, Malte
Haust

Client:
Combination Records

Description:
For the album
release of 'A Com-
pilation called
Underducks' Car-
hartt and Combi-
nation Records
invited Bionic
Systems and 5 other
artists to create
a T-shirt design
to be shown in
Carhartt stores
around the globe.
The Carhartt shirt
is limited to 100
pieces and comes in
a pizza box: a true
collectors' item.

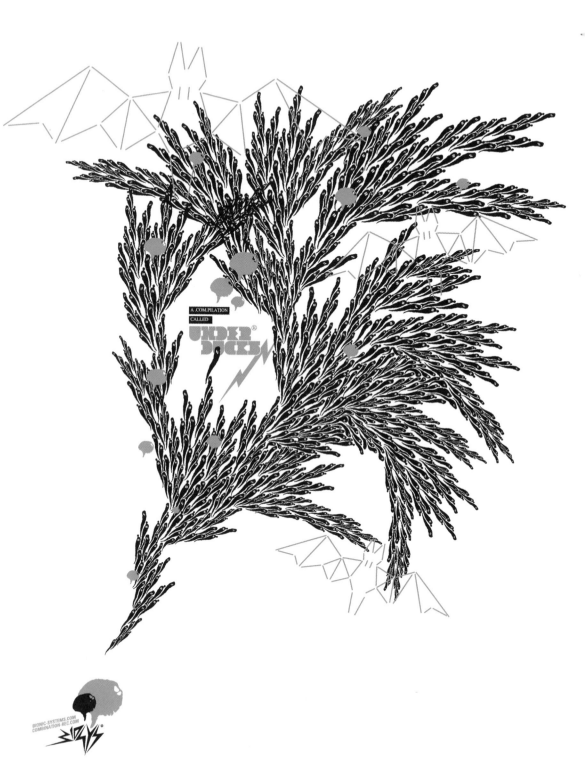

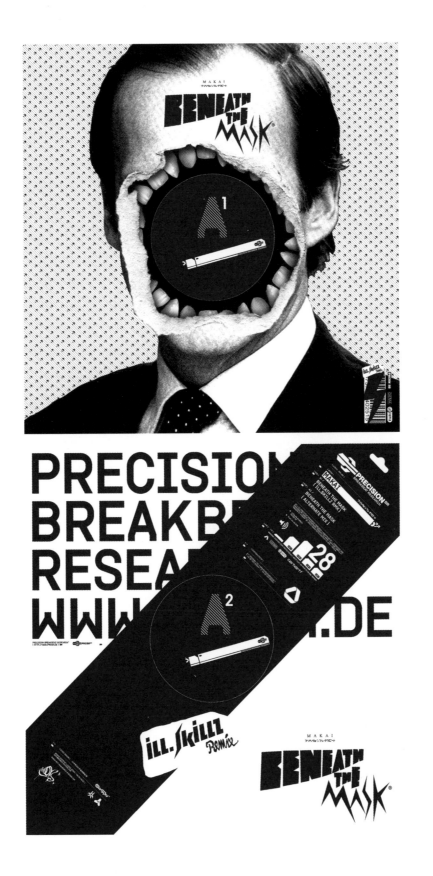

Title:
Makai – Beneath the
Mask (PRCSN28)

Type of Work:
CD cover

Year:
2007

Contributed by:
Bionic Systems

Design:
Doris Fürst, Malte
Haust

Client:
Precision Breakbeat
Research

Musician(s):
Makai

Description:
Cover design for
the latest Makai
Single. The design
obviously is an
allusion to the
title 'Beneath the
Mask.'

Title:
Super Shiny ...

Type of Work:
CD cover

Year:
2006

Contributed by:
Sopp

Art Direction:
Katja Hartung

Design:
Katja Hartung

Client:
Feral Media

Description:
A series of limited edition screen-printed Feral Media samplers. The idea was to create a series of unique sleeves that can be used very flexibly for different upcoming projects at small quantities and with a quick turnaround.

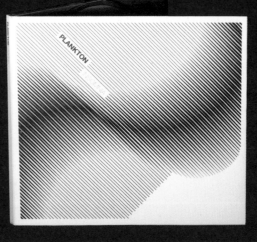

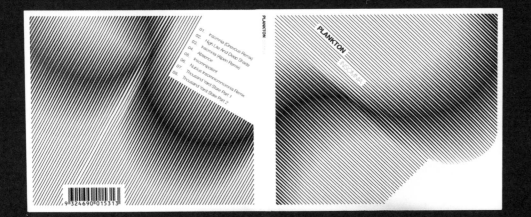

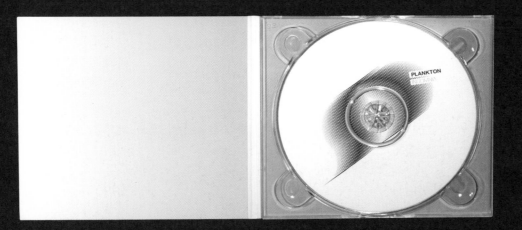

Title:
Plankton

Type of Work:
CD cover

Year:
2006

Contributed by:
Sopp

Art Direction:
Thorsten Kulp

Design:
Thorsten Kulp

Client:
Feral Media

Musician(s):
Plankton

Description:
Sleeve design for
the Australian
band Plankton. The
intention of using
an abstract pattern
as graphic for the
cover was to make
people feel dizzy
when they look
at it. Sopp felt
that this sensa-
tion comes close to
insomnia.

Title:
Chkchkchk

Type of Work:
Tour artwork

Year:
2007

Contributed by:
Sopp

Art Direction:
Katja Hartung

Design:
Katja Hartung

Client:
Civil Society,
Sydney

Musician(s):
!!! (chk)(chk)(chk)

Description:
The poster and
flyer promoted the
band's Australian
tour with touring
agency Civil Soci-
ety in March 2007.
The brief for this
design was very
open, it just had
to capture and pro-
mote the energy of
the band and their
music.

The three !!! were
actually made of
candies and hung
off a frame for the
shoot which proved
to be a little
challenge in the
hot Australian sum-
mer month.

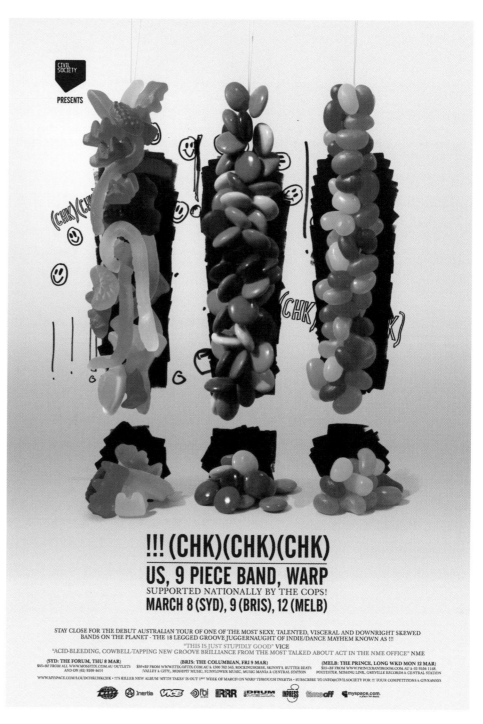

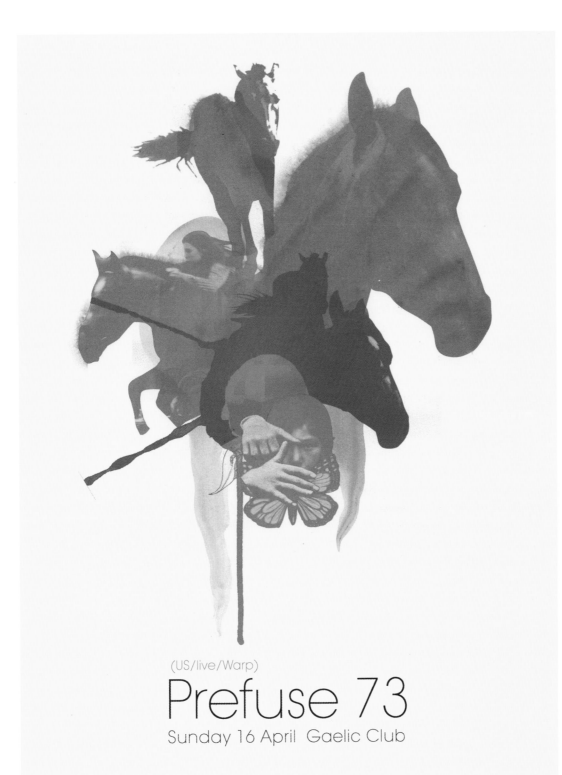

(US/live/Warp)
Prefuse 73
Sunday 16 April Gaelic Club

Title:
Prefuse 73

Type of Work:
Tour artwork

Year:
2006

Contributed by:
Sopp

Art Direction:
Kåre Martens

Design:
Kåre Martens

Client:
Civil Society,
Sydney

Musician(s):
Prefuse 73

Description:
Tour Art for Pre-
fuse 73. The poster
and flyer promoted
his Australian tour
with touring agency
Civil Society in
2006. There was
an open brief and
Sopp made their own
visual interpreta-
tion of the music.

Title:
Bipolar

Type of Work:
CD jacket

Year:
2006

Contributed by:
Vasava

Art Direction:
Vasava

Design:
Vasava

Client:
Lovemonk, Chop Suey

Musician(s):
Chop Suey

Description:
Playing with the concept of the album, bipolarity. Vasava has created an illustration with 2 different meanings. At first sight you can see the flowers representing the bright side of the album. On a closer look you can notice that those flowers are made by bugs, representing the dark side of the album.

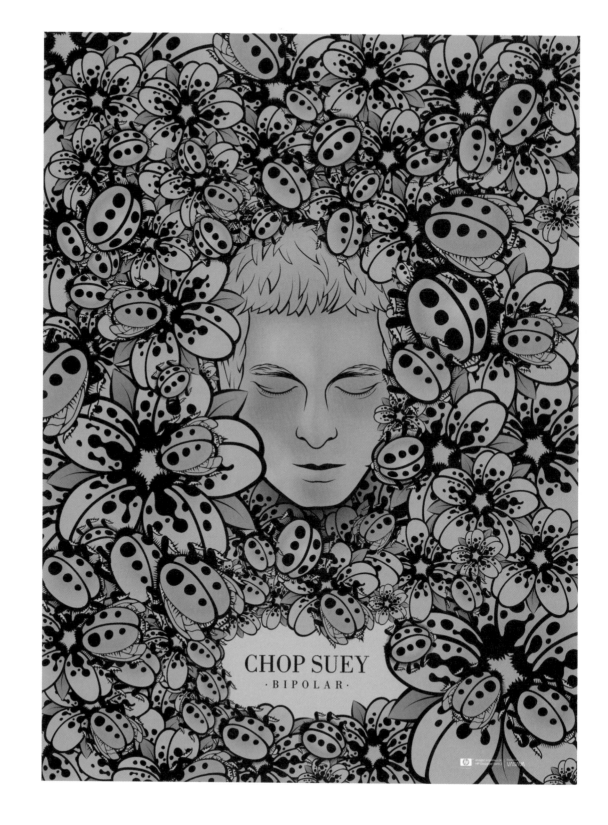

CHOP SUEY
· BIPOLAR ·

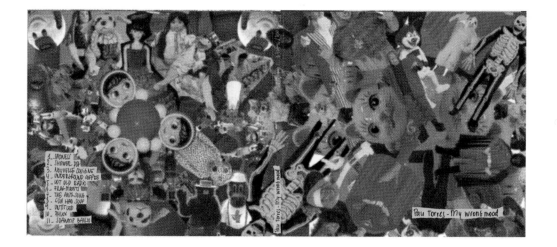

Title:
My Wrong Mood"

Type of Work:
CD jacket, DIgicase

Year:
2003

Contributed by:
Vasava

Art Direction:
Vasava

Design:
Vasava

Client:
Testing Ground

Musician(s):
Pau Torres

Description:
CD cover made by
different pieces
of pictures rep-
resenting the
music style of
the author, music
made by pieces o
random samples p
together.

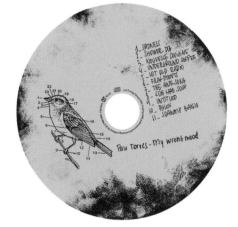

Title:
The Hollow Vol. 2

Type of Work:
CD packaging

Year:
2006

Contributed by:
Sam Weber

Art Direction:
Ricardo Ribeiro

Design:
Ricardo Ribeiro

Client:
More Than A
Thousand

Musician(s):
More Than A
Thousand

Description:
Little Red Riding
Hood emerges alive,
from the wolf's
stomach.

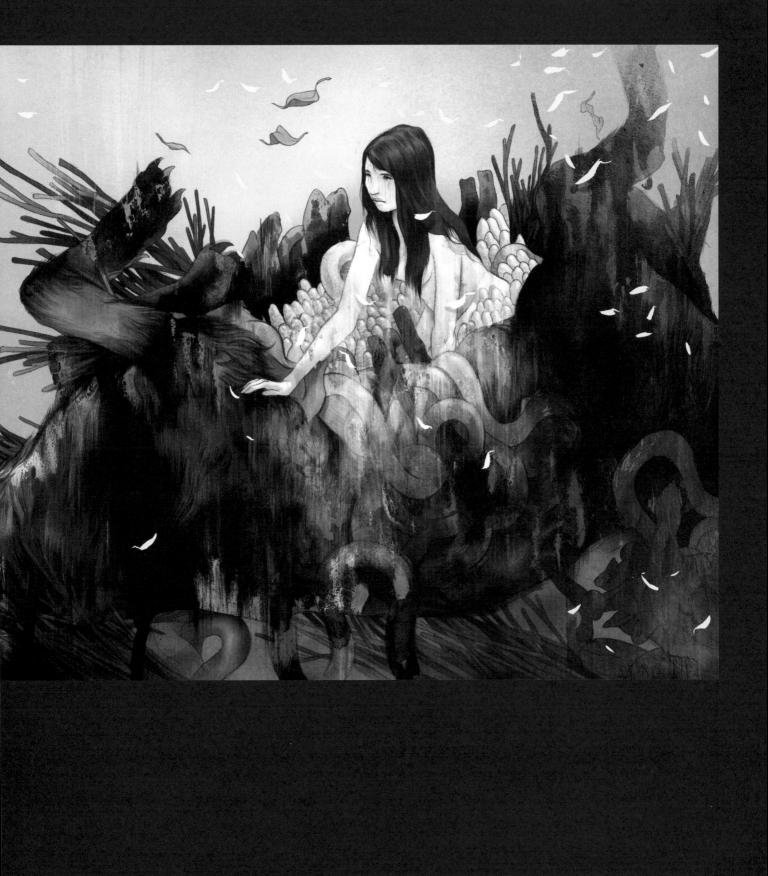

Title:
Happy Pills '17 Songs'

Type of Work:
CD packaging, CD promotion, Website design

Year:
2006

Contributed by:
Lucha Design

Art Direction:
Lucha Design

Design:
Lucha Design

Client:
Happy Pills

Musician(s):
Happy Pills

Description:
CD package design and promotional materials for a compilation — 'the best of' from albums of the cult underground 5-piece band. Happy Pills functioned on the edge of independent and commercial scenes, but became well known for their bold moves and ability to create media buzz. The packaging captures the DIY modus operandi of the group and the genuine energy of the music. The booklet collage features elements from previous record covers, videos, stories of concerts and legends that grew around the band.

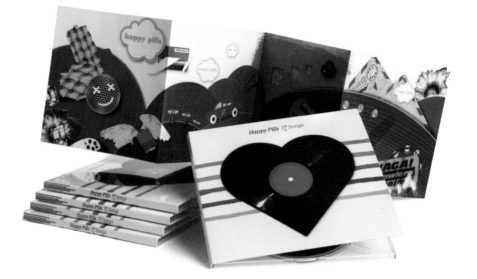

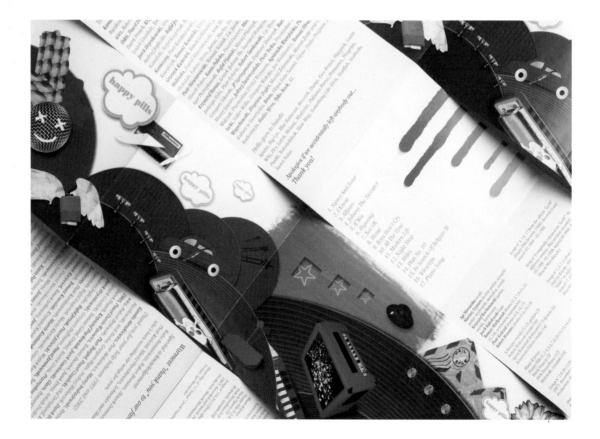

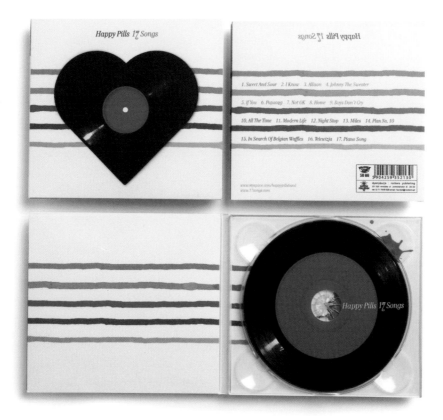

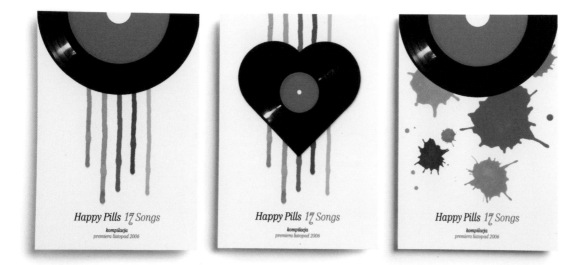

Title:
Chitose Yagi

Contributed by:
Chitose Yagi
(digmeout)

Design:
Chitose Yagi

Description:
Design by Chitose Yagi who is represented by digmeout.

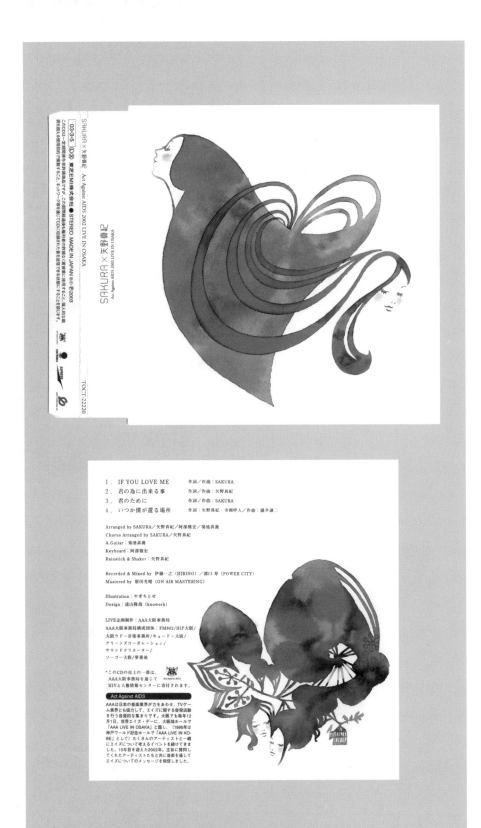

Title:
Kazuko Taniguchi
Contributed by:
Kazuko Taniguchi
(digmeout)
Design:
Kazuko Taniguchi
Description:
Design by Kazuko
Taniguchi who is
represented by
digmeout.

Title:
Alpen

Type of Work:
CD cover

Year:
2005

Contributed by:
Sopp

Art Direction:
Thorsten Kulp,
Kåre Martens

Design:
Kåre Martens,
Thorsten Kulp

Client:
Feral Media

Musician(s):
Alpen

Description:
Cover art for solo
artist Alpen's
first release.
The album is named
after the technique
that helped him
produce his complex
sounds: 'overdub-
bing or overdub.'
The designers took
the concept of
layering differ-
ent instruments and
vocals and applied
it to the cover by
creating a land-
scape of different
plants and animals
coated in white
plaster.

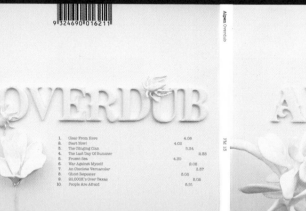
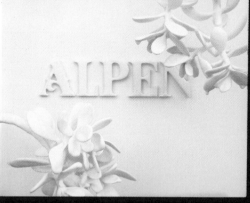
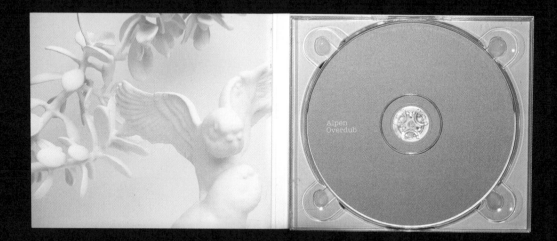

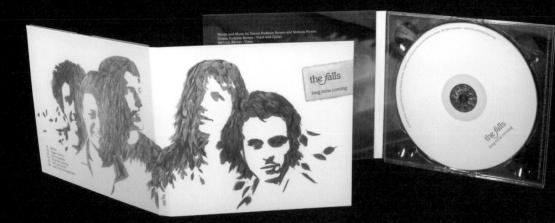

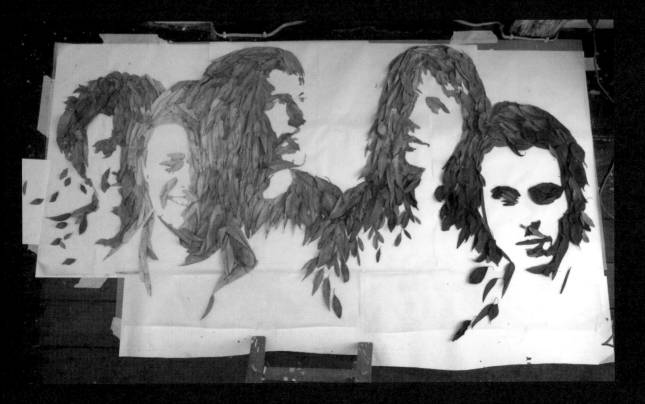

Title:
The Falls

Type of Work:
CD cover

Year:
2006

Contributed by:
Sopp

Art Direction:
Katja Hartung

Design:
Katja Hartung

Client:
The Falls

Musician(s):
The Falls (Simon Rudston-Brown, Melinda Kirwin)

Description:
Album art for the acoustic pop duo 'The Falls.' The portrait of the band members was made of actual leaves. The leaves were collected and sorted by colour to become part of the 2x3m floor piece.

Title:
Waxed

Type of Work:
CD packaging

Year:
2006

Contributed by:
S E I Z

Art Direction:
Gui Seiz

Design:
Gui Seiz

Client:
Daniel Rollins

Musician(s):
Waxed

Description:
Waxed's dark vibe
inspired the visu-
alization of the
sound in the shape
of hectic lines
being broadcasted
from old industrial
objects.

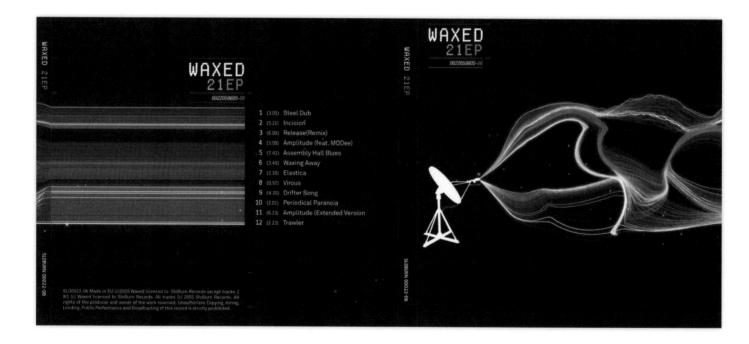

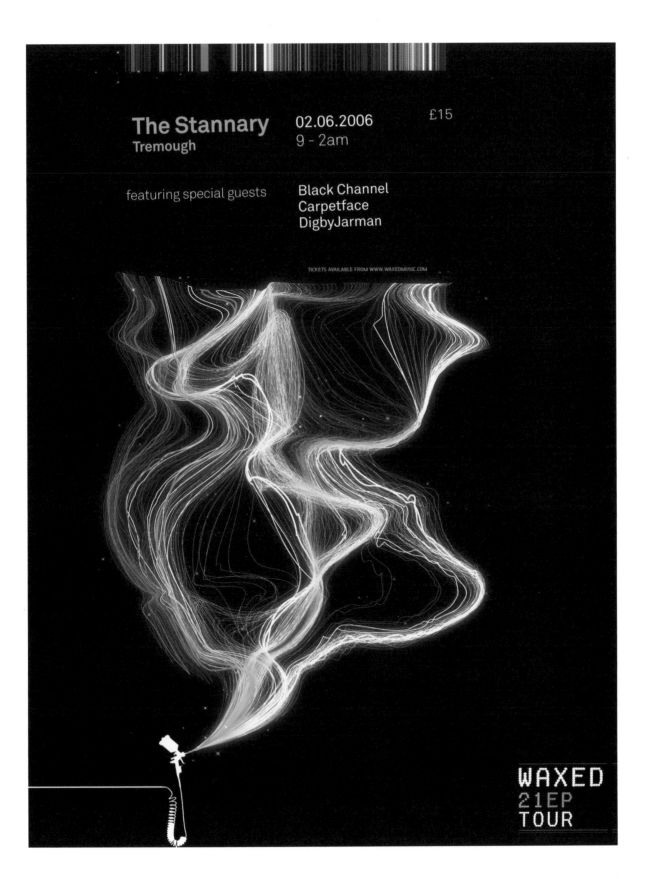

The Stannary
Tremough

02.06.2006
9 - 2am

£15

featuring special guests

Black Channel
Carpetface
DigbyJarman

TICKETS AVAILABLE FROM WWW.WAXEDMUSIC.COM

WAXED
21EP
TOUR

Title:
Ornand Altenburg

Type of Work:
Poster

Year:
2007

Contributed by:
Rune Mortensen
Design Studio

Art Direction:
Rune Mortensen

Design:
Rune Mortensen

Photography:
Geir Dokken

Client:
MTG Music Norway

Musician(s):
Ornand Altenburg

Description:
The design process for this project was very much a collaboration between the designer and the photographer, they tried to make the artist stand out with a unique portrait. The result was a playful image that reflects the strange and alternative side to Altenburg's soul/jazz music. The photo was taken at the musician's studio using all his own instruments and equipment, they tried to literally capture him within his music.

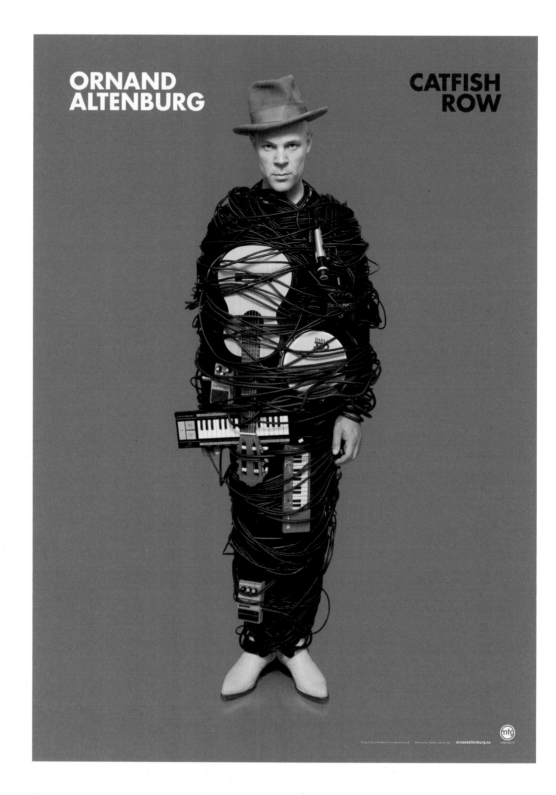

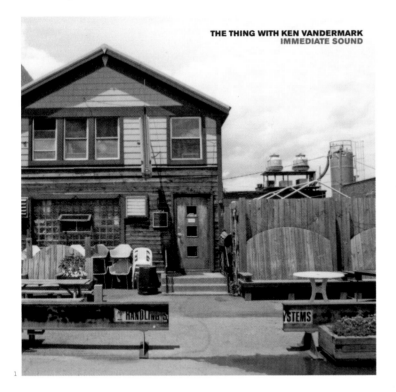

THE THING WITH KEN VANDERMARK
IMMEDIATE SOUND

Title:
1. Immediate Sound
2. The Point in a Line

Type of Work:
CD sleeve

Year:
2007

Contributed by:
Rune Mortensen
Design Studio

Art Direction:
Rune Mortensen

Design:
Rune Mortensen

Photography:
1. Ken Vandermark
2. Rune Mortensen

Client:
Smalltown
Superjazzz

Musician(s):
1. The Thing with
Ken Vandermark
2. Free Fall

Description:
1. This is a live
recording from the
venue Hide Out in
Chicago. The unique
qualities of this
place inspired
the designers so
much, they wanted
to reflect this
atmosphere in the
cover.
2. Browsing through
the image archive
the designers found
this image and it
just seemed to fit
perfectly with the
title of the album,
'The Point in a
Line.'

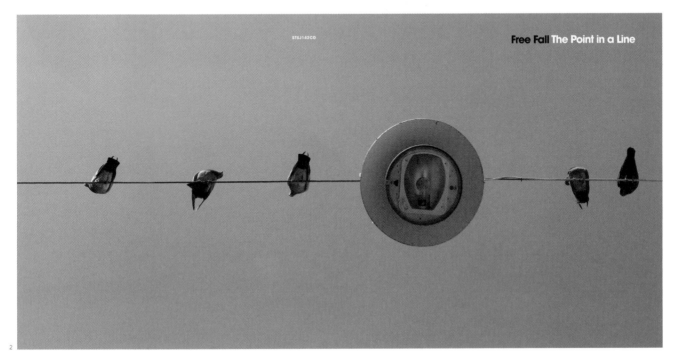

STSJ142CD

Free Fall The Point in a Line

Title:
Forbidden Fruit
(Part 1, Part 2)

Type of Work:
CD packaging

Year:
2002 (Part 1),
2006 (Part 2)

Contributed by:
Purple Haze Studio

Art Direction:
Clemens Baldermann

Design:
Clemens Baldermann

Client:
Sellwell Records

Musician(s):
Peabird & Tomahawk

Description:
Art direction and
title type design
for music packag-
ing.

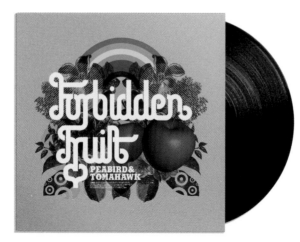

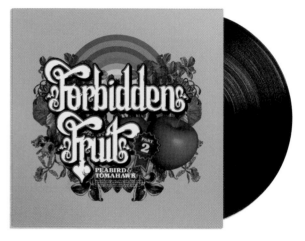

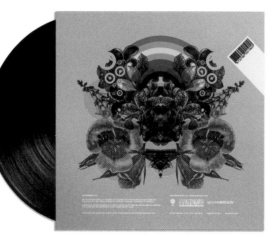

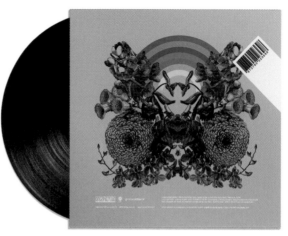

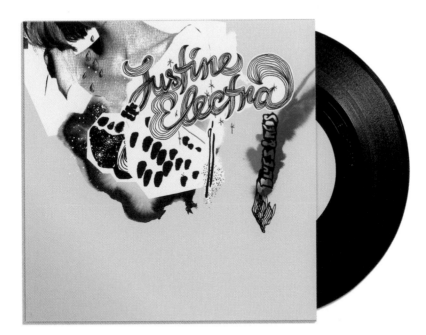

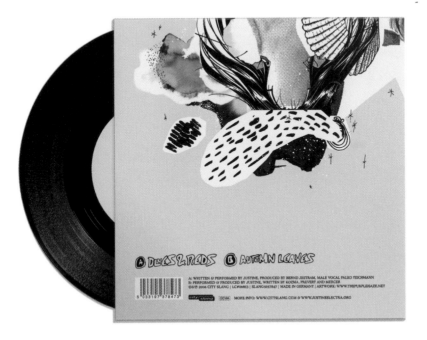

Title:
Blues and Reds

Type of Work:
CD packaging

Year:
2006

Contributed by:
Purple Haze Studio

Art Direction:
Clemens Baldermann

Design:
Clemens Baldermann

Client:
Cityslang

Musician(s):
Justine Electra

Description:
Design and illus-
tration for music
packaging.

Title:
Now and Forever

Type of Work:
Poster, CD box

Year:
2007

Contributed by:
Rune Mortensen
Design Studio

Art Direction:
Rune Mortensen

Design:
Rune Mortensen

Client:
Smalltown
Superjazzz

Musician(s):
The Thing

Description:
The task was to
design a CD-box
set for the free
jazz band The Thing
under the title
'Now and Forever.'
This poster was
rejected by the
label but the band
loved it.

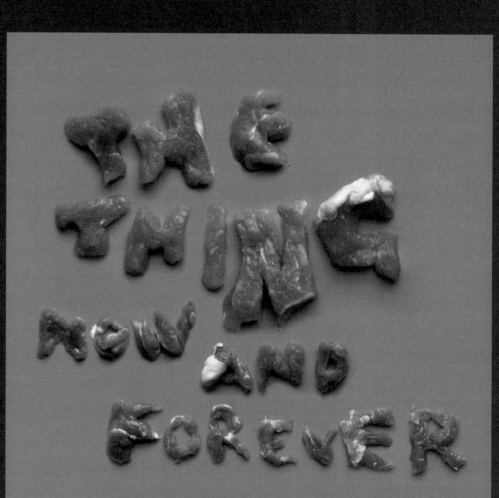

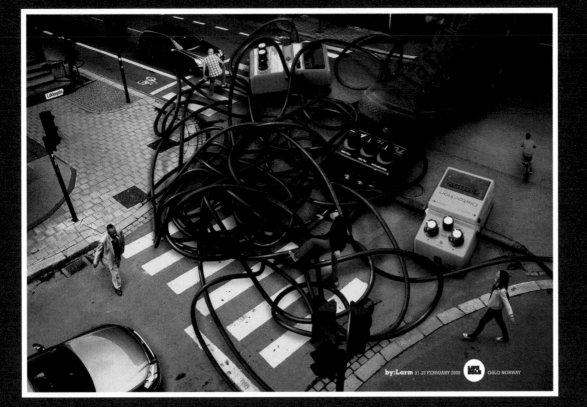

Title:
by:Larm 2008

Type of Work:
Poster

Year:
2007

Contributed by:
Rune Mortensen
Design Studio

Art Direction:
Rune Mortensen

Design:
Rune Mortensen

Photography:
Rune Mortensen

Client:
Bureau Storm

Description:
by:Larm is the big-
gest music confer-
ence in Scandina-
via. Rune Mortensen
Design Studio was
invited to cre-
ate a new profile
for the event in
2008. The event is
happening in Oslo,
Norway and the
concept is about
bringing music to
the streets. Since
hundreds of bands
are coming from
all over Scandina-
via to Oslo on this
particular week,
the studio tried to
illustrate this as
an invasion.

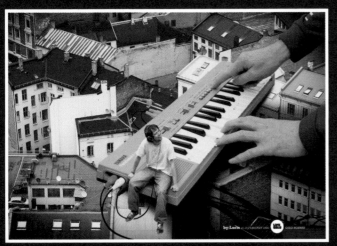

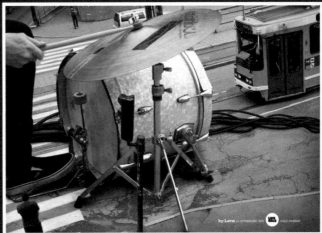

Title:
Puch

Type of Work:
Poster

Year:
2005-07

Contributed by:
Herburg Weiland

Art Direction:
Tom Ising

Design:
Andrea Posteiner

Client:
Puch

Description:
Poster design for an
open air festival.

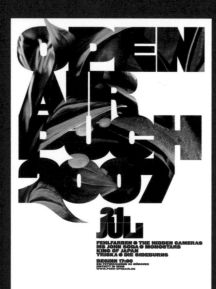

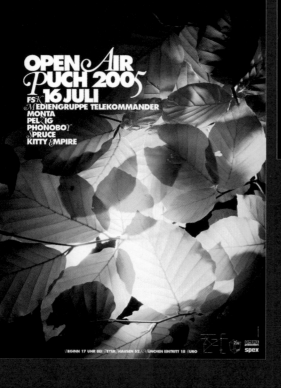

Title:
Medley
Type of Work:
Flyer
Year:
2001
Contributed by:
Herburg Weiland
Art Direction:
Tom Ising
Photography:
Martin Fengel
Client:
Punch
Description:
Flyer design for
clublight Ultra-
schall.

Title:
Grand Slam

Type of Work:
Poster

Year:
2006

Contributed by:
Purple Haze Studio

Art Direction:
Clemens Baldermann

Design:
Clemens Baldermann

Client:
Erste Liga Club

Musician(s):
Various

Description:
Poster design and
title type design
for a hiphop club-
night series.

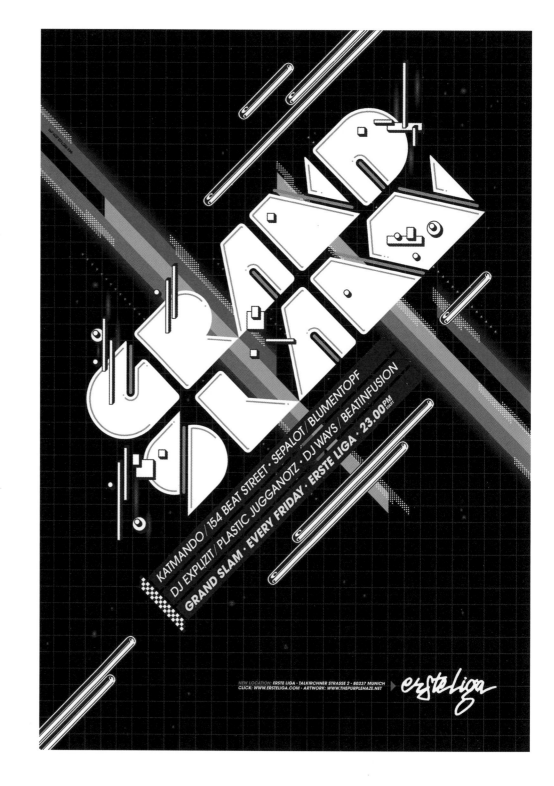

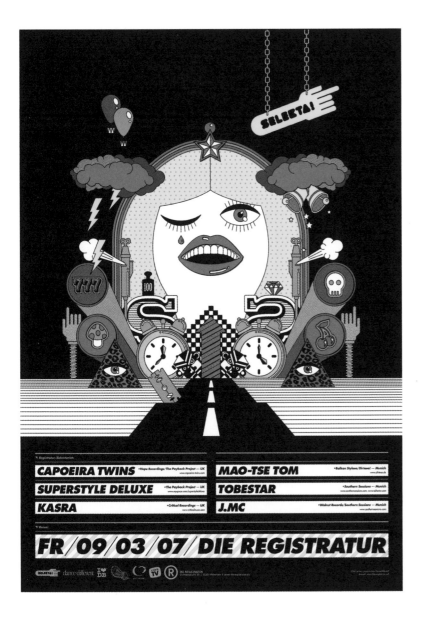

Title:
Selekta!

Type of Work:
Poster

Year:
2007

Contributed by:
Purple Haze Studio

Art Direction:
Clemens Baldermann

Design:
Clemens Baldermann

Client:
Die Registratur
Club

Musician(s):
Various

Description:
Poster design,
illustration and
logotype design
for an electro
clubnight series.
Printed in vari-
ous spot colours,
metallic and fluo-
rescent inks.

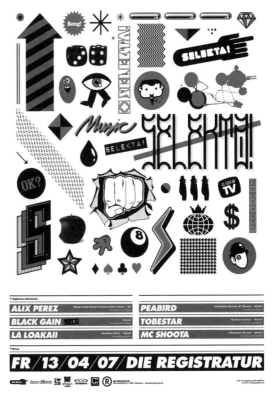

Title:
EMI

Type of Work:
Brand identity/
communications

Year:
2000-07

Contributed by:
SEA

Art Direction:
SEA

Design:
SEA

Client:
EMI

Description:
Investor brand com-
munications for a
global music com-
pany including cor-
porate literature.

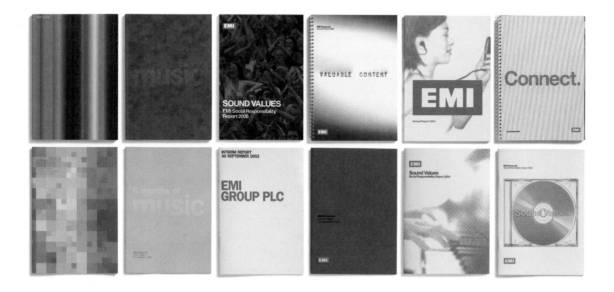

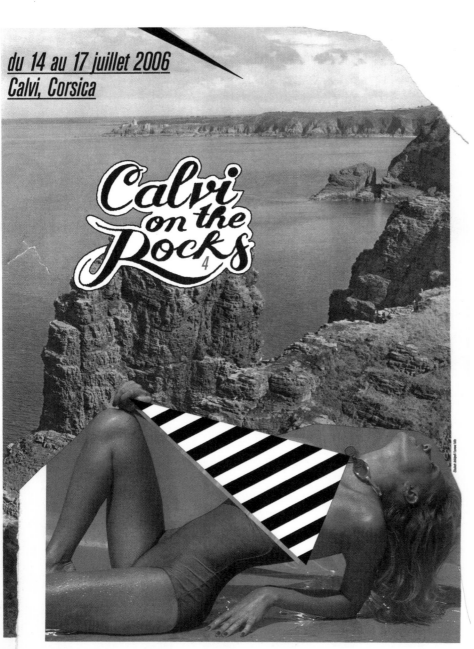

du 14 au 17 juillet 2006
Calvi, Corsica

Calvi on the Rocks 4

Phoenix / Cirkus avec Neneh Cherry / Hot Chip / James Murphy (LCD Soundsystem) /
Para One / Patrizia Gattaceca / Optimo / T.Noo / Voltair Feat. MC Papo Reto (Favela Chic) /
Pedro Winter / Apparat / Williams Traffic / Yaya Herman Düne / Medi & The Medicine Show /
Dj Oil / Dirty Sound System / Blague A Part / Vicarious Bliss / Dj Paul / Laurent Fétis /
Izia / Marco Dos Santos / Lesser Panda / and many more ———— calviontherocks.com

Pass 1 jour–15 euros / Pass 4 jours–45 euros disponibles dans les points de vente habituels et chez Black & Blue (Calvi)

Title:
Calvi on the Rocks

Type of Work:
Collage

Year:
2006

Contributed by:
Elisabeth Arkhipoff

Art Direction:
Laurent Fétis

Design:
Elisabeth Arkhipoff

Client:
Festival Calvi on
the Rocks, France

Client:
Various

Description:
Poster design for
the music festival
Calvi on the Rocks
2006.

Title:
Adama -
Delicate Dragon

Type of Work:
CD illustration

Year:
2007-08

Contributed by:
Brand Nu

Art Direction:
Radim Malinic,
Adama

Design:
Radim Malinic

Client:
4D People records

Musician(s):
Adama, Gili
Wiseburgh

Description:
Illustration and
design commiss-
sioned by and for
4D People records
to launch their new
signing into the
world of beauti-
fully crafted
female pop music.

Delicate Dragon
artwork goes hand
in hand with deep
and meaningful lyr-
ics and compliments
the music. Radim
Malinic / Brand Nu
created, drawn,
illustrated and
layed out the whole
project.

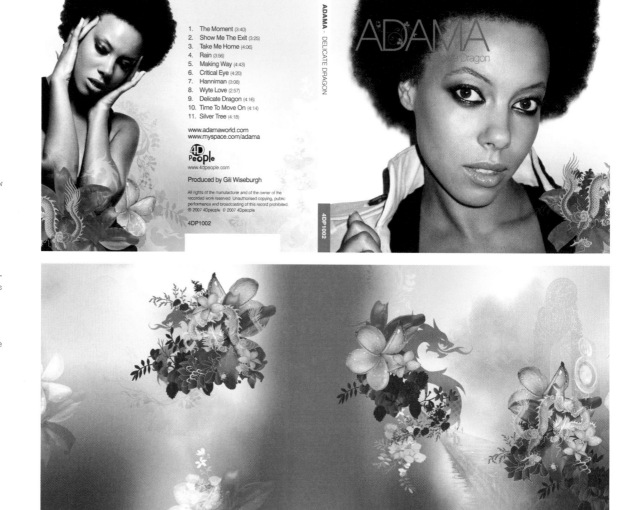

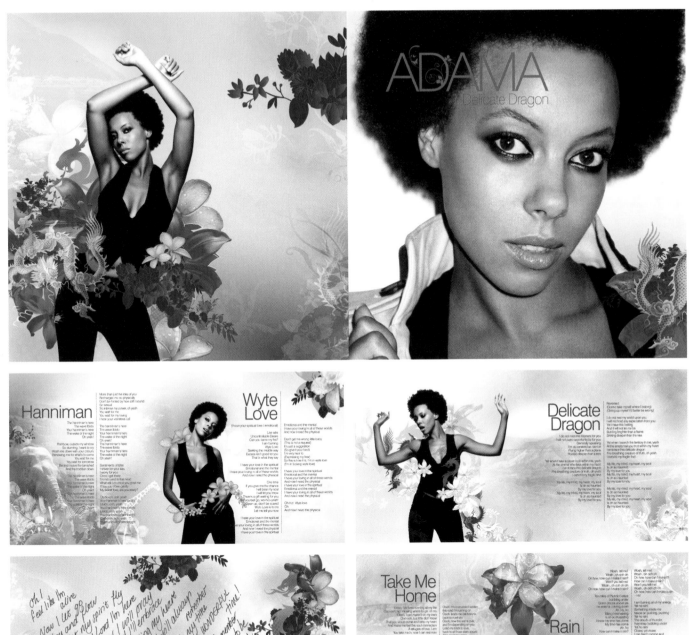

Title:
Marble

Type of Work:
CD artwork

Year:
2004

Contributed by:
cucumber

Art Direction:
Miki Rezai

Design:
Miki Rezai

Photography:
Hiroto Hata (mili)

Client:
BMG JAPAN INC.

Musician(s):
Tamamizu

Description:
Pop and cool, real
and fake, pink and
black. CD illus-
tration by Kiyoshi
Kuroda.

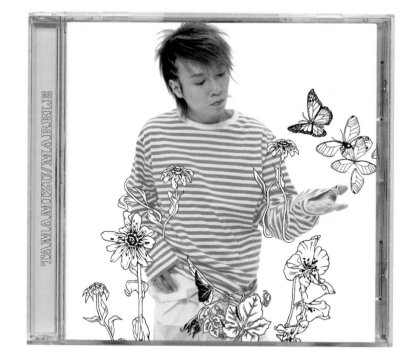

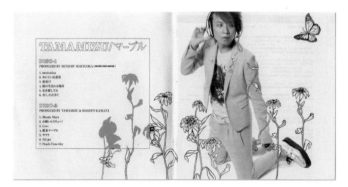

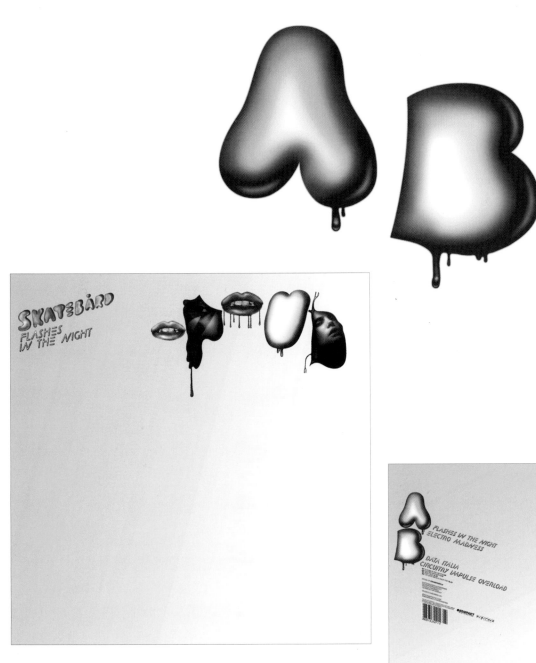

Title:
Flashes in The
Night

Type of Work:
CD sleeve

Year:
2006

Contributed by:
Grandpeople

Design:
Grandpeople

Client:
Kompakt Records

Musician(s):
Skatebård

Description:
'Flashes in the
Night' is Norwe-
gian tecno artist
Skatebård's first
12-inch release on
Kompakt Records.
'Flashes in the
Night' is taken
from his solo debut
CD 'Midnight Magic'
and the artwork is
a prolongation of
this album, though
a bit sweeter in
style.

Title:
To Whom It May...

Type of Work:
Poster

Year:
2007

Contributed by:
Designkönig

Art Direction:
Johannes König

Design:
Johannes König

Client:
Everybody Loves Eve

Musician(s):
Everybody Loves Eve

Description:
Artwork for a promotional poster for the alternative/electro band Everybody Loves Eve.

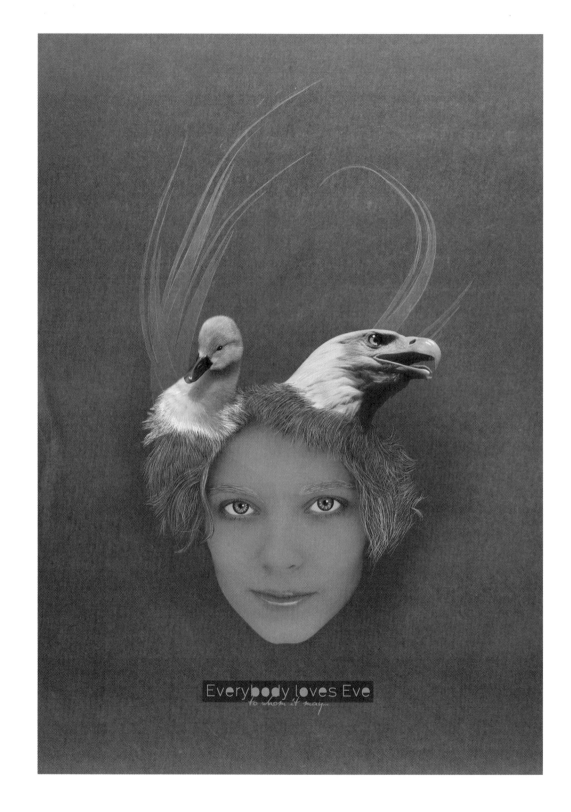

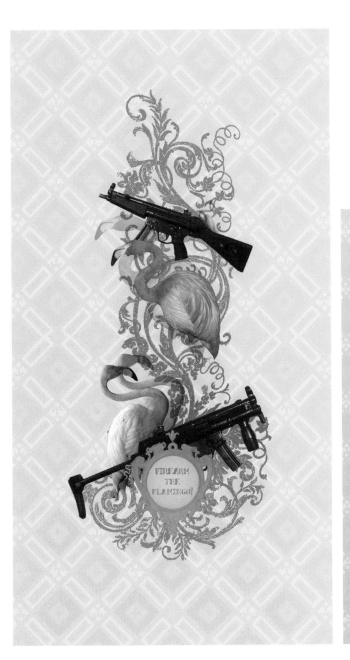
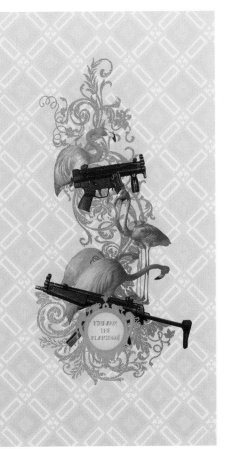

Title:
Firearm the
Flamingo
Type of Work:
Poster
Year:
2007
Contributed by:
Designkönig
Art Direction:
Johannes König
Design:
Johannes König
Client:
Club 47
Description:
Artwork for a pro-
motional poster for
a regular alterna-
tive/indie/electro
music event.

Title:
Hajimete no Yano
Akiko

Type of Work:
CD artwork

Year:
2006

Contributed by:
Bluemark Inc.

Art Direction:
Atsuki Kikuchi

Design:
Atsuki Kikuchi

Client:
YAMAHA MUSIC COMMU-
NICATIONS CO.,LTD.

Musician(s):
Akiko Yano

Description:
'Hajimete' means
for the first time.
White is used to
express purity.

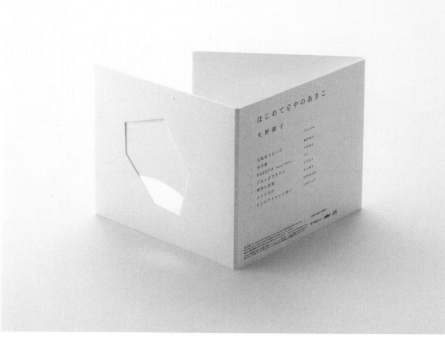

Title:
1. Paid Holiday
2. BOOK OF DAYS
3. Music for the Young and the Restless

Type of Work:
CD artwork

Year:
1, 2. 2003
3. 2004

Contributed by:
Bluemark Inc.

Art Direction:
Atsuki Kikuchi

Design:
Atsuki Kikuchi

Client:
1. Bluemark Inc.
2. Wacoal Art Center
3. bit of heaven

Musician(s):
1. KB
2. V.A.
3. Jeremy Dower

Description:
1. The bird has colourful wings including metal and fluorescent. Each ink has a different texture.
2. Brown silk-screen printing. The shapes blend representation and abstraction.
3. Fish and strawberry are used as motifs for matching the mood of electronica sounds. It is like a surreal painting.

Title:
1. The Bassman
2. Pace and
Distance
3. Feather
4. From Blast
5. I AGAINST I
(Next spread)

Type of Work:
CD artwork

Year:
2006

Contributed by:
Tetsuya Nagato

Art Direction:
Tetsuya Nagato

Design:
Tetsuya Nagato

Description:
This black and
white work was
influenced by
various sounds.

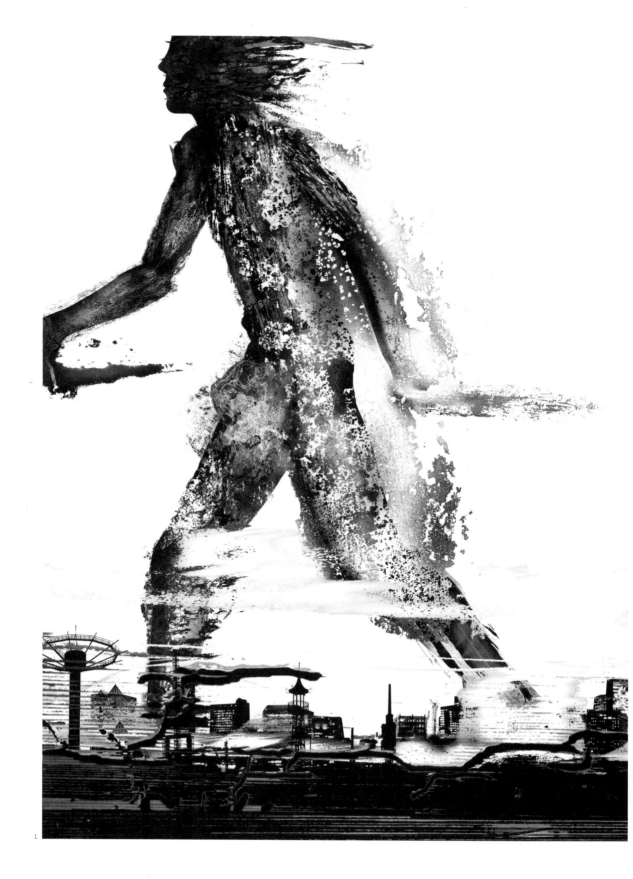

1

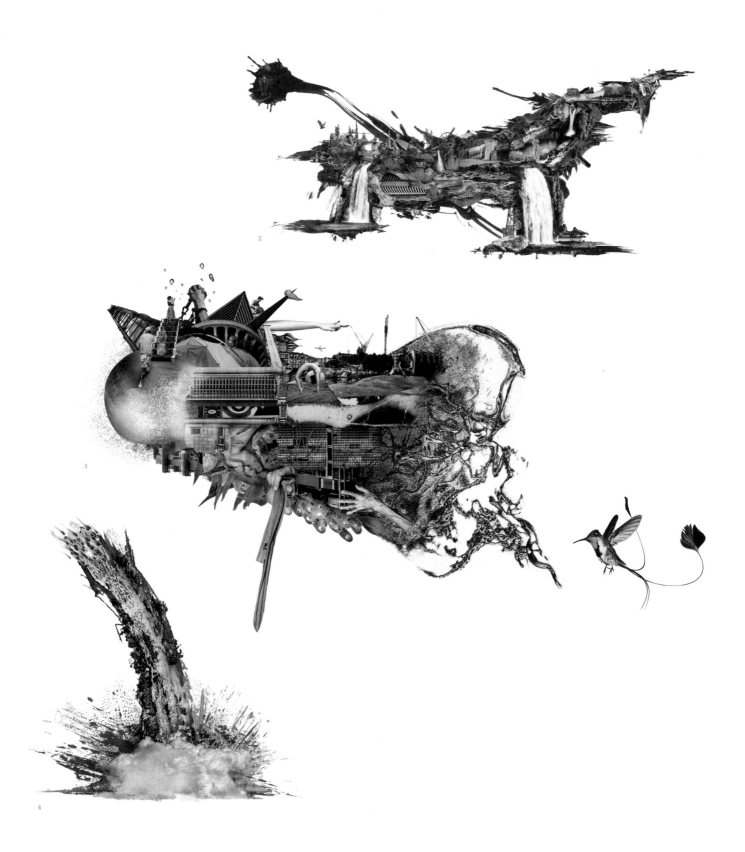

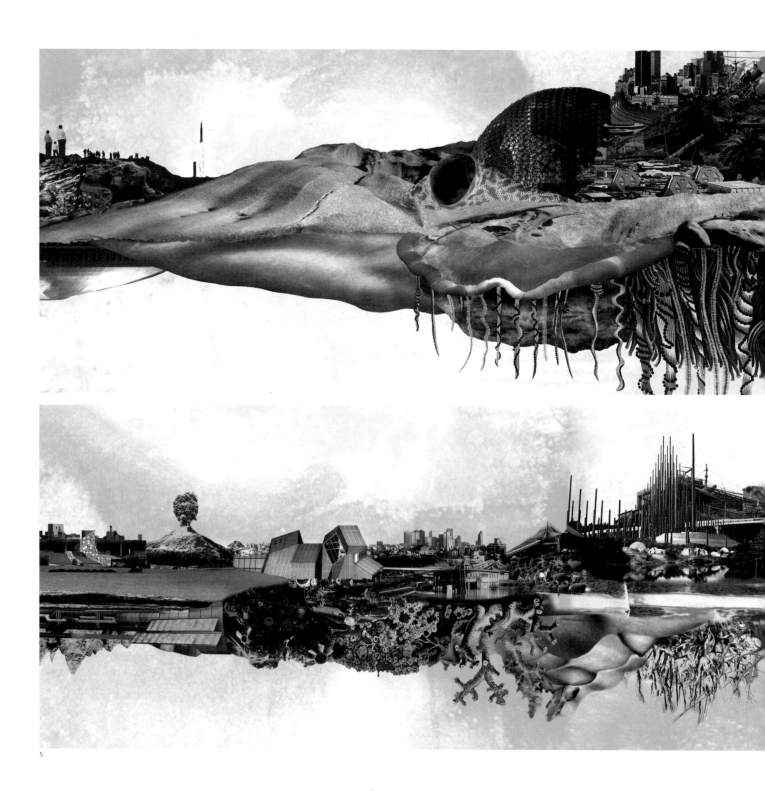

5

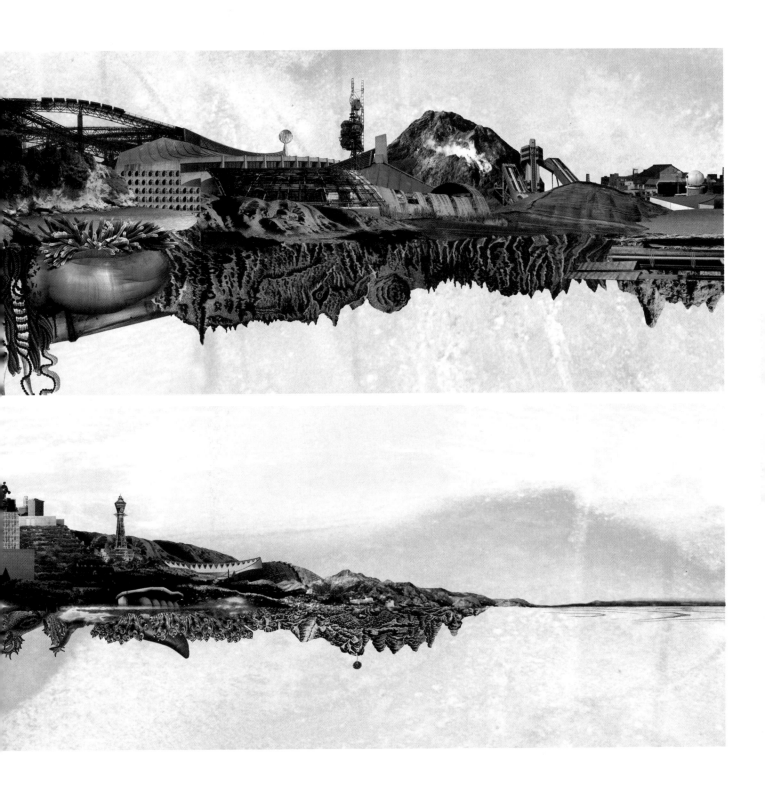

Title:
Barrikaderock
Festival

Type of Work:
Poster

Year:
2007

Contributed by:
Bleed

Art Direction:
Fredrik Melby

Design:
Fredrik Melby

Client:
Radio Orakel

Musician(s):
Nextlife, Magnus
Eliassen

Description:
Promotional poster
work for the 'Bar-
rikade Rock' festi-
val, which was held
by the Oslo-based
feminist radio sta-
tion Radio Orakel.
Bleed wanted to add
a different fla-
vour to the whole
feminist outlook.
The idea was based
around allowing
yourself to be who
you want to be,
feminist or not.

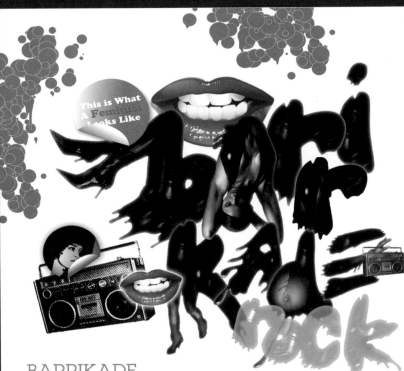

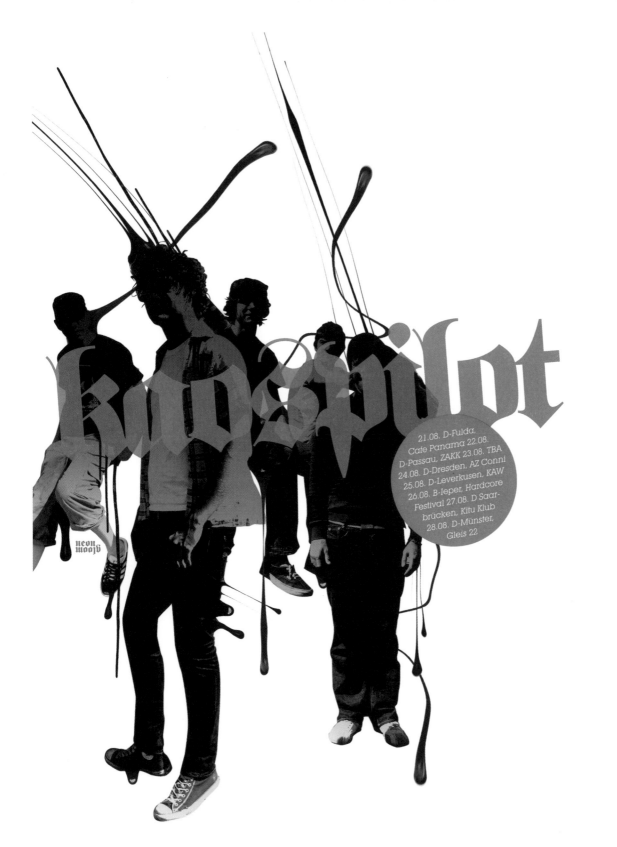

Title:
Kaospilot

Type of Work:
Poster

Year:
2007

Contributed by:
Bleed

Art Direction:
Fredrik Melby

Design:
Fredrik Melby

Client:
Kaospilot

Musician(s):
Kaospilot

Description:
This is the tour
poster for Kaospi-
lot from Oslo.
The band wanted a
photo-based poster,
but with a twist.
Bleed added some
organic shapes to
the portrait photo
of the band that
complements their
chaotic music.
When it comes
to colour usage
they added really
bright colours to
make them stand
out nicely against
all the bloody and
gore-based imager-
ies that are often
used in hardcore
music.

21.08. D-Fulda,
Cafe Panama 22.08.
D-Passau, ZAKK 23.08. TBA
24.08. D-Dresden, AZ Conni
25.08. D-Leverkusen, KAW
26.08. B-Ieper, Hardcore
Festival 27.08. D Saar-
brücken, Kitu Klub
28.08. D-Münster,
Gleis 22

Title:
You are on Your Own
Type of Work:
CD cover, Logo
Year:
2006
Contributed by:
Géraldine Georges
Art Direction:
Géraldine Georges
Design:
Géraldine Georges
Client:
Marcus
Musician(s):
Davy Standaert,
Stephane Matten,
Geert Standaert
Description:
Géraldine did
illustrations for
Marcus' new video-
clip/song and kept
their kitsh uni-
verse in the clip.
The dog was the
main character so
she decided to work
around it. She also
created a logo for
the band.

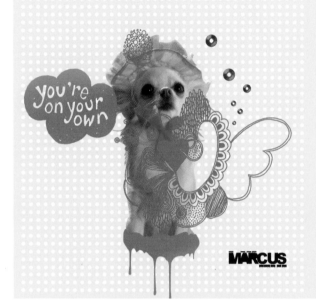

1. You're on your own (3:32)

2. Weekend in Paris (Swirl People Remix) (5:13)

>

+ "You're on your own" (Bonus video)

http://www.myspace.com/bandmarcus
booking@marcus-band.com
Produced by : Davy Standaert, Stéphane Matten, Geert Standaert
Artwork made by www.geraldinegeorges.be

MARCUS
Marcus Band Productions
tam films

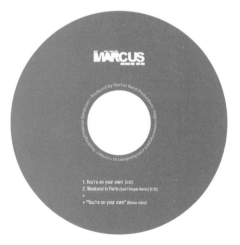

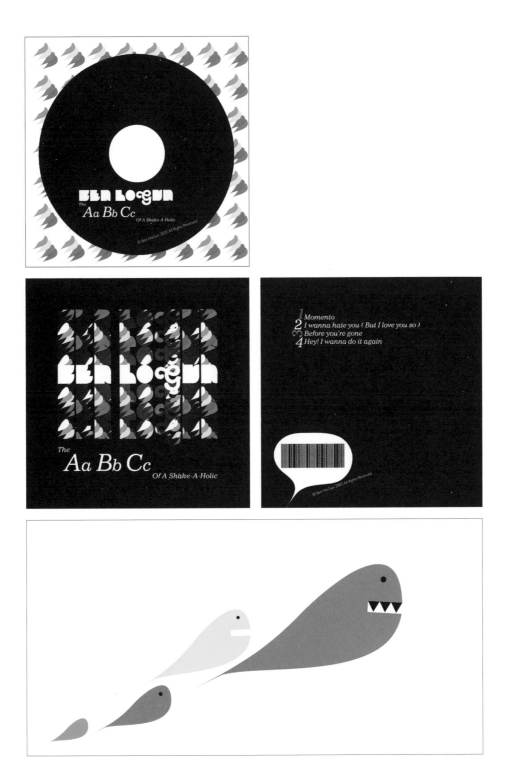

Title:
Ben HoGun EP

Type of Work:
CD cover

Year:
2007

Contributed by:
Johanna Lundberg

Art Direction:
Johanna Lundberg

Design:
Johanna Lundberg

Client:
Ben HoGun

Musician(s):
Ben HoGun

Description:
Ben HoGun is an
energetic band and
wanted something
that could reflect
that. After a lot
of different exam-
ples they decided
that this was the
most suitable for
the band and their
sound. Being able
to easily trans-
fer the design to
posters and gig
backgrounds was
also important, and
therefore Lundberg
chose to work with
colourful vector
images and created
a logo for them.

Title:
Lifetime

Type of Work:
CD digipack

Year:
2006

Contributed by:
Bongoût

Art Direction:
Meeloo Gfeller,
Anna Hellsgard

Design:
Meeloo Gfeller,
Anna Hellsgard

Client:
Fueled by Ramen,
Decadence Records

Musician(s):
Lifetime

Description:
Lifetime is a cult American melodic hardcore band. The band contacted Bongoût to do the design for their new release and they gave the company total creative freedom. Bongoût wanted to create abstract, fresh, innovative and powerful design that fits their music. The inner note lyrics were handwritten by the lead singer.

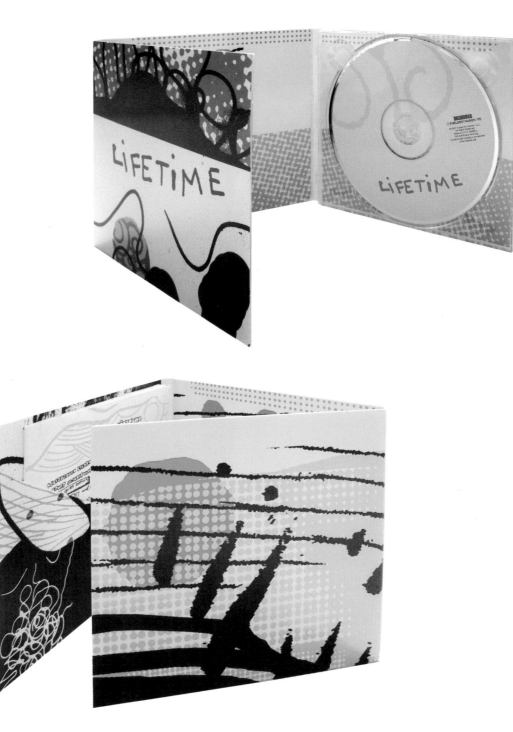

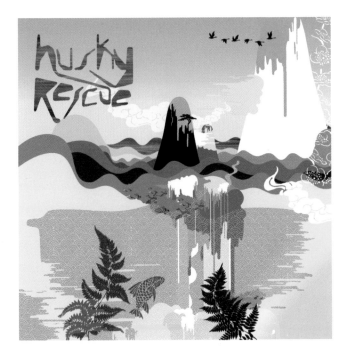

Title:
Husky Rescue

Type of Work:
CD artwork

Year:
2005-07

Contributed by:
Kustaa Saksi
(Unit CMA)

Art Direction:
Kustaa Saksi

Design:
Kustaa Saksi

Client:
Catskills Records

Musician(s):
Husky Rescue

Description:
Art direction and
illustrations for
Husky Rescue's
releases.

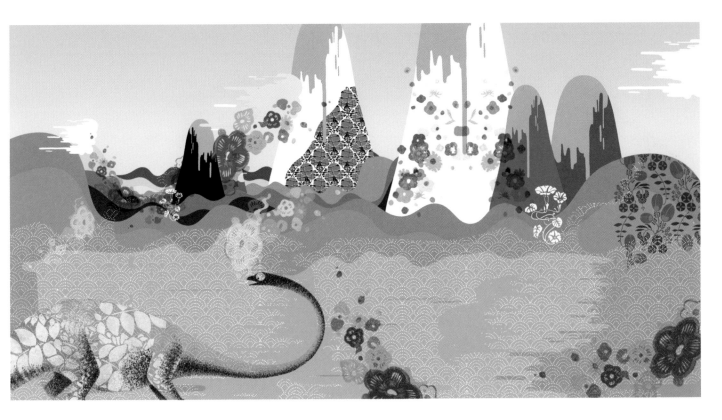

Title:
1. Efterklang,
Under Giant Trees
2. Efterklang,
Parades

Type of Work:
CD artwork

Year:
2007

Contributed by:
Hvass&Hannibal

Design:
Hvass&Hannibal

Client:
The Leaf Label

Musician(s):
Efterklang

Description:
The outside and
inside of Eft-
erklang's mini
album 'Under Giant
Trees.' The album
was released in
Spring 2007 as a
limited edition
with special pack-
aging and included
a set of magic
puzzle cards that
can be laid in
many ways.

The designers were
also responsible
for the cover of
Parades, Efter-
klang's latest
album.

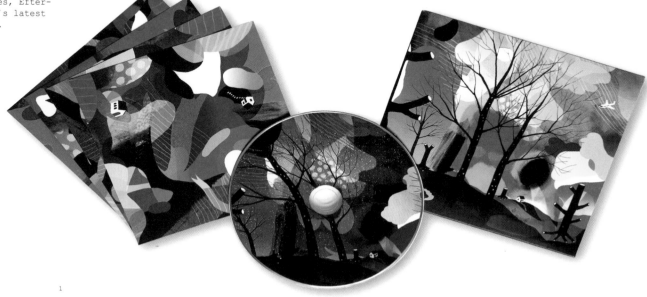

1

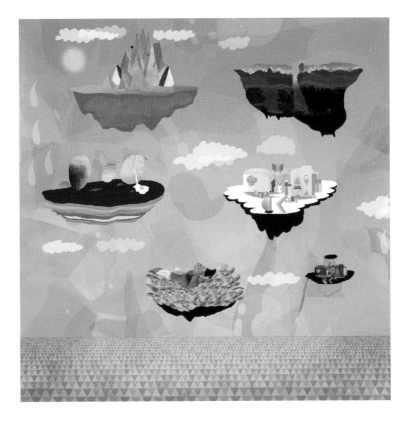

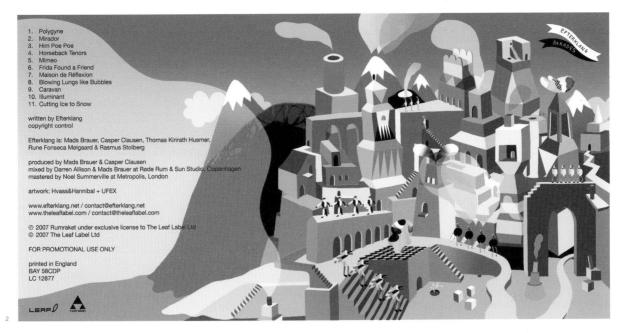

1. Polygyne
2. Mirador
3. Him Poe Poe
4. Horseback Tenors
5. Mimeo
6. Frida Found a Friend
7. Maison de Réflexion
8. Blowing Lungs like Bubbles
9. Caravan
10. Illuminant
11. Cutting Ice to Snow

written by Efterklang
copyright control

Efterklang is: Mads Brauer, Casper Clausen, Thomas Kirirath Husmer,
Rune Fonseca Molgaard & Rasmus Stolberg

produced by Mads Brauer & Casper Clausen
mixed by Darren Allison & Mads Brauer at Røde Rum & Sun Studio, Copenhagen
mastered by Noel Summerville at Metropolis, London

artwork: Hvass&Hannibal + UFEX

www.efterklang.net / contact@efterklang.net
www.theleaflabel.com / contact@theleaflabel.com

℗ 2007 Rumraket under exclusive license to The Leaf Label Ltd
© 2007 The Leaf Label Ltd

FOR PROMOTIONAL USE ONLY

printed in England
BAY 58CDP
LC 12877

LEAF rumraket

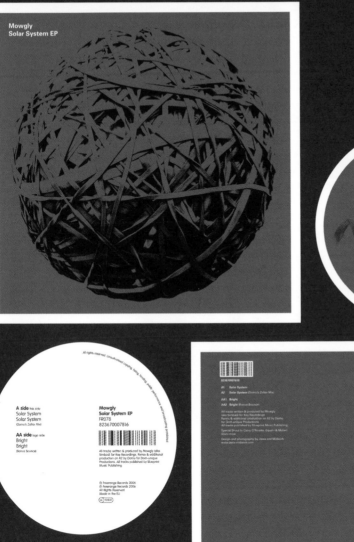

Mowgly
Solar System EP

A side This side
Solar System
Solar System
(Darrick's Zoltar Mix)

AA side Logo side
Bright
Bright
(Bonus Bounce)

Mowgly
Solar System EP
FR078
8236700078l6

freerange

Title:
Solar Systems EP
Type of Work:
CD sleeves
Year:
2006
Contributed by:
Jawa and Midwich
Art Direction:
Simon Dovar,
Nils Davey
Design:
Jawa and Midwich
Client:
Freerange Records
Musician(s):
Mowgly
Description:
Elastic band ball.

Title:
The Pain EP

Type of Work:
CD sleeves

Year:
2006

Contributed by:
Jawa and Midwich

Art Direction:
Simon Dovar,
Nils Davey

Design:
Jawa and Midwich

Client:
Freerange Records

Musician(s):
Jake Childs

Description:
Foliage.

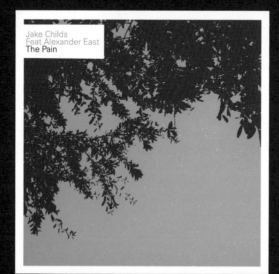

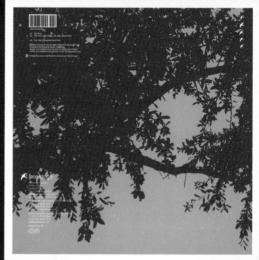

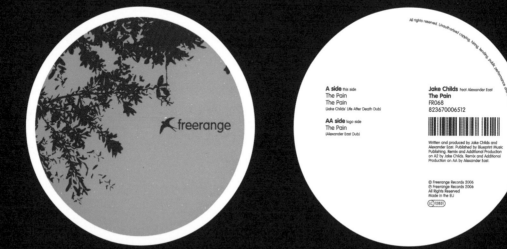

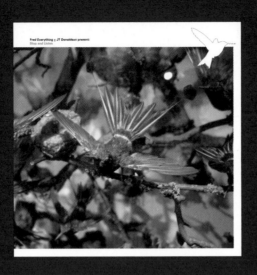

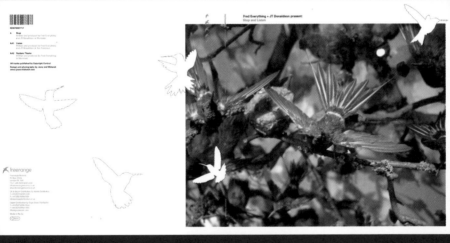

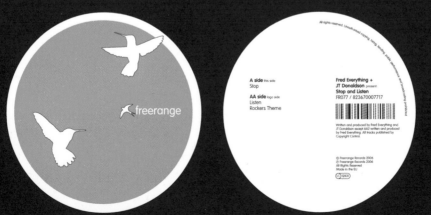

Title:
Stop and Listen
Type of Work:
CD sleeves
Year:
2006
Contributed by:
Jawa and Midwich
Art Direction:
Simon Dovar,
Nils Davey
Design:
Jawa and Midwich
Client:
Freerange Records
Musician(s):
Fred Everything +
JT Donaldson
Description:
This CD artwork
features photog-
raphy of a Victo-
rian bird cabinet
containing humming
birds.

Title:
1. Zig Zag
2. Minion

Type of Work:
CD sleeves

Year:
1. 2007
2. 2006

Contributed by:
Jawa and Midwich

Art Direction:
Simon Dovar,
Nils Davey

Design:
Jawa and Midwich

Client:
Freerange Records

Musician(s):
1. Yellow Sox
2. Shik Stylko

Description:
1. Bold minimal
solution to the
title 'Zig Zag.'
2. Circular pat-
terns with colour
overlay.

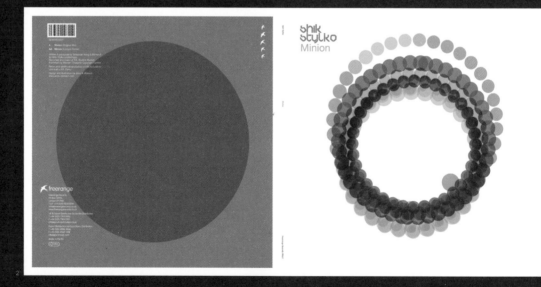

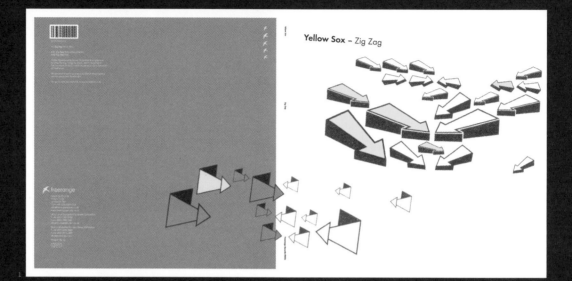

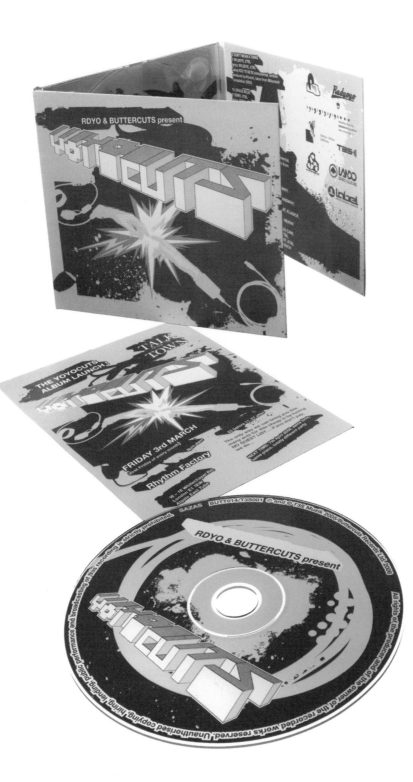

Title:
Yoyocuts

Type of Work:
CD Digipack

Year:
2006

Contributed by:
Jawa and Midwich

Art Direction:
Simon Dovar,
Nils Davey

Design:
Jawa and Midwich

Client:
Buttercuts Records

Musician(s):
RDYO

Description:
The client wanted
a new approach to
a hip-hop sleeve.
Jawa and Midwich
provided them with
a bastardization of
music cables, paint
drips and human
limbs.

Title:
Healthy Boy

Type of Work:
CD artwork

Year:
2006

Contributed by:
Grandpeople

Art Direction:
Grandpeople

Design:
Grandpeople

Client:
Healthy Boy Records

Musician(s):
Id Submerged,
GoCab, DJ Woo

Description:
Healthy Boy is
a new Norwe-
gian record label
for electronic
music. Grandpeo-
ple designed the
visual profile for
the label which is
strictly typograph-
ical. The profile
is strengthened
when adapted to the
CD releases. The
illustrations are
of the darker and
tactile sort, mak-
ing an odd meeting
between the eerie
nature-like objects
and the strict
lines in the let-
ters.

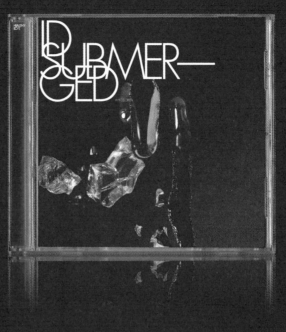

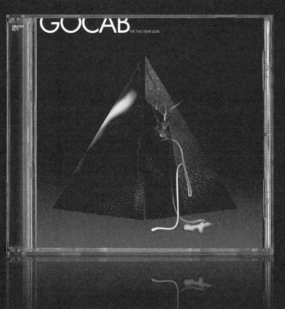

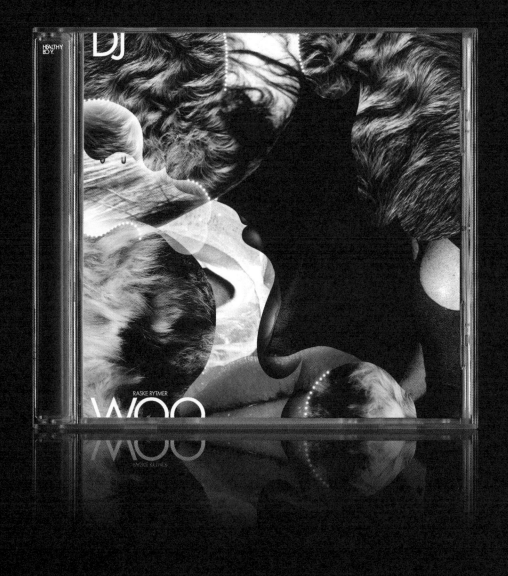

Title:
Ministry of Sound
Summer Guide 06

Type of Work:
Guide cover

Year:
2006

Contributed by:
Urbancowboy

Art Direction:
Karen Bell -
EMI Music

Design:
Patrick Boyer

Client:
Ministry of Sound

Musician(s):
Ministry of Sound

Description:
A cover design for
MOS Summer Guide
Australia. (This
version wasn't used
for the cover.)

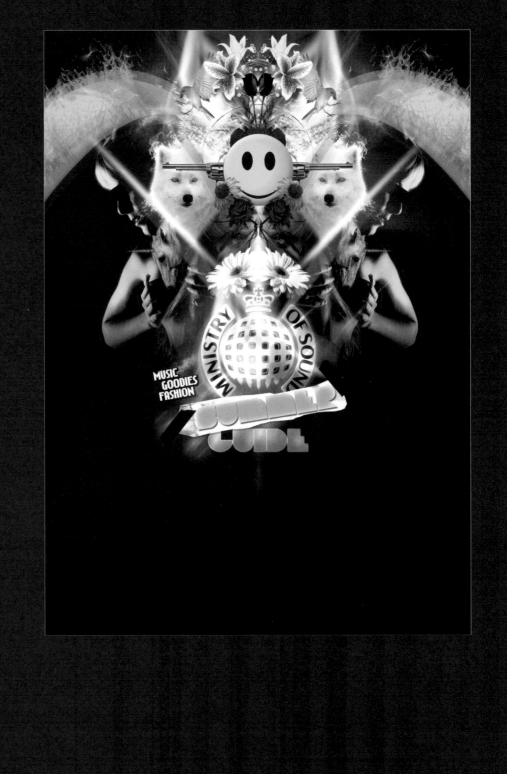

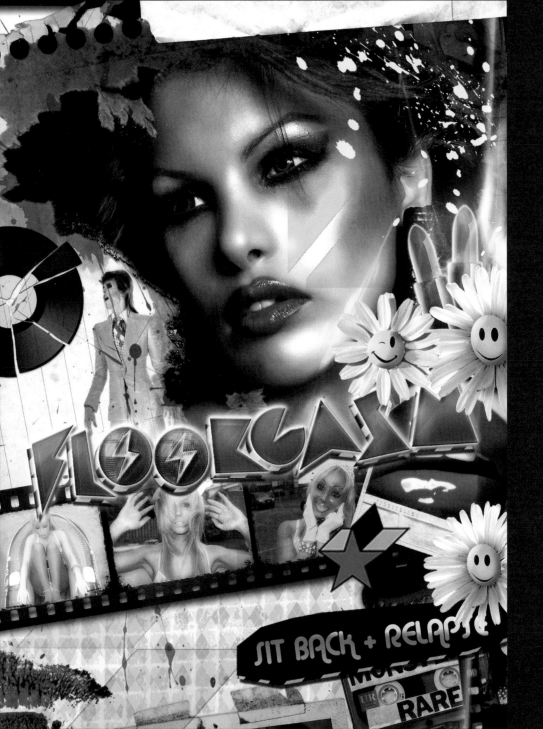

Flyer, Poster
other promoti
materials

Year:
2006

Contributed b
Urbancowboy

Art Direction
Patrick Boye,
Rob Kittler

Design:
Patrick Boyer

Client:
Dance/Electro
parties throw
Australia, Ne
Zealand (Floo
night organiz
Rob Kittler)

Musician(s):
Various leadi

Description:
A visual mash
promote and b
organized ele
house parties
process was a
style collage
glamour, sex,
and bright co

Title:
Maimon and
The Mongoose

Type of Work:
Promotional Poster

Year:
2006

Contributed by:
Tragiklab

Art Direction:
Charles Bitton -
YODI Studio

Design:
Dhanank Pambayun

Photography:
Beth Wimmer,
Isaac Benaim

Client:
YODI Studio, NY

Musician(s):
Maimon and
The Mongoose

Description:
Promotional poster
from skank band
live show, this
piece was inspired
by some psychedelic
art style, and
mixed with various
colourful objects
to present happi-
ness, dancing, etc.

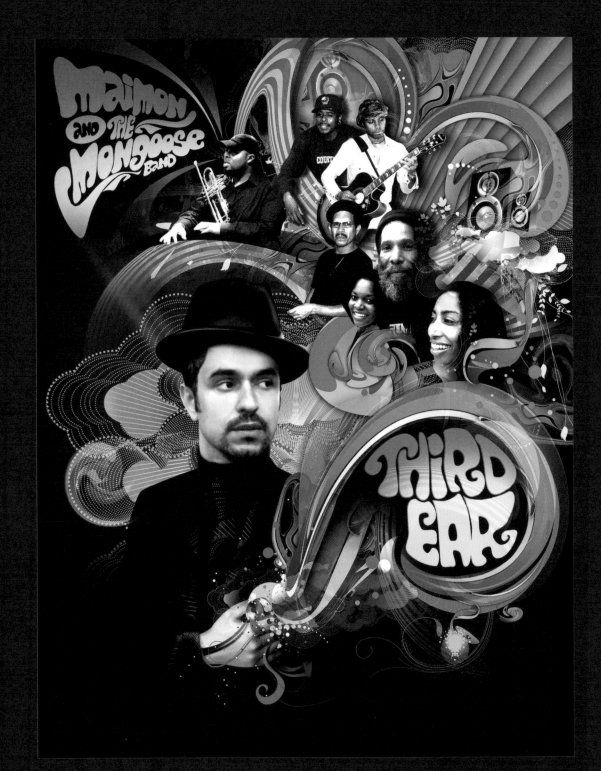

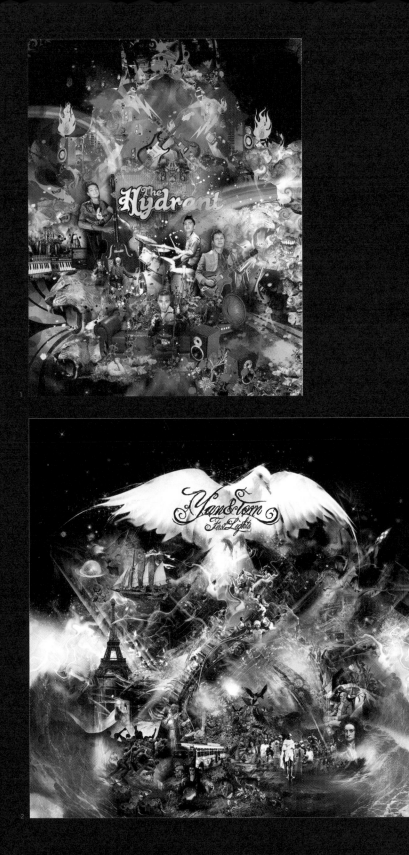

Title:
1. The Hydrant
2. First Lights

Type of Work:
1. Spreads
illustration
2. Cover
illustration

Year:
1. 2006
2. 2007

Contributed by:
Tragiklab

Design:
Dhanank Pambayun

Photography:
1. Soleh Solihudin

Client:
1. Jeune Magazine,
Indonesia
2. Far Records,
France

Musician(s):
1. The Hydrant
2. Yan & Tom

Description:
1. The Hydrant is
the Rockabilly Band
from Indonesia, and
they need an illus-
tration to com-
plete their inter-
view in a magazine.
The illustration
comprises several
music instruments,
flowers, lions and
many things that
represent their
music.
2. This piece is
about a metaphor
(philosopical,
political,mystical,
theological) that
stands for the wind
of changes. In
the background a
pacific army with
a lot of different
people and things
symbolizes energy,
faith, freedom,
peace, etc.

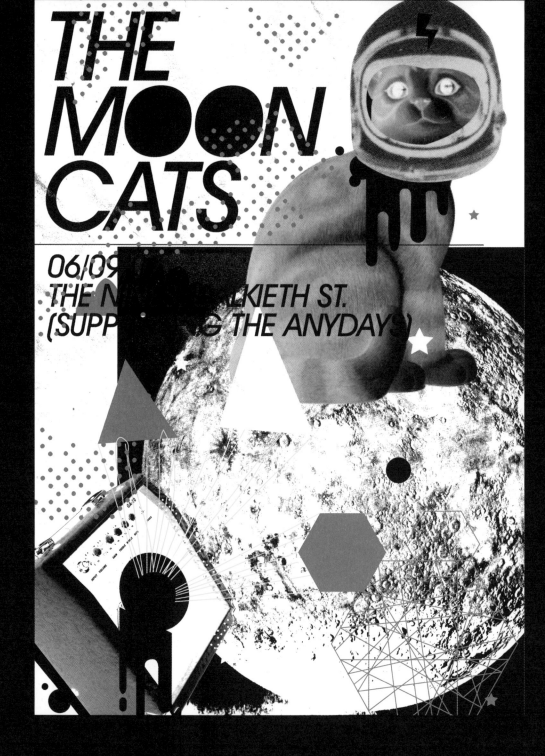

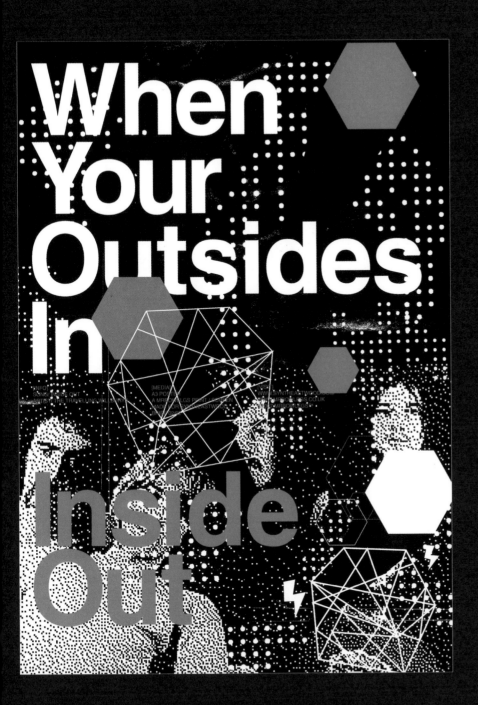

Title:
Inside out
Type of Work:
Print
Year:
2007
Contributed by:
Mr. Bowlegs
Art Direction:
Mr. Bowlegs
Design:
Mr. Bowlegs
Client:
Syntheastwood.com
Musician(s):
Various
Description:
Syntheastwood is a
submission-based
group that shares
and promotes skills
in current elec-
tronically influ-
enced art. They
organize electronic
gigs and events.
This was the sec-
ond brief they had
set; the theme was
on 'Inside Out.'
This was a chance
for Mr. Bowlegs to
explore and express
new techniques he
had been working
on and produce an
A2-size poster for
the gig/event. It
was based on the
Traveling Willburys
song and the lyrics
from 'Inside Out.'

Title:
A New Language

Type of Work:
CD artwork

Year:
2006

Contributed by:
Joel Lardner

Art Direction:
David Calderley
(Graphic Therapy,
NYC)

Design:
Joel Lardner

Photography:
Ji Shin

Client:
V2 Records, NYC

Musician(s):
The Adored

Description:
The aim of this project was to produce a series of images that would best represent The Adored's spiky and kinetic sound.

Having liaised with the band and label creatives in New York and Los Angeles it was agreed to take a photomontage direction for the cover artwork. This would involve collaboration with photographer Ji Shin. The band was photographed against a white background and dynamic paint marks and photographic elements were applied.

The collaborative nature of this process provided an opportunity to challenge preconceptions of illustration and photography. The accuracy of studio photography combined with the fluid nature of contemporary illustration continues to be an avenue of research that Lardner has always found fascinating.

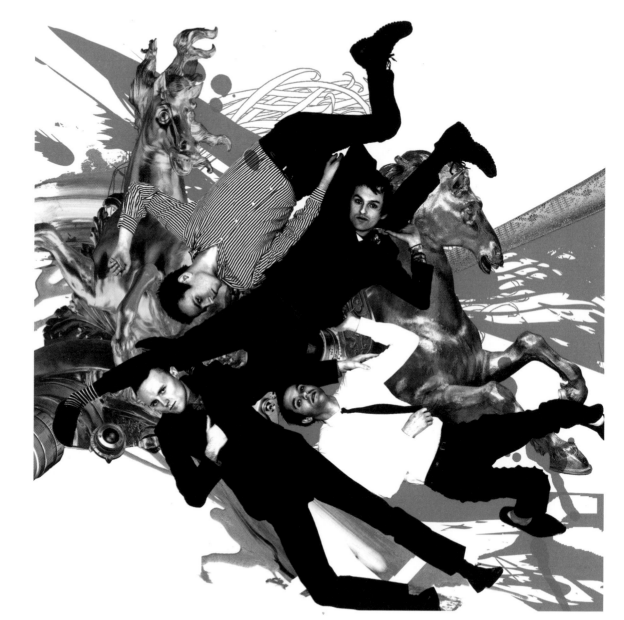

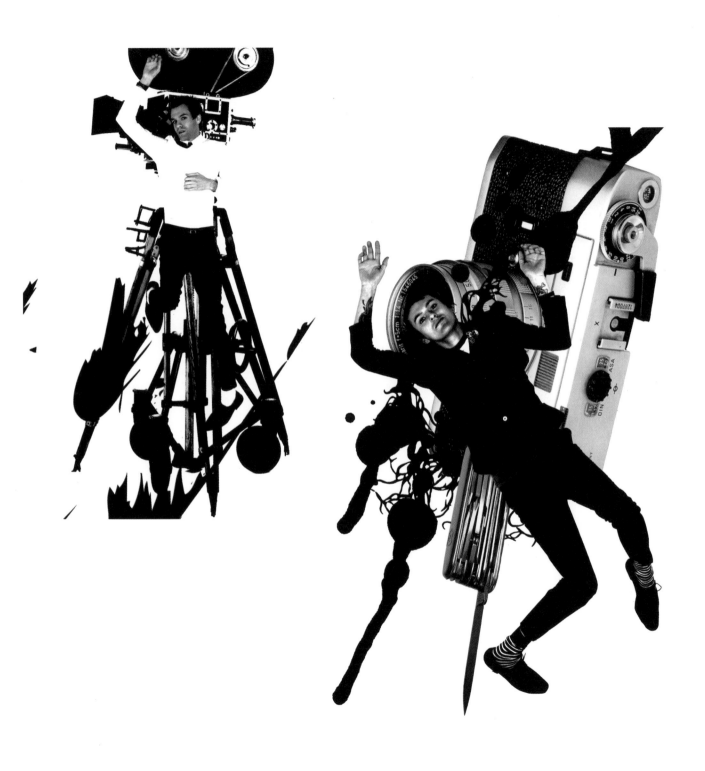

Title:
Love Age

Type of Work:
CD artwork

Year:
2006

Contributed by:
RADIO

Art Direction:
Yoshi Tajima

Design:
Yoshi Tajima

Client:
CHATANIX recordings
(Japan)

Musician(s):
CHATANIX

Description:
The client wanted
to use Tajima's
collage works which
was originally a
private work. He
re-worked it for
the CD cover and
used flashy pink
colours which he
had never used
before.

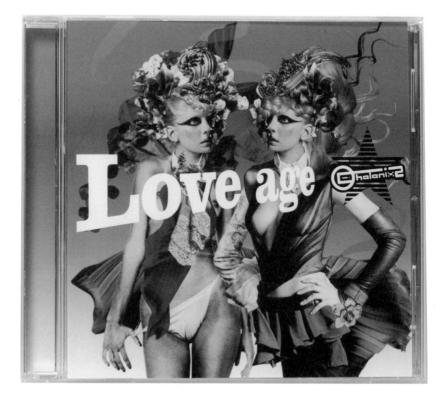

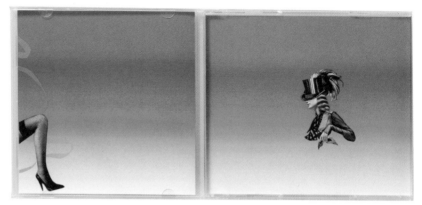

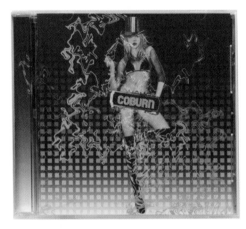

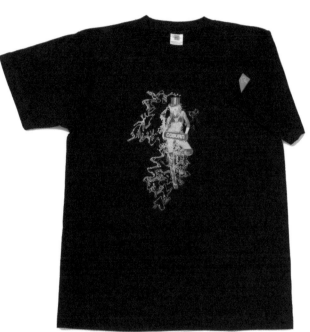

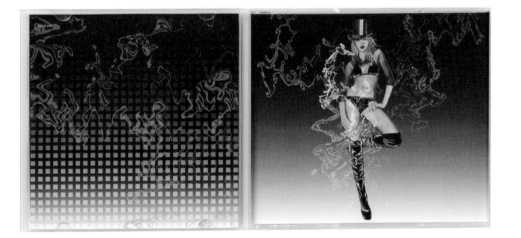

Title:
COBURN CD album

Type of Work:
CD, T-shirt

Year:
2006

Contributed by:
RADIO

Art Direction:
Yoshi Tajima

Design:
Yoshi Tajima

Client:
KSR (Japan)

Musician(s):
COBURN

Description:
This cover is exclusive for Japan. Tajima tried to visualize COBURN's electro house beat with erotic and wild moods.

Title:
Bota'Sentido! 1995-2014, Pay'Attention!
1995-2014

Type of Work:
CD cover

Year:
2006

Contributed by:
chemega

Art Direction:
Ricardo Chemega

Design:
Ricardo Chemega

Client:
Matarroa

Musician(s):
Various

Description:
Collection album made of old and new songs from various artists. The packaging features an embriodery, a traditional Portuguese technique very unusual in the music business.

Title:
Dinosaur + Boysen-
berry = Choo Choo
(Errors in
Thinking)

Type of Work:
CD packaging

Year:
2005

Contributed by:
Natasha Jen

Art Direction:
Natasha Jen

Design:
Natasha Jen

Client:
Dinosaur + Boysen-
berry = Choo Choo

Musician(s):
Dinosaur + Boysen-
berry = Choo Choo

Description:
A CD package for an
experimental music
project. The music
is an intense col-
lection of indus-
trial sounds. The
sharpness in the
sound reminded Jen
of violence and
sharp objects but
in the design pro-
cess she wanted to
use a quiet, even
a little sweet,
visual to avoid the
direct reference to
violence thus to
create a kind of
ambiguity.

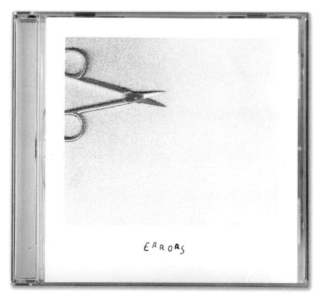

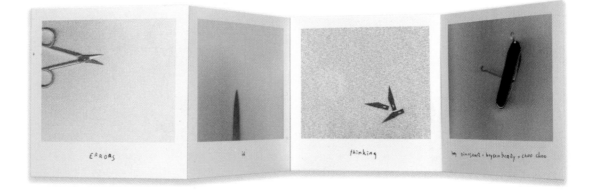

Title:
Origam E2

Type of Work:
CD cover

Year:
2005

Contributed by:
ngdesign.it

Art Direction:
Nazario Graziano

Design:
Nazario Graziano

Client:
Il rumore del fiore
di carta

Musician(s):
Il rumore del fiore
di carta

Description:
CD cover for Ital-
ian post rock band
Il rumore del fiore
di carta.

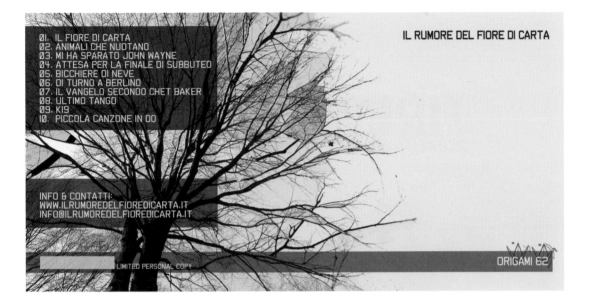

01. IL FIORE DI CARTA
02. ANIMALI CHE NUOTANO
03. MI HA SPARATO JOHN WAYNE
04. ATTESA PER LA FINALE DI SUBBUTEO
05. BICCHIERE DI NEVE
06. DI TURNO A BERLINO
07. IL VANGELO SECONDO CHET BAKER
08. ULTIMO TANGO
09. KI9
10. PICCOLA CANZONE IN DO

IL RUMORE DEL FIORE DI CARTA

INFO & CONTATTI:
WWW.ILRUMOREDELFIOREDICARTA.IT
INFO@ILRUMOREDELFIOREDICARTA.IT

LIMITED PERSONAL COPY

ORIGAMI 62

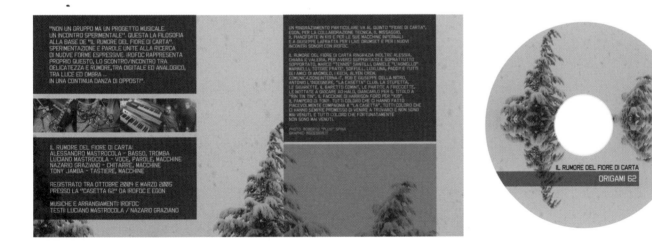

IL RUMORE DEL FIORE DI CARTA

ORIGAMI 62

Title:
Firewater

Type of Work:
Art direction for
FW 06/07

Year:
2006-07

Contributed by:
ngdesign.it

Art Direction:
Nazario Graziano

Design:
Nazario Graziano

Client:
Firewater

Musician(s):
Various

Description:
Art direction for
Firewater events
at Brancaleone in
Rome. It includes
flyer, poster, and
gadgets for the
events.

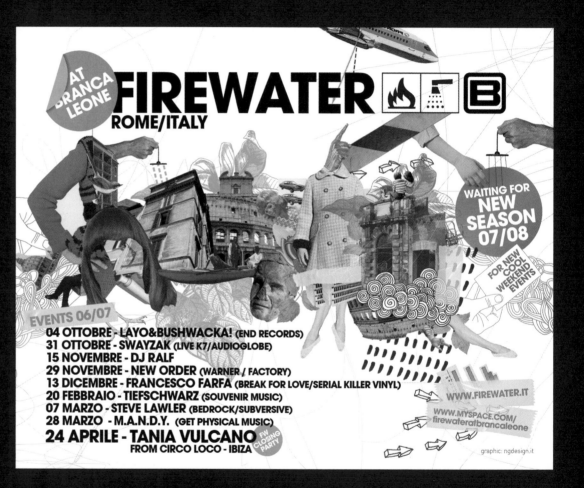

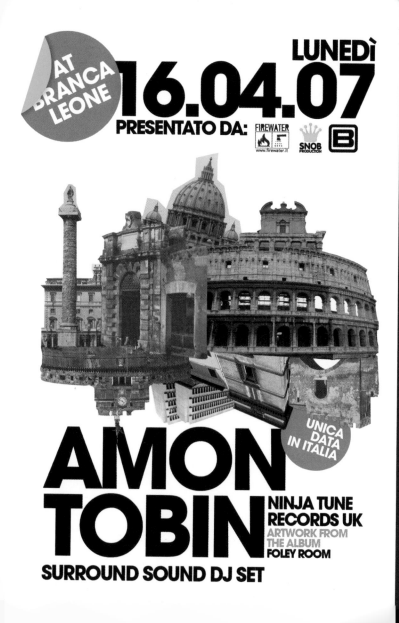

AT BRANCA LEONE

LUNEDÌ
16.04.07
PRESENTATO DA: FIREWATER www.firewater.it SNOB PRODUCTION B

UNICA DATA IN ITALIA

AMON TOBIN
NINJA TUNE RECORDS UK
ARTWORK FROM THE ALBUM FOLEY ROOM

SURROUND SOUND DJ SET

FIREWATER www.firewater.it SNOB B LUNEDÌ 16.04.07

AMON TOBIN
NINJA TUNE RECORDS UK

UNICA DATA IN ITALIA

SURROUND SOUND DJ SET
(START AT 00:00)

DJ SET: RAFFAELE COSTANTINO
AFTERSHOW DJ SET: ANDREA LOMBARDO
VISUALS: PIXELORCHESTRA

MEDIA PARTNERS

BASEBOG LIFEGATE radio xister

graphic: nydesign.it

Title:
MSTRKRFT - The
Looks LP/CD

Type of Work:
CD packaging

Year:
2006

Contributed by:
Seripop

Art Direction:
Seripop

Design:
Seripop

Client:
Last Gang records/
Universal

Musician(s):
MSTRKRFT

Description:
Seripop's con-
cept was a pretty
simple pun on the
record title. The
front cover has a
woman with her eyes
cut out. The eyes
allow the psyche-
delic patterns on
the inner sleeve,
which can be turned
to create different
ways of looking.

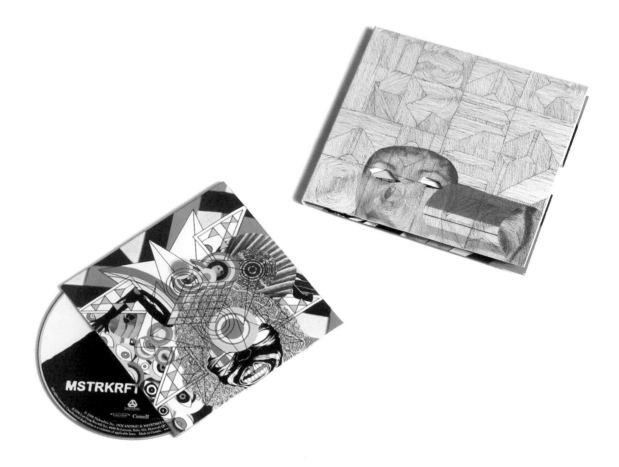

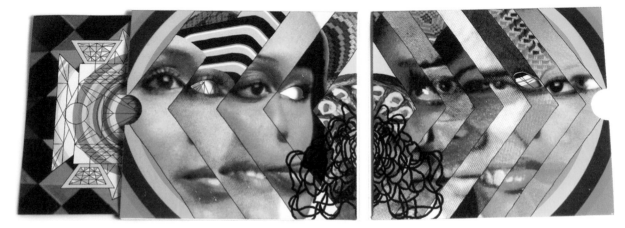

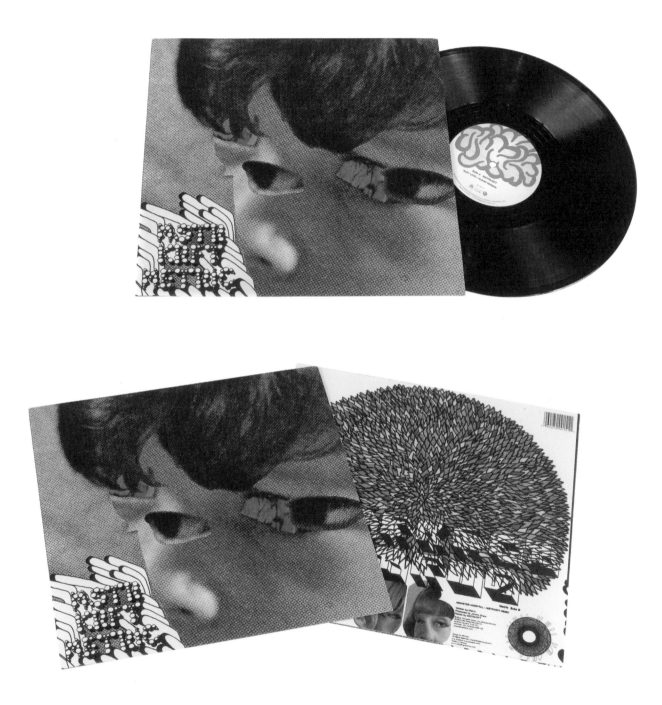

Title:
Gropu-Arch

Type of Work:
CD, CD card cover

Year:
2007

Contributed by:
Graphic Design
Studio 3group

Art Direction:
Ryszard Bienert

Design:
Slawomir Lukuc,
Ryszard Bienert

Client:
Gropu-Arch

Description:
Silk screen
printed, CD cover –
300gsm cardboard in
4 different colours
to represent 4
international
departments.

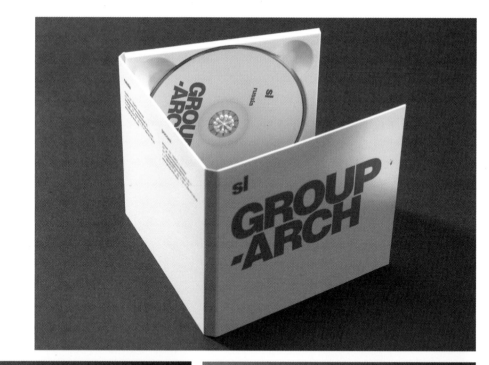

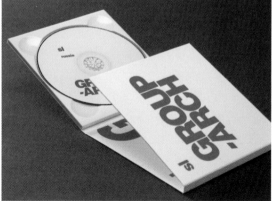

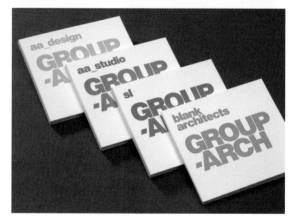

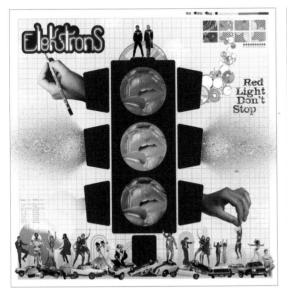

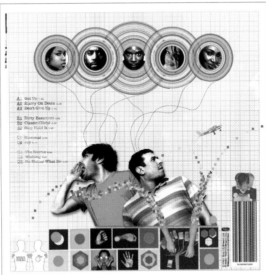

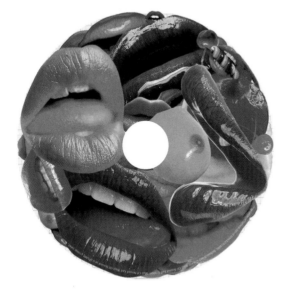

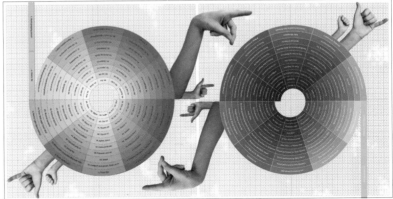

Title:
Elektrons
(Next spread)

Type of Work:
Campaign,
Promotional
materials,
CD sleeves

Year:
2007

Contributed by:
No Days Off

Art Direction:
Patrick Duffy

Design:
Patrick Duffy

Client:
Wall Of Sound

Musician(s):
Elektrons

Description:
Modern psychedelia.

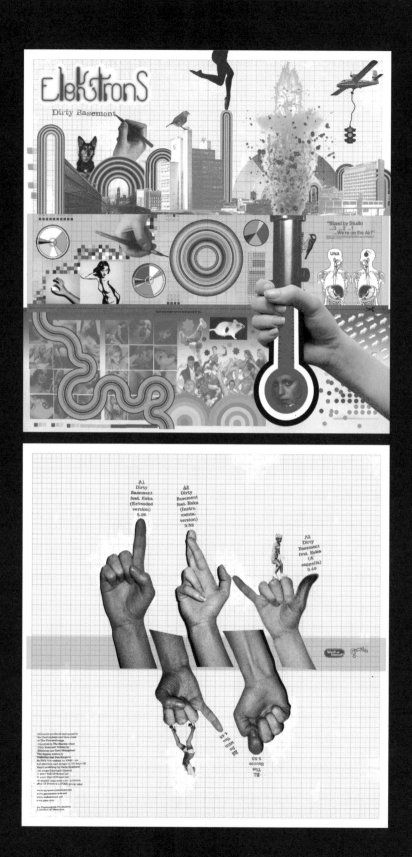

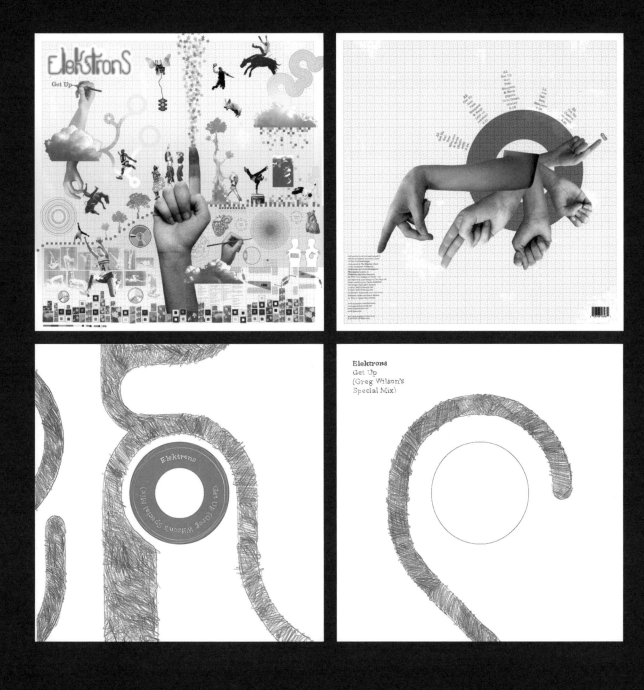

Title:
Ochsenfest

Type of Work:
Flyer/Postcard,
Poster, T-shirt

Year:
2006

Contributed by:
Nicole Jacek

Design:
Nicole Jacek

Client:
MVP e.V.

Description:
The traditional
biennial Ochsenfest
in Ludwigsburg is
a 4-day festival,
famous for its
barbecued ox since
1968.

Over the years it
became more and
more well known a
music festival.

Especially Rock
and the mix of a
little bit of Jazz
and good tradi-
tional German music
are played live on
stage.

Jacek designed
everything from
identity, posters
and flyer to menu
card and T-shirts.
The concept is very
simple and is based
on a pictogram ox.

Title:
South – With the
Tides

Type of Work:
CD cover

Year:
2003

Contributed by:
Kai and Sunny

Art Direction:
Kai and Sunny

Design:
Kai and Sunny

Client:
Kinetic Records

Musician(s):
South (Joel
Cadbury, Jamie
McDonald, Brett
Shaw)

Description:
Eye of the storm.

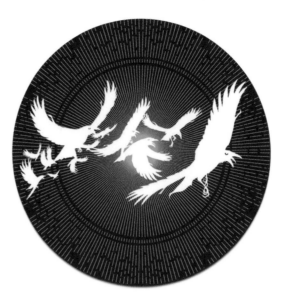

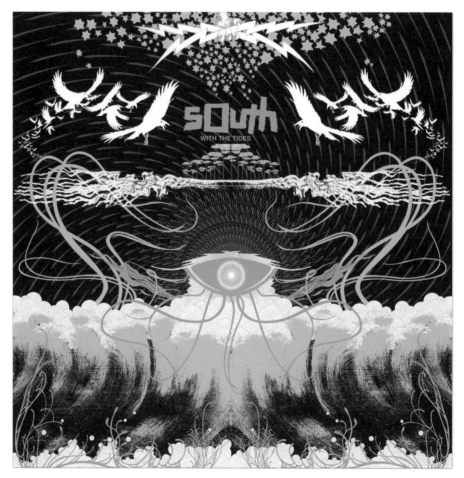

Title:
A Tantra - A Place
Called Tarot

Type of Work:
Logo, Record sleeve

Year:
2003

Contributed by:
Kai and Sunny

Art Direction:
Kai and Sunny

Design:
Kai and Sunny

Client:
Tirk Records

Musician(s):
Idjut Boys

Description:
Kaleidoscope view
of the logo.

Title:
KEANE

Type of Work:
CD artwork

Contributed by:
Sanna Annukka
(Big Active)

Design:
Sanna Annukka

Client:
KEANE

Description:
A series of CD
artwork for KEANE.

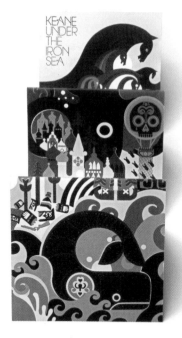

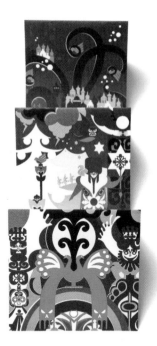

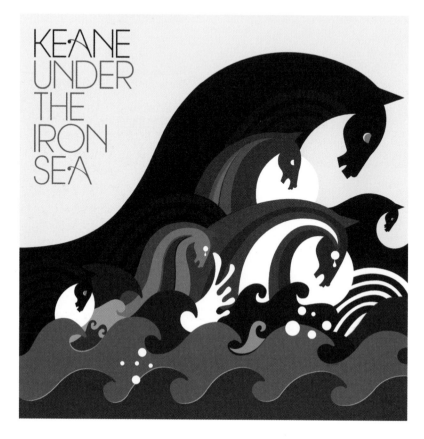

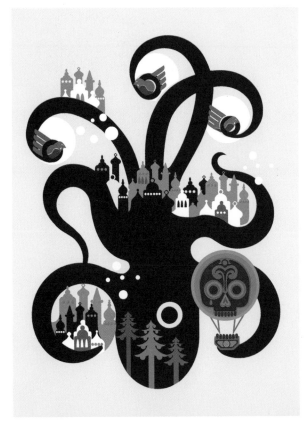

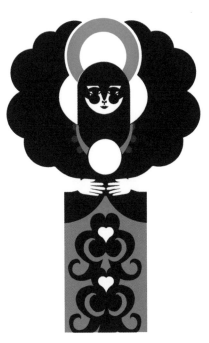

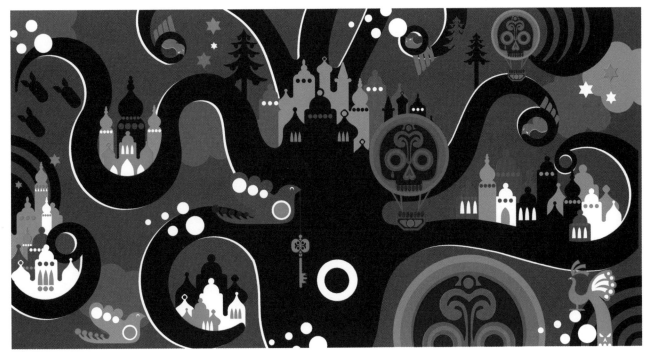

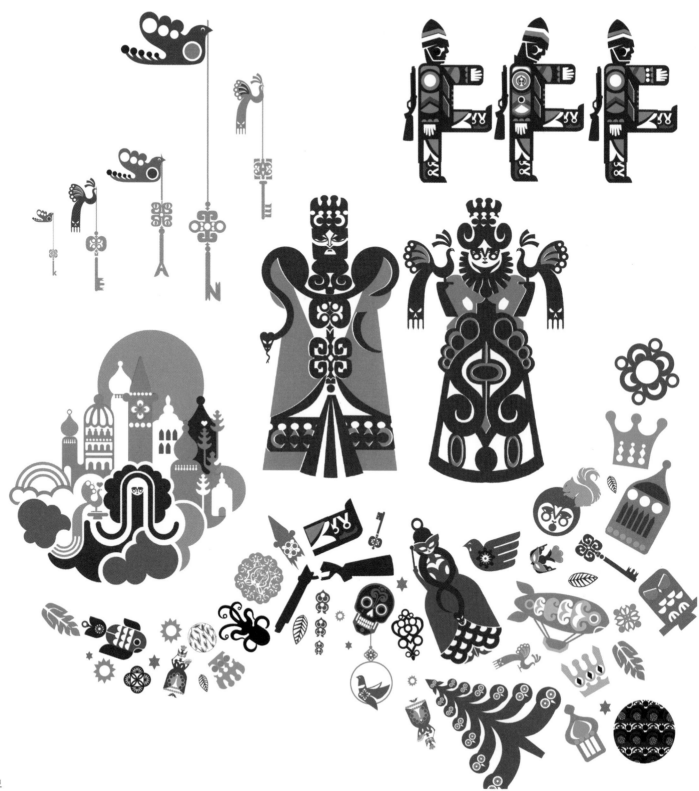

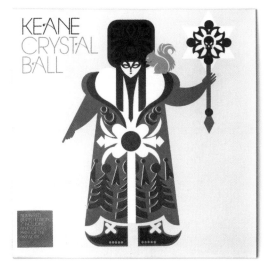

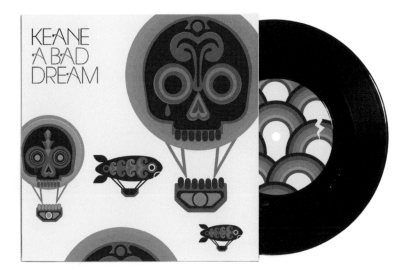

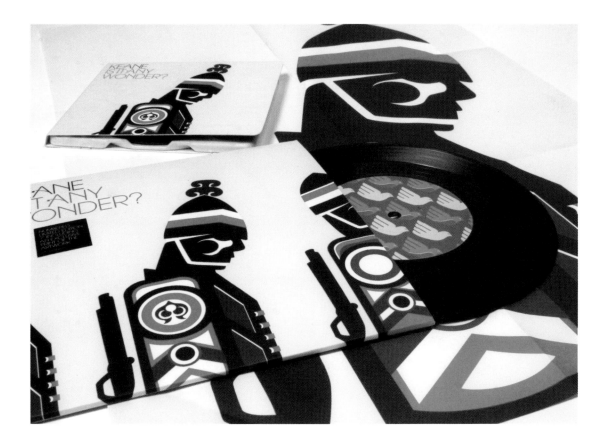

Title:
Une Affaire Demode
Et de Musique

Type of Work:
CD packaging

Year:
2007

Contributed by:
C100 Studio

Art Direction:
C100 Studio

Design:
C100 Studio

Client:
Feraud/Compost
Records, Krauts PR

Musician(s):
Marsmobil

Description:
French fashion
label Feraud col-
laborated with
German Pop band
Marsmobil for their
2007 tour. There-
fore a limited
edition of CDs in
special packaging
(Feraud produced a
special pink pin-
striped cloth) was
produced for the CD
case and the DJ
bag.

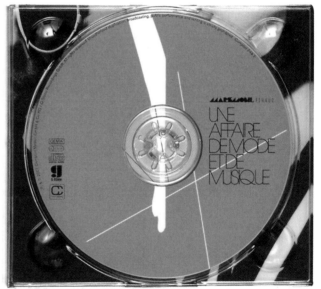

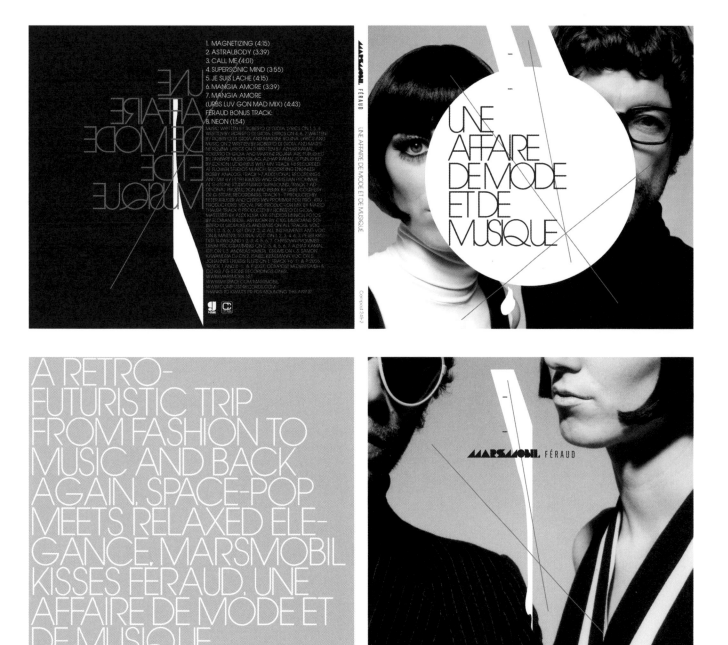

1. MAGNETIZING (4:15)
2. ASTRALBODY (3:39)
3. CALL ME (4:01)
4. SUPERSÖNIC MIND (3:55)
5. JE SUIS LACHE (4:15)
6. MANGIA AMORE (3:39)
7. MANGIA AMORE
(URBS LUV GON MAD MIX) (4:43)
FÉRAUD BONUS TRACK:
8. NEON (1:54)

UNE
AFFAIRE
DE MODE
ET DE
MUSIQUE

A RETRO-
FUTURISTIC TRIP
FROM FASHION TO
MUSIC AND BACK
AGAIN. SPACE-POP
MEETS RELAXED ELE-
GANCE. MARSMOBIL
KISSES FÉRAUD. UNE
AFFAIRE DE MODE ET
DE MUSIQUE.

UNE
AFFAIRE
DE MODE
ET DE
MUSIQUE

MARSMOBIL FÉRAUD

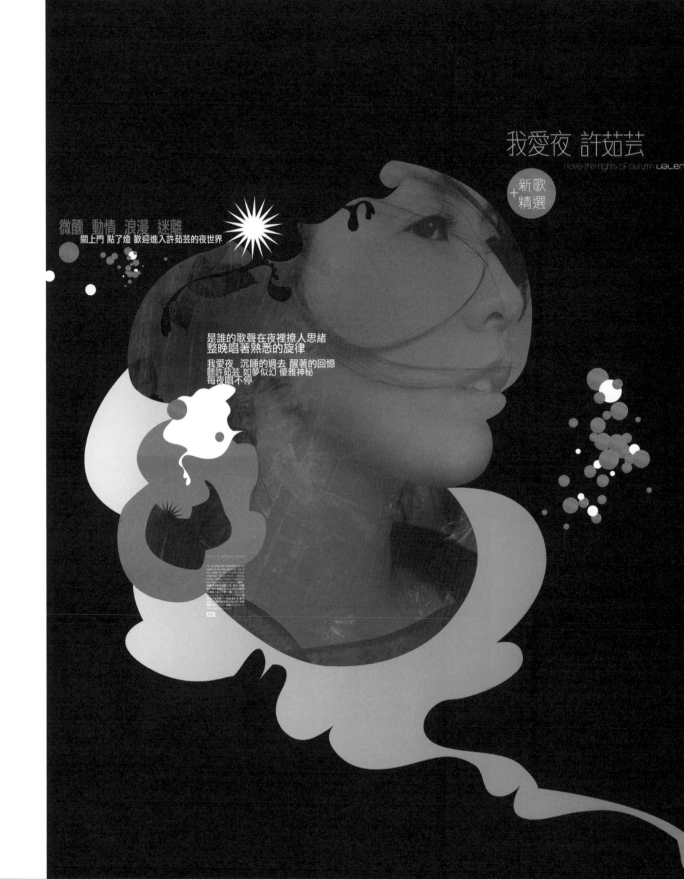

我愛夜 許茹芸

i love the nights of autumn ualen

新歌 + 精選

微醺 動情 浪漫 迷離

關上門 點了燈 歡迎進入許茹芸的夜世界

是誰的歌聲在夜裡撩人思緒
整晚唱著熟悉的旋律

我愛夜 沉睡的過去 醒著的回憶
聽許茹芸 如夢似幻 優雅神秘
每夜唱不停

Title:
我愛夜 許茹芸 新歌+精選
(Next Spread)
Type of Work:
CD cover,
CD booklet, Poster
Year:
2003
Contributed by:
R-one
Art Direction:
R-one
Design:
R-one
Client:
EMI (TAIWAN) Ltd.
Musician(s):
Valen Hsu (許茹芸)
Description:
This album boasts
lounge music with a
romantic feel.

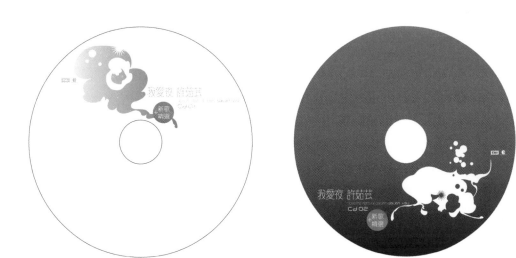

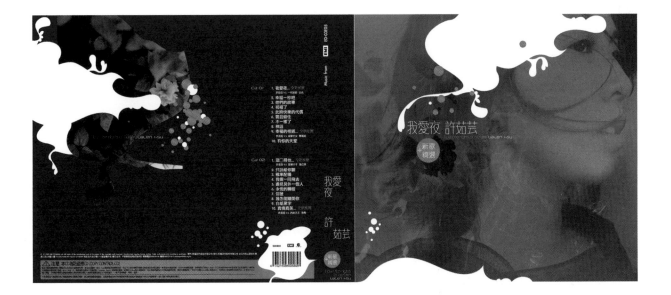

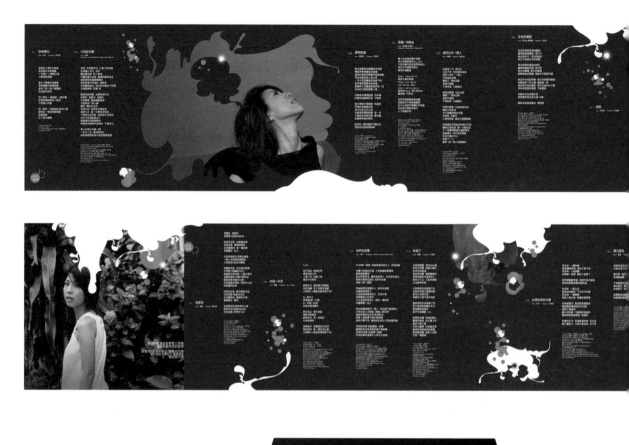

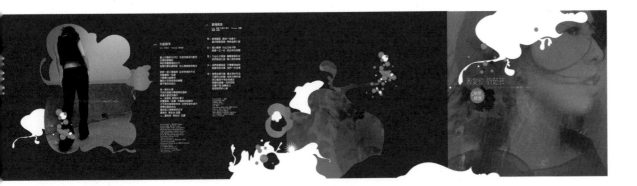

Title:
Rolled Gold Plus

Type of Work:
Typography

Year:
2007

Contributed by:
Alex Trochut

Art Direction:
Zip Design
(David Bowden,
James White)

Design:
Alex Trochut

Client:
Universal Records

Musician(s):
The Rolling Stones

Description:
Lettering based on
a golden ribbon for
The Rolling Stones'
compilation album
'Rolled Gold Plus.'

Dumbfound
BargainRed

Quagmire
Wruck
Be Still
Space key
Go Limp

Dumbfound

Title:
Bargain Red and
Result Blue

Type of Work:
CD cover

Year:
2005

Contributed by:
Madebymade

Art Direction:
Robin Snasen
Rengård

Design:
Robin Snasen
Rengård

Client:
Middelmodig

Musician(s):
Dumbfound

Description:
Design for rock
group from Oslo,
Norway. The 2 EPs
are from the same
recording session.

Title:
Plano B, B Plan

Type of Work:
CD cover

Year:
2005

Contributed by:
chemega

Art Direction:
Ricardo Chemega

Design:
Ricardo Chemega

Client:
Matarroa

Musician(s):
Factos Reais

Description:
In a war environment Plan B is traced with minutiae.

Title:
Viagem Verbal,
Verbal Travel

Type of Work:
CD cover

Year:
2005

Contributed by:
chemega

Art Direction:
Ricardo Chemega

Design:
Ricardo Chemega

Client:
Matarroa

Musician(s):
Verbal

Description:
To pack its own
verbal trip in an
airplane ticket.

Title:
Souvenirs

Type of Work:
CD cover,
CD digipack

Year:
2004

Contributed by:
desres design group

Art Direction:
Michaela Kessler

Design:
Michaela Kessler,
Dirk Schrod

Client:
Ian Pooley

Musician(s):
Ian Pooley

Description:
Artworks for slip
case, CD plus 2
12-inch releases.
Ian featuring Terry
Callier, Marcos
Valle, Rosanna,
Zeila and many
more.

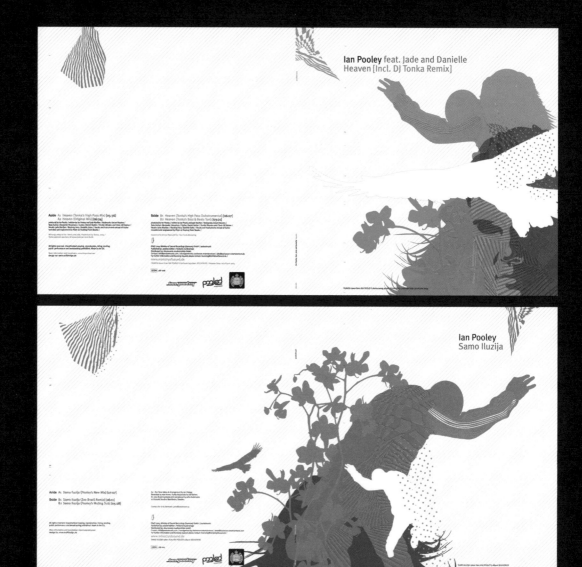

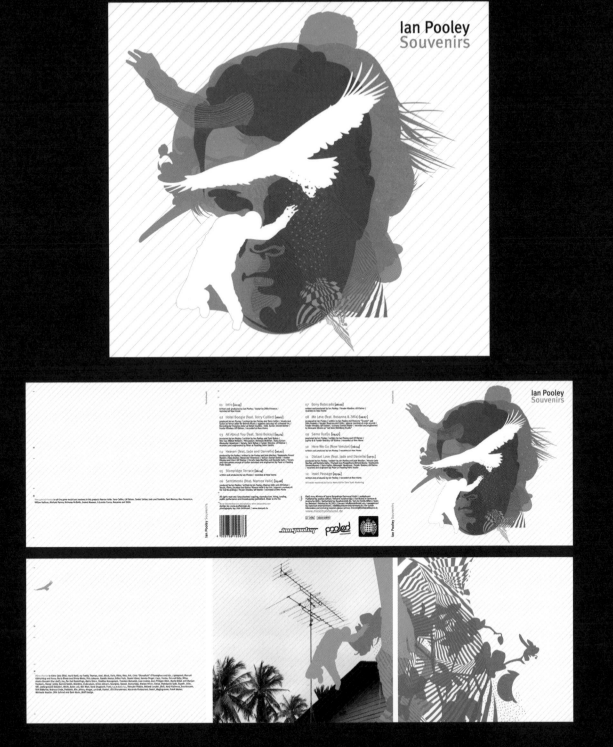

Title:
The Fantômas-
Melvins Big Band

Type of Work:
Concert poster

Year:
2006

Contributed by:
Bongoût

Art Direction:
Meeloo Gfeller,
Anna Hellsgard

Design:
Meeloo Gfeller,
Anna Hellsgard

Client:
Melvins Fantômas
tour manager

Musician(s):
The Fantômas-
Melvins Big Band

Description:
3-coloured hand-
printed limited
edition silkscreen
on 300gr paper.
The visual part is
inspired by 60s
French noir film
aesthetic and the
font work was an
interpretation
of some unknown
Russian font
artists' work.

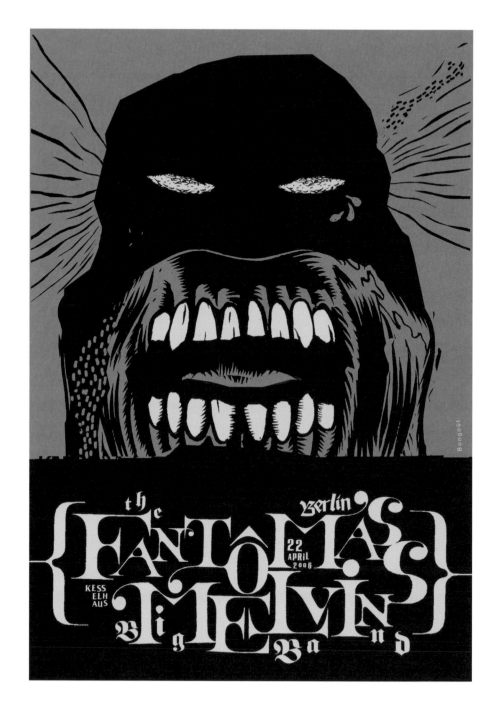

Title:
Billy Childish

Type of Work:
Concert poster

Year:
2006

Contributed by:
Bongoût

Art Direction:
Meeloo Gfeller,
Anna Hellsgard

Design:
Meeloo Gfeller,
Anna Hellsgard

Client:
Festsaal Kreuzberg

Musician(s):
Billy Childich

Description:
Hand-printed
silkscreen limited
edition poster, 2
colours on 300gr
paper, for British
garage punk legend
Billy Childish.
The visual was
influenced by
Majakowski's
Russian Rosta-
Fenster graphics
in the 20s.

Title:
Music for Invisible
People

Type of Work:
Digital work

Year:
2007

Contributed by:
Deesk
(Xavier Brunet)

Art Direction:
Deesk

Design:
Deesk

Photography:
Violaine, Laurent
Girard, Deesk

Client:
Autres Directions
in Music

Musician(s):
Melodium

Description:
This artwork is
built like a polar
movie with a crime
scene and clues in
the CD. Some clues
have disappeared
like if a killer
wanted to clear
evidence.

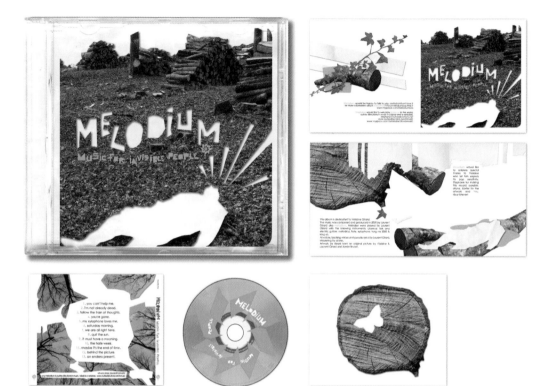

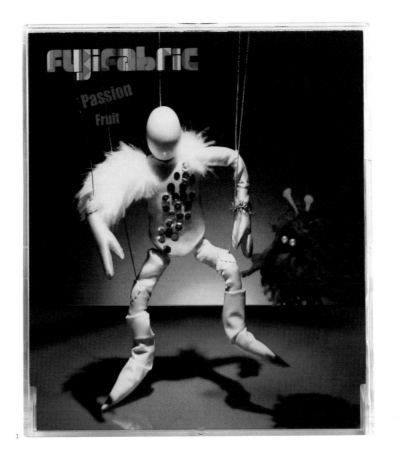

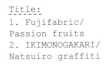

Title:
1. Fujifabric/
Passion fruits
2. IKIMONOGAKARI/
Natsuiro graffiti

Type of Work:
CD jacket, Props

Year:
2007

Contributed by:
Giottographica

Art Direction:
Yoshihiro Inoue,
Yukinko

Design:
Yoshihiro Inoue,
Yukinko

Client:
1. Capitol Music
Co., EMI Music
Japan
2. Epic Records
Japan

Musician(s):
1. Fujifabric
2. IKIMONOGAKARI

Description:
1. To the fantasy
of a man who became
it after eating
passion fruits.
2. This is the
highest in the hot
summer. It is eaten
from anywhere.

1

2

Title:
Music Affects our
Environment

Type of Work:
Illustration

Year:
2007

Contributed by:
Khaki Creative
& Design

Art Direction:
Nod Young

Design:
Nod Young

Description:
Illustration for
the book 'Creative.'

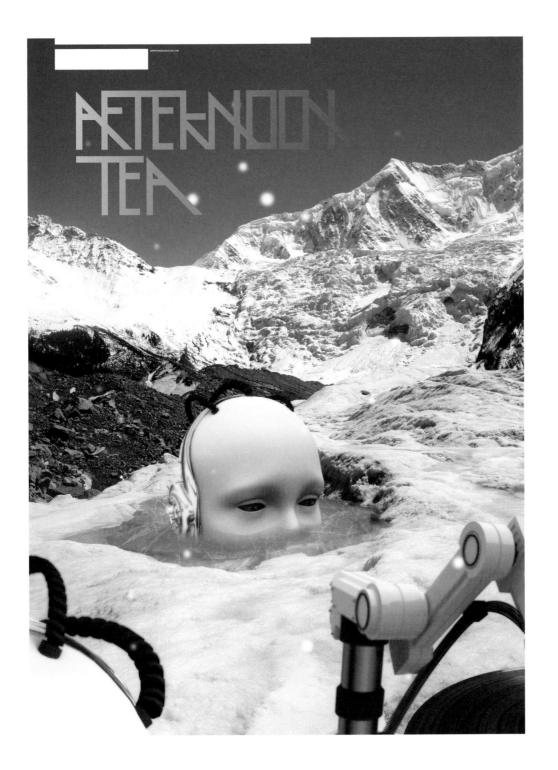

Title:
Afternoon Tea

Type of Work:
Poster

Year:
2007

Contributed by:
Khaki Creative &
Design

Art Direction:
Nod Young

Design:
Nod Young

Description:
Young created this
piece at the begin-
ning of the day,
and listened to
music while doing
so. The feeling
is very comfort-
able when you dip
in the music, as to
drink a cup of hot
tea in the winter
sunshine. During
that period of time
Young very much
liked electronic
music.

Title:
1. Wild Flowers
2. Golden Tears

Type of Work:
CD sleeve

Year:
1. 2007
2. 2005

Contributed by:
UFG (Unidentified
Flying Graphics)
Inc.

Art Direction:
Keiji Ito

Design:
1. Takamitsu Hatta
2. Takamitsu
Hatta, Shinobu
Fukuda(hugh)

Client:
1. BMG Japan
2. Warner Music
Japan Inc.

Musician(s):
1. Orange Pekoe
2. Bonnie Pink

Description:
Collages by digital
and analog.

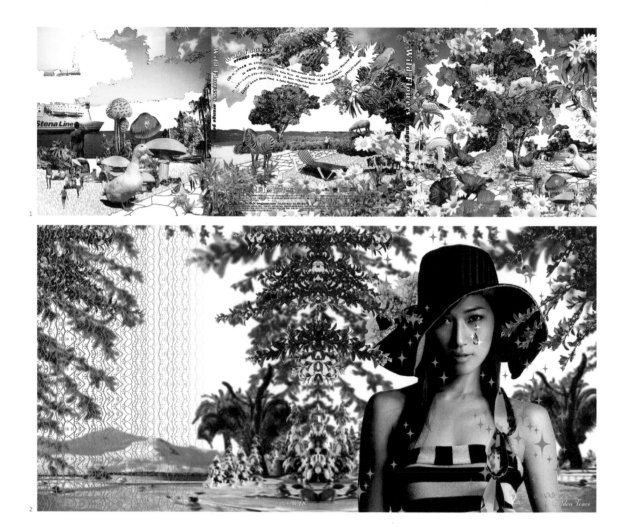

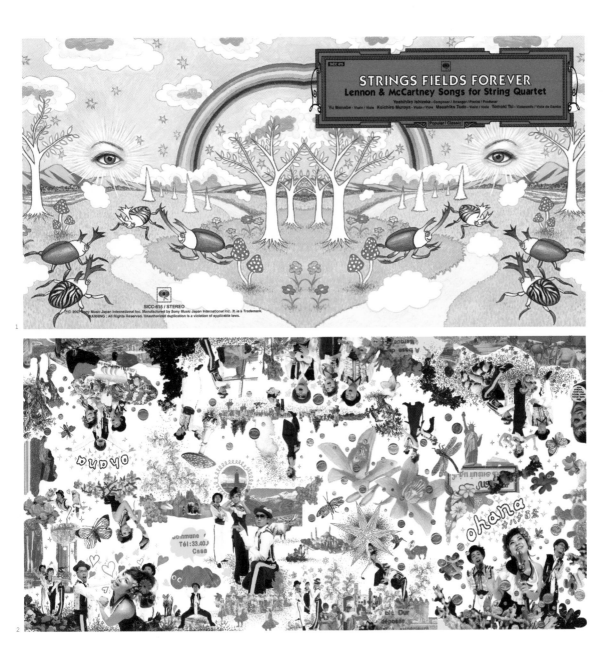

Title:
1. Strings Fields
Forever
2. Ohana Hyakkei

Type of Work:
CD sleeve

Year:
1. 2007
2. 2006

Contributed by:
UFG (Unidentified
Flying Graphics)
Inc.

Art Direction:
Keiji Ito

Design:
Takamitsu Hatta

Client:
1. Sony Music Japan
2. Columbia Music
Entertainment, Inc.

Musician(s):
1. The Long and
Winding Road /
Lennon & McCartney
Songs for String
Quartet
2. Ohana

Description:
2. Analog collage,
drawing and paint-
ing which weren't
digitally enhanced.

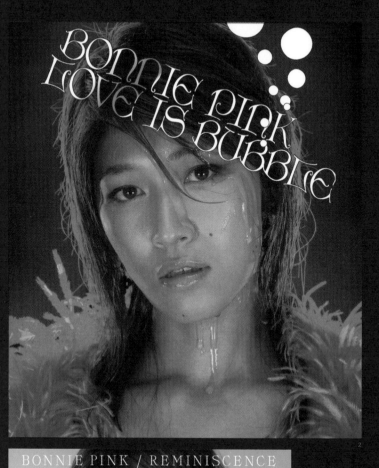

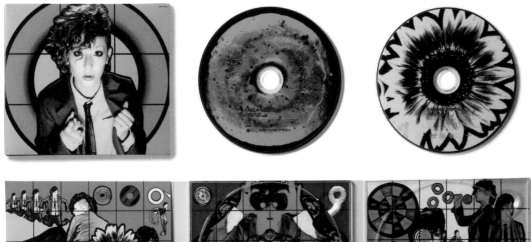

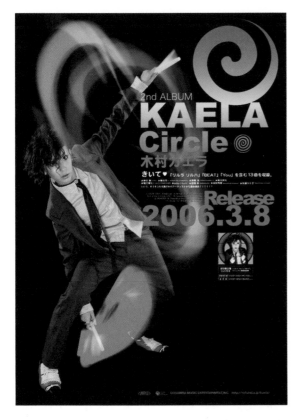

Title:
Circle

Type of Work:
CD jacket

Year:
2006

Contributed by:
Giottographica

Art Direction:
Yoshihiro Inoue,
Yukinko

Design:
Yoshihiro Inoue,
Yukinko

Client:
Columbia Music
Entertainment, Inc.

Musician(s):
Kaela Kimura

Description:
Full album of the
second work for
Kaela Kimura.
'Circle' was the
title and the motif
was composed of
the item of various
circles.

Title:
MQN - Fuck CD
Sessions

Type of Work:
Vinyl cover

Year:
2006

Contributed by:
Nitrocorpz

Art Direction:
Nitrocorpz

Design:
Claudio Cologni,
Marck Al

Client:
MQN

Musician(s):
MQN

Description:
Record sleeve
illustration for
the band MQN.
Nitrocorpz also
did the complete
art direction for
web and collateral
materials.

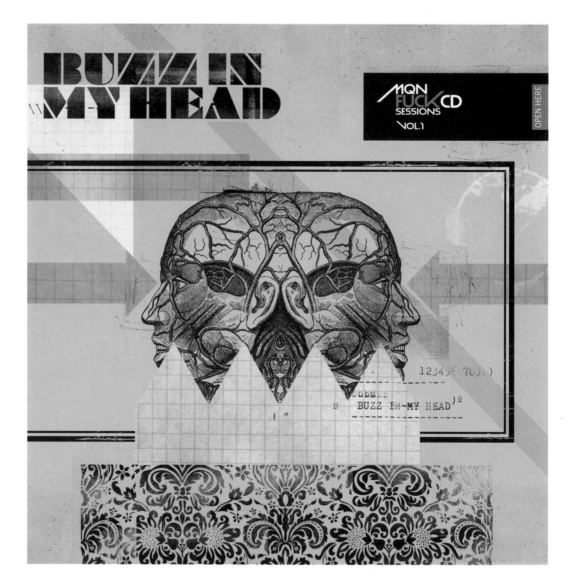

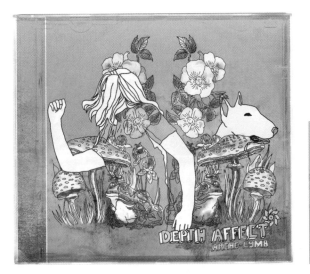

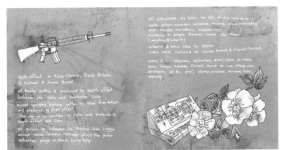

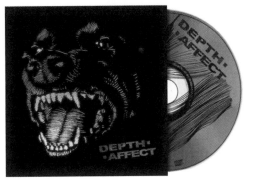

Title:
1. Depth Affect
Arche - Lymb Art-
work
2. Rot

Type of Work:
1. Drawing
2. Digital drawing

Year:
1. 2006
2. 2007

Contributed by:
Deesk (Xavier
Brunet)

Art Direction:
1. Deesk, David
Bideau
2. Deesk

Design:
1. Deesk, David
Bideau
2. Deesk

Client:
1. Autres
Directions in Music
2. Depth Affect

Musician(s):
Depth Affect

Description:
1. The drawings
were inspired by
old books for kids.
Deesk wanted a
strange and cute
world in the first
view, but this cute
world subsequently
became dark with
preoccupations of
adults.
2. Deesk was
inspired by
Scratchcard that
he made when he
was young, and he
wanted to mix this
with an aggres-
sive picture like
a dangerous dog.
The Music of Depth
Affect is sometimes
sweet and sometimes
dark and violent.

Title:
&

Type of Work:
CD jacket, Poster

Year:
2005

Contributed by:
Enlightenment

Art Direction:
Enlightenment

Design:
Enlightenment

Client:
Columbia Music
Entertainment

Musician(s):
Yo Hitoto

Description:
Enlightenment
expressed an image
of the wonderland
where an artist
stood by a collage.

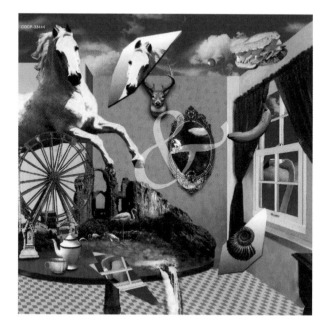

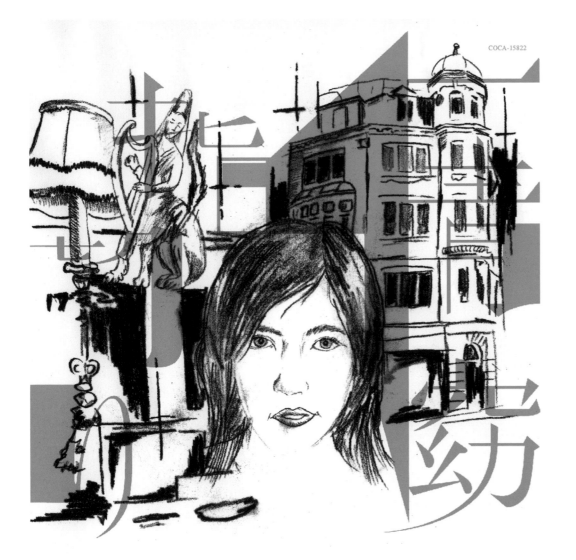

COCA-15822

Title:
Yubikiri

Type of Work:
CD jacket

Year:
2005

Contributed by:
Enlightenment

Art Direction:
Enlightenment

Design:
Enlightenment

Client:
Columbia Music
Entertainment

Musician(s):
Yo Hitoto

Description:
Enlightenment
expressed the view
of the world of the
song by drawing.

Title:
You

Type of Work:
CD jacket

Year:
2006

Contributed by:
Giottographica

Art Direction:
Yoshihiro Inoue,
yukinko

Design:
Yoshihiro Inoue,
yukinko

Client:
Columbia Music
Entertainment

Musician(s):
Kaela Kimura

Description:
Diversity and the
importance of the
popular word 'YOU'
were comically
expressed. The head
accessory featuring
the word 'YOU' was
used as a motif,
which Kimura wore
in various ways.
This brought her
playfulness to the
fore.

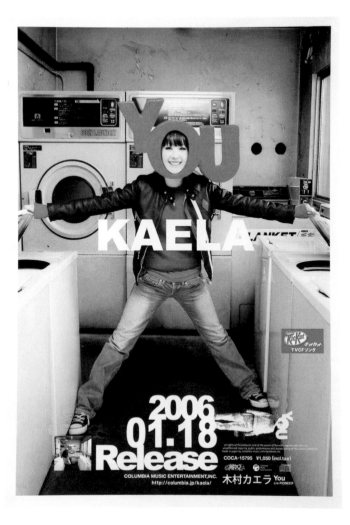

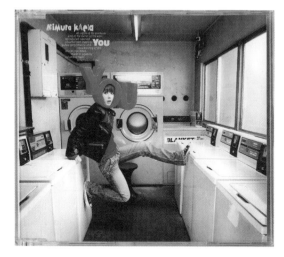

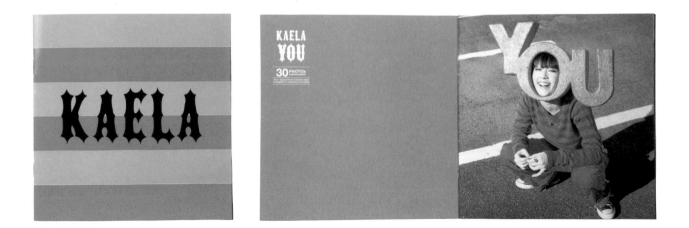

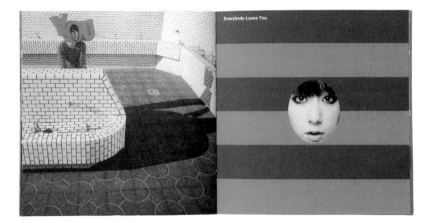

Title:
1. Fuji Rock
Festival 04 Gorilla
T-shirts
2. Hottottottona
Mainichi

Type of Work:
1. Logo
2. CD jacket

Year:
1. 2004
2. 2007

Contributed by:
cucumber

Art Direction:
Miki Rezai

Design:
Miki Rezai

Photograph:
2. Masato
Yoshikawa(SPUTNIK)

Client:
1. Fuji Rock
Festival 04
2. Victor
Entertainment, Inc.

Musician(s):
1. Various
2. Kigurumichiko

Description:
Collage by digital
and analog.

1

2

Title:
ON, ON - limited
edition

Type of Work:
CD sleeve

Year:
2006

Contributed by:
Tycoon Graphics

Art Direction:
Tycoon Graphics

Design:
Tycoon Graphics

Client:
Sony Music Records
Inc.

Musician(s):
Boom Boom Satel-
lites

Description:
CD artwork for Boom
Boom Satellites.

Mr.Children
HOME
TOUR 2007

Mr.Children LIVE DVD
2007.11.14 RELEASE

[DISC 1] 01. OPENING 02. 彩り 03. and I love you 04. youthful days 05. 箒星 06. Another Story 07. もっと 08. いつでも微笑みを
 09. PIANO MAN 10. ランニングハイ 11. imagine 12. CENTER OF UNIVERSE 13. Dance Dance Dance 14. シェイク 15. Any

[DISC 2] 16. to U 17. タガタメ 18. ポケット カスタネット 19. Worlds end 20. 終わりなき旅 21. しるし
 22. あんまり覚えてないや 23. overture ～ 蘇生 24. 彩り

DVD 1枚組 / 158 min. / DISC 1・DISC 2 / 片面2層 / MPEG-2 / COLOR / STEREO / リニアPCM / 5.1ch対応 / 複製不可 / 16:9 LB / NTSC 2

初回限定生産：SPECIALパッケージ（ジグソーパズル）仕様 New Single
TFBQ-18077 ¥5,800 (TAX INCLUDE) 旅立ちの唄 TFCC-89291
 2007.10.31 RELEASE ¥1,050(TAX include)
performed by Mr.Children 全国東宝系ロードショー 映画「星空」主題歌
all tracks written by Kazutoshi Sakurai
produced by Takeshi Kobayashi & Mr.Children including
 track 01. 旅立ちの唄
http://www.mrchildren.jp track 02. 風、水と太
 track 03. いつでも微笑みを from HOME TOUR 2007.06.16 NAGOYA

TOY'S FACTORY DVD http://www.toysfactory.co.jp

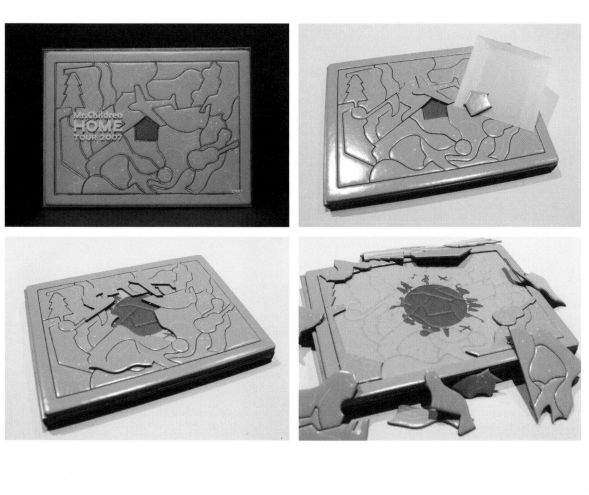

Title:
Mr. Children
HOME TOUR 2007

Type of Work:
DVD jacket

Year:
2007

Contributed by:
Yellow Brain
Co., LTD

Art Direction:
Kouki Tange

Design:
Yuhei Urakami

Client:
TOY'S FACTORY

Musician(s):
Mr. Children

Description:
One of the high-
lights of this
DVD package is
its jigsaw puz-
zle design. The
puzzle has pieces
that lie side-by-
side. It cannot
be completed if
any piece is lost.
This is similar to
what is happening
around the world.
All things, good
and bad, are con-
nected and linked
like this puzzle.
This work zooms in
on this fact, and
the design was the
result. The miss-
ing piece can also
symbolize people
who have lost their
way. Everyone is
looking for that
missing piece on
their own, so Yel-
low Brain Co., LTD
dared to make an
unfinished puzzle.

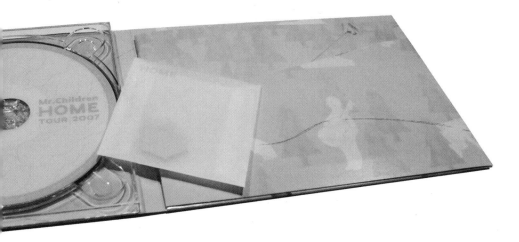

Title:
I ♥ U

Type of Work:
CD jacket

Year:
2005

Contributed by:
Yellow Brain
Co., LTD

Art Direction:
Kouki Tange

Design:
Yuhei Urakami

Client:
TOY'S FACTORY

Musician(s):
Mr. Children

Description:
This piece started with the idea that a heart-shaped tomato is crushed and is left bleeding. These images on paper give the cliché of 'I love you' new and cute connotations. A half heart coming out at the side of the picture means that love does exist, even if the whole of it is invisible.

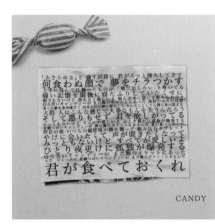

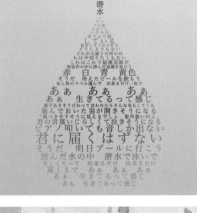

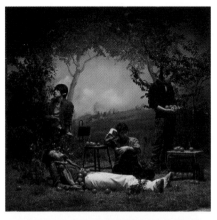

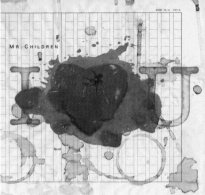

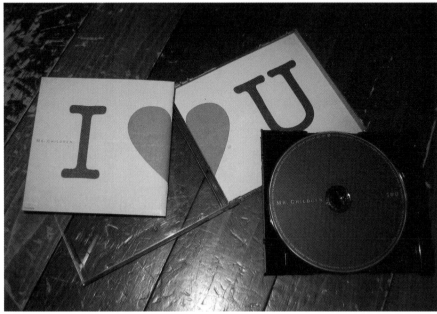

Title:
My Book Laughs

Type of Work:
CD single cover

Year:
2007

Contributed by:
Oscar & Ewan

Art Direction:
Ewan Robertson

Design:
Ewan Robertson

Client:
One Records

Musician(s):
The Xcerts

Description:
Each song on the single has a side of the cover with an image which represents its title. For the A side, My Book Laughs, Robertson made a jovial and literal photographic translation. For the B side, Weather Warning, a more serious image using a predicted sea level rise graph. Although the images use different mediums and have different undertones, he used the same colour palette and graphic language so they would appear quite similar.

THE XCERTS
1. My Book Laughs
2. Weather Warning
OR021

Title:
1. Picture Perfect
2. 卒業、そして未来へ。
3. Change

Type of Work:
CD jacket

Year:
2007

Contributed by:
Yellow Brain
Co., LTD

Art Direction:
Kouki Tange

Design:
Yuhei Urakami

Client:
Avex Entertainment
Inc.

Musician(s):
1. Monkey Majik,
m-flo
2. Monkey Majik,
SEAMO
3. Monkey Majik,
吉田兄弟

Description:
Yellow Brain knew
this project would
be a trilogy when
they first heard of
it. They thought
that for Monkey
Majik and the other
artists, collabo-
ration would act
as a good medi-
cine. So they came
up with the idea
of coloured medi-
cine capsules and
the doctor uniform.
They used 2 other
colours besides
white. In the last
of the trilogy,
the theme colour
matches the first
one.

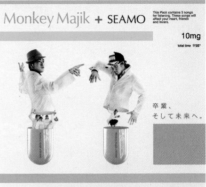

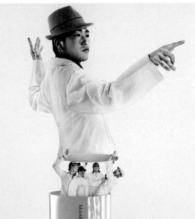

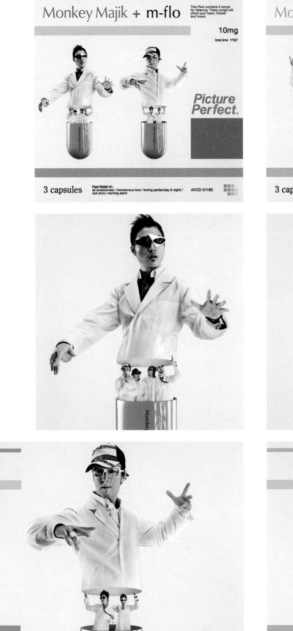

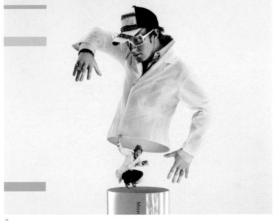

1

2

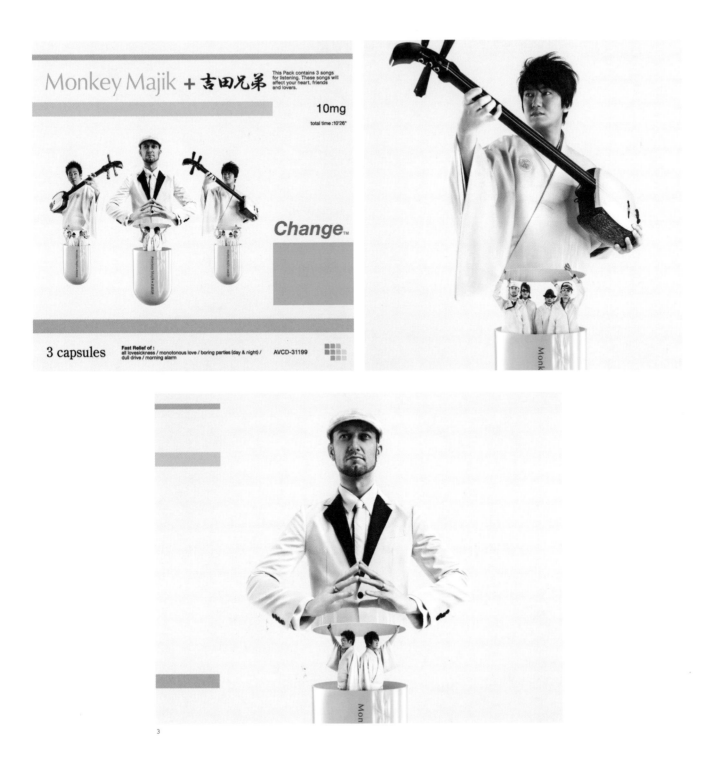

Title:
パレード

Type of Work:
CD jacket

Year:
2007

Contributed by:
Yellow Brain
Co., LTD

Art Direction:
Kouki Tange

Design:
Yuhei Urakami

Client:
Epic Records Japan
Inc.

Musician(s):
THE CONDORS

Description:
Sushi Cat - Yellow Brain matched the song title 'Parade' to traditional Japanese parade and somehow thought, 'Sushi.' The sushi is lined up with the intent to represent each band member's character. Cats love to eat fishes, therefore in an attempt at black humour and giving a lesson, the studio thought it would be best to transform the cats into sushi.
©2007 Epic Records Japan Inc.

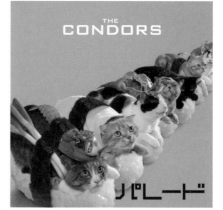

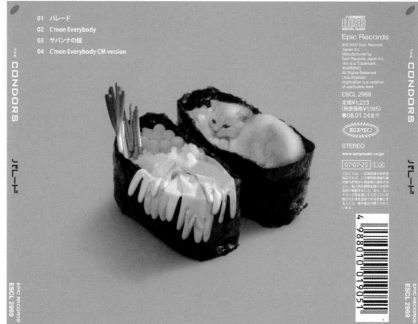

to U/
Bank Band

Bank Band to U

1. to U / Bank Band with Salyu 2. 全ての終わる始めために / Bank Band 3. to U (Piano Version) / Bank Band

http://www.apbank.jp

Bank Band

Bank Band

Bank Band NEW SINGLE / to U
2006.07.19 Release!

ap bank eco-reso

Title:
to U

Type of Work:
CD jacket

Year:
2006

Contributed by:
Yellow Brain
Co., LTD

Art Direction:
Kouki Tange

Design:
Yuhei Urakami

Client:
TOY'S FACTORY

Musician(s):
Bank Band with
Salyu

Description:
Ecology - Bank band
was started as a way
to finance people
who work for the
ecological move-
ment. Yellow Brain
came to think, "Why
should CDs always
be kept fresh by
plastic cases like
food with preser-
vatives?" There-
fore, in the intent
to promote addi-
tives-free natu-
ral products, this
jacket is made from
recycled trees
and comes with no
plastic cases. They
also put a note on
the opposite side
of the jacket,
'Touch this product
a lot. You might
damage it, but you
could enjoy natural
transformation.'

Title:
無条件幸福

Type of Work:
CD jacket

Year:
2007

Contributed by:
Yellow Brain
Co., LTD

Art Direction:
Kouki Tange

Design:
Yuhei Urakami

Client:
Epic Records Japan
Inc.

Musician(s):
THE CONDORS

Description:
降伏(kouhuku)and
幸福(kouhuku) - in
Japanese, the word
'Kouhuku' is syn-
onymous with 'hap-
piness' and 'sur-
render.' Yellow
Brain realized that
a popular phrase in
Japanese, 'Mujouken
Kouhuku,' is armed
with double mean-
ing. One is 'uncon-
ditional surren-
der.' And the other
one is 'uncondi-
tional happiness.'
Under 'uncondi-
tional happiness,'
you feel completely
satisfied, even if
you are threatened
by danger. The stu-
dio portrayed that
kind of moment with
the mother's breast
and scary tattoos.
©2007 Epic Records
Japan Inc.

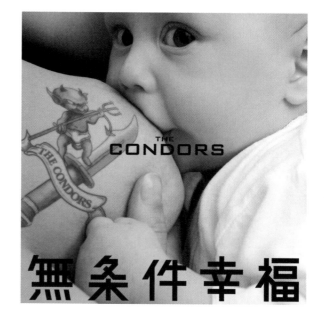

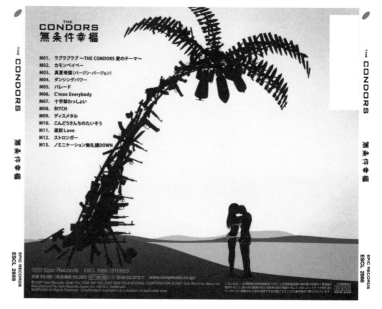

THE CONDORS

THE CONDORS

1ST ALBUM

無条件幸福

2007.8.8 RELEASE!!

ESCL-2988　　¥3,150 (tax in)

www.thecondors.jp

THE CONDORS 無条件幸福 TOUR 2007

2007年11月10日(土)　大阪Shangri-La　OPEN 18:30 / START 19:00　【問】サウンドクリエーター　TEL:06-6357-4400
プレイガイド　【チケットぴあ】（Pコード:265-957）TEL:0570-02-9999　【ローソンチケット】（Lコード:58520）TEL:0570-084-005　【e+】http://eplus.co.jp

2007年11月15日(木)　仙台JUNK BOX　OPEN 19:00 / START 19:30　【問】ノースロードミュージック　TEL:022-256-1000
プレイガイド　【チケットぴあ】（Pコード:266-054）TEL:0570-02-9999　【ローソンチケット】（Lコード:22494）TEL:0570-084-002　【e+】http://eplus.co.jp

2007年11月29日(木)　東京キネマ倶楽部　OPEN 18:30 / START 19:30　【問】HOT STUFF　TEL:03-5720-9999
プレイガイド　【チケットぴあ】（Pコード:266-352）TEL:0570-02-9999　【ローソンチケット】（Lコード:35337）TEL:0570-084-003　【e+】http://eplus.co.jp

チケット一般発売日　2007年9月30日(日)

Title:
Baby

Type of Work:
Electronic
promotion,
Silkscreen poster

Year:
2007

Contributed by:
Lucha Design

Art Direction:
Lucha Design

Design:
Lucha Design

Client:
Baby

Musician(s):
Doorknobs, JohnDC

Description:
'Baby' is a monthly
party series.
'Minimal, elec-
tronic, but with
beautiful melodies.
And sweet.' — that
was the brief from
Lucha Design's cli-
ent. Their solution
was to visually
express an mish-
mash of bits and
candies!

BABY OH ONE

with DJs: Doorknobs, JohnDC
Tuesday June 12th, 7PM GalleryBar, 120 Orchard St

Title:
Domino T-shirt
Club, Membership
Pack

Type of Work:
Graphic design,
Packaging

Year:
2007

Contributed by:
Airside

Art Direction:
Airside

Design:
Airside

Client:
Domino Records

Description:
Airside worked with
Domino Records to
run the Domino T-
shirt club - simi-
lar to Airside's
own T-shirt club.
You pay a subscrip-
tion fee to receive
4 T-shirts over 4
months, but you
don't know what
the designs on the
shirts are until
you receive them.
The Domino T-shirt
club T-shirts are
designed by 4 bands
represented by
the record label.
So when it came
to designing the
membership pack,
it made complete
sense to continue
the music theme by
sending the members
a real random 7"
vinyl.

Title:
1. Bionic Birthday Session
2. 12 Years of Freebase

Type of Work:
Poster design

Year:
1. 2006
2. 2007

Contributed by:
Bionic Systems

Design:
Doris Fürst, Malte Haust

Client:
1. Bionic Sessions Crew
2. Freebase Records

Musician(s):
1. DJ Real, Phone-heads, etc.
2. Guillaume & the Coutu Dumonts, Baby Ford, etc.

Description:
1. Poster design for the birthday party of the German Drum'n'Bass crew 'Bionic Session.'
2. Poster design for the anniversary night of Freebase Records.

Title:
Freebase Party

Type of Work:
Poster design

Year:
2007

Contributed by:
Bionic Systems

Design:
Doris Fürst,
Malte Haust

Client:
Freebase Records

Musician(s):
Shinedoe, Dan
Curtin, Einzelkind,
etc.

Description:
Poster design
for the Freebase
Records party at
the Robert Johnson
club.

Title:
Surfer King

Type of Work:
CD jacket

Year:
2007

Contributed by:
Giottographica

Art Direction:
Yoshihiro Inoue,
Yukinko

Design:
Yoshihiro Inoue,
Yukinko

Client:
Capitol Music Co. /
EMI MUSIC JAPAN

Musician(s):
Fujifabric

Description:
Single CD of the
work of Fujifabric.
This work is about
a guy who has not
surfed yet wants to
be popular among
the girls.

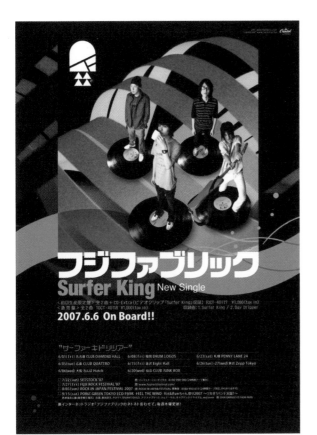

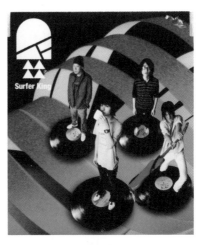

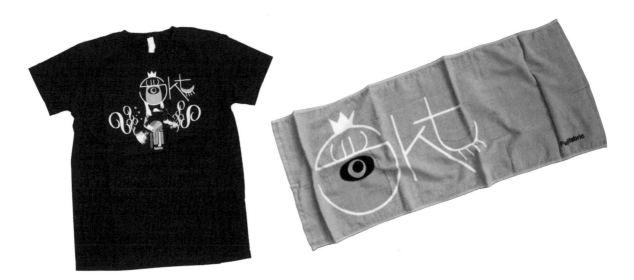

Title:
Double D Force

Type of Work:
CD pack

Year:
2006

Contributed by:
KarpaTM

Art Direction:
David Carvalho

Design:
David Carvalho

Client:
Loop Recordings

Musician(s):
Double D Force

Description:
Double D Force is
an Electro Funk DJ
duo. The concept of
this project was
the reflection of
the duo, who wanted
to remain anonymous
yet also wanted to
be portrayed as 2
persons.

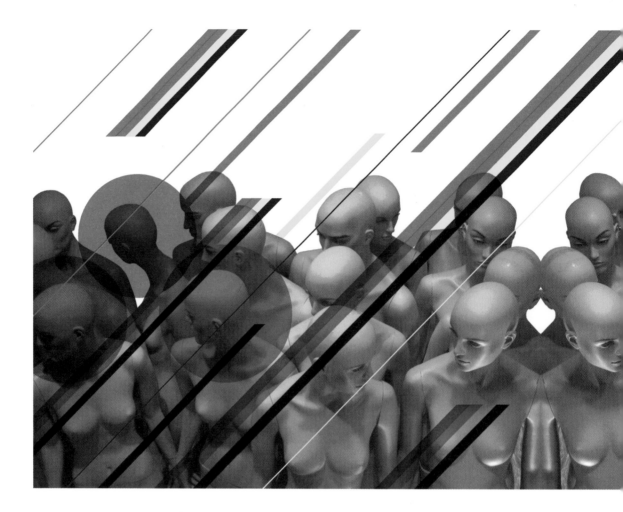

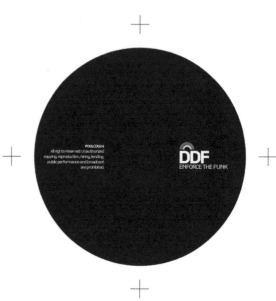

DDF
ENFORCE THE FUNK

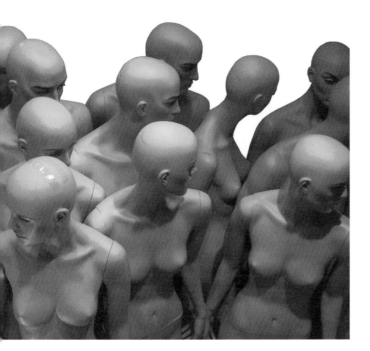

DDF
DOUBLE D FORCE ARE:
D_FINE (VOCALS, SYNTHS)
D-MARS (MPC 2000, SYNTHS, VOCALS)

01.ENFORCE THE FUNK
02.LET YOURSELF GO
03.FEEL IT
04.ELECTRIC THOUGHTS (REENFORCED VERSION)
05.IT'S LIKE A JUNGLE SOMETIMES
06.DOUBLE D ROCK
07.COME BACK
08.TETRIS
09.B BOY LOVE
10.BOOGIE TILL YOU DIE
11.EARGAZM

PLAYLIST

LOOP RECORDINGS™

ARRANGE & PRODUCTION
DOUBLE D FORCE

RECORDING & MIX
D-MARS AT LOOP STUDIOS,
WINTER 2004 – SPRING 2006

MASTERING
JOAO LOPES

GUITAR LIKS
T ONE

EXECUTIVE PRODUCTION
LOOPDIGGAZ

PHOTOGRAPHY
ALEJANDRO GUERRA
KADRI POLDMA

ART DIRECTION & DESIGN
DC/ELECTROCLANDESTINO
WWW.ELECTROCLANDESTINO.COM

CREDITS

loopglobal, produções multimedia, lda 2006

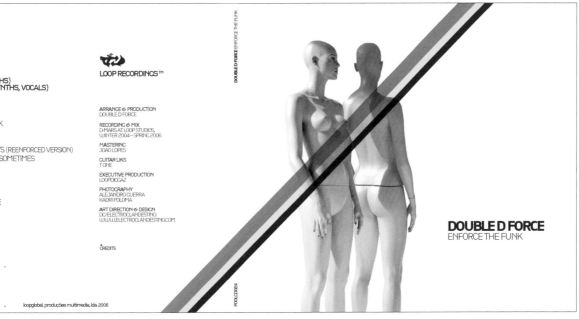

DOUBLE D FORCE
ENFORCE THE FUNK

DOUBLE D FORCE ENFORCE THE FUNK

POOLD0024

Title:
Magnetic North

Type of Work:
CD cover

Year:
2006

Contributed by:
Studio8 Design

Design:
Matt Willey,
Zoë Bather

Photography:
Giles Revell

Client:
Wall of Sound
Records

Musician(s):
Iain Archer

Description:
In 2006, Ivor
Novello award-
winning song-
writer Iain Archer
released his second
album, Magnetic
North, on Wall of
Sound. Studio8
Design designed and
art directed cov-
ers for the album
and a number of
associated single
releases.

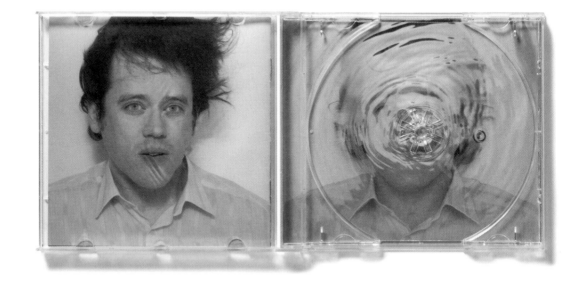

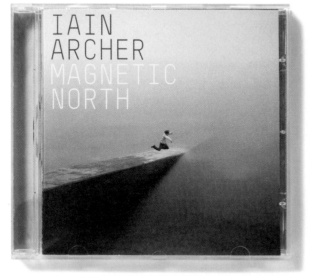

Canal Song (End Of Sentence)

I saw it leave your face ∘ It's the only thing that I need ∘ It's the only thing that I need so take it ∘ I caught you and your canvas eyes ∘ With the only thing that I need ∘ With the only thing that I need but take it ∘ Something you put in the waste I'm craving ∘ It's the only thing that I need ∘ It's the only thing that I need but take it ∘ If you'd prefer it erased then bleach the place ∘ It's the only thing that I need ∘ It's the only thing that I need ∘ But my heart is never breaks ∘ It just beats on despite the ache ∘ And the day I touch you and make you see ∘ Broken we'll be ∘ You and me ∘ The birds fly south tonight ∘ They've given up ∘ It's the only thing that I need ∘ It's the only thing that I need but take it ∘ The skies grow dark beneath their wings ∘ What does it mean? ∘ It's the only thing that I need ∘ It's the only thing that I need ∘ But my heart it never breaks ∘ It just beats on despite the ache ∘ And the day I touch you and make you see ∘ Broken we'll be ∘ You and me ∘

Minus Ten

My transatlantic sentence arrived upon your ears ∘ "We doubt everything too much" I said, "we hold too many fears" ∘ "Tell me something that is vaguely original" you said ∘ And the ensuing silence was book ended ∘ "It's minus ten out here" you said and then you went ∘ "It's minus ten out here" you're voice was shaking ∘ "It's minus ten out here", I know the feeling" I said ∘ "I can see through to my veins – green glass under the skin", ∘ "Don't talk like that" you said, "it scares me when you do", "But we're so brittle deep inside" I said, "don't you think it's true?" ∘ And down the line I heard you roll your eyes but I was on to you ∘ "It's minus ten out here" you said and then you went ∘ "It's minus ten out here" you're voice was distorting ∘ "It's minus ten out here" "I know the feeling" I said ∘

When It Kicks In

Well the streets are on fire and the army's on the main street ∘ Firing a plastic round ∘ There's a dark plume of smoke from the hospital car park ∘ Explosion just shook the house ∘ And I go down the street, they're scrambling for cover ∘ As a car bomb destroys the town ∘ There's a woman and a child on the kerb under a jacket ∘ As the fragments come raining down ∘ When it kicks in, when it kicks in you'll know ∘ When it kicks in you'll know it alright ∘ When it kicks in, when it kicks in you'll know it ∘ A truth drug is gonna open you weeping eyes ∘ Your place it just gives me the creeps when I come over ∘ Cos your talk is the talk of ghosts ∘ I missed what you said, it kept on disappearing ∘ And slamming the open doors ∘ And now that I don't come by your new distractions ∘ Have become to you everything ∘ Well I need to work out just how to make you see it ∘ Cos your mind it needs opening ∘ When it kicks in, when it kicks in you'll know ∘ When it kicks in you'll know it alright ∘ When it kicks in, when it kicks in you'll know it ∘ A truth drug is gonna open you weeping eyes ∘

Collect Yourself

Lets take a walk to clear our heads and talk with openness and feeling ∘ Lets change the subject infrequently, then return, so you can beseech me ∘ And you'll say, "Come on collect yourself" ∘ Sounds like there's nothing to it but somehow I couldn't and it's no surprise ∘ Yea, "Come on collect yourself" ∘ While I'm on the edge of something dark like the slack by the riverside ∘ What's with a breaking heart? – the dark weight of seeded clouds unborn and swollen ∘ Tyres blacken skies alight, the heat on your face too bright, your comfort is stolen ∘ And you say, "Come on collect yourself" ∘ Sounds like there's nothing to it but somehow I couldn't and it's no surprise ∘ Yea, "Come on collect yourself" ∘ While I'm on the edge of something dark like the slack by the riverside ∘ And you say, "Come on collect yourself" ∘ With just a hint of frustration but you don't know the full situation ∘ "Come on collect yourself and lets get things back to normal" ∘ Well normal for me, don't know where that's at ∘

Soleil

This has been a truly flawless education, ∘ But we never learn ∘ I'm looking in your eyes and I see a nascent flash of brilliance, ∘ It's in there somewhere ∘ So come on lets get ourselves lost out in the woods after dark and we'll share the danger ∘ Feel it closing in until we see... ∘ Soleil, I had a feeling you would come ∘ Soleil, I had this feeling all along ∘ Thinking that I'd lost everything I walk the ghostly streets at midnight ∘ The kerbs are caving in ∘ With the weight of every step crumbling east end tenement blocks away ∘ The place is dissolving, then I see ∘ Soleil, I had a feeling you would come ∘ Soleil, I had this feeling all along ∘

Everything I've Got

With complication comforting my mind it was easy ∘ To throw it to the air and watch it fall gently ∘ And leave it scattered never pick it up ∘ Plot the endless patterns of chaos ∘ And learn to never ever count the cost ∘ Of not feeling ∘ I bet you anything you want ∘ I'll risk everything I've got ∘ You watched me lose it all every day and feared me ∘ In your room you're trying to get things straight and failing ∘ And how you must have longed for it to stop ∘ Crying 'til you're almost throwing up ∘ I don't know where you ever found the hope ∘ But I know why ∘ I bet you anything you want ∘ I'll risk everything I've got ∘ I bet you anything I won't ∘ Lose it all again oh no ∘ Lose it all again oh no ∘ I'll risk everything I've got ∘

Title:
Prayer For The
Weekend

Type of Work:
CD jacket

Year:
2007

Contributed by:
Zion Graphics

Art Direction:
Ricky Tillblad

Design:
Ricky Tillblad

Client:
Roxy Recordings

Musician(s):
The Ark

Description:
Design for the
latest album of
The Ark.

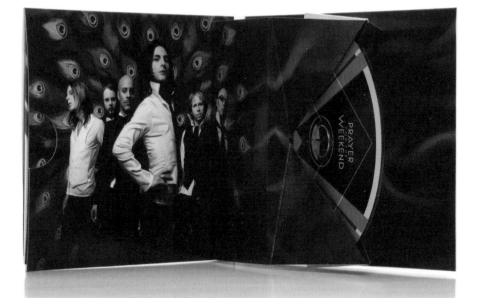

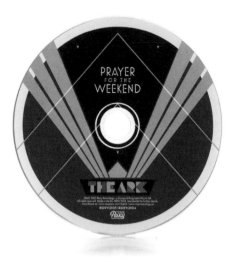

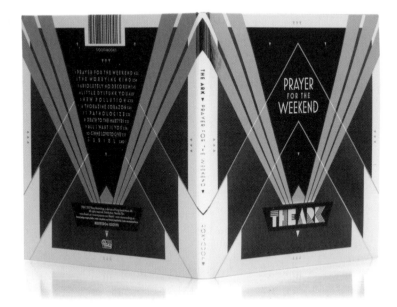

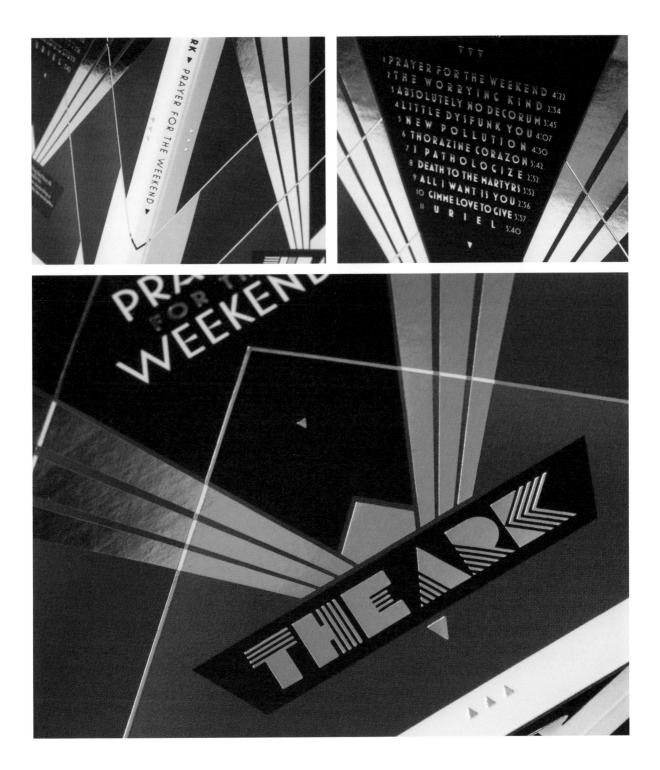

RK ▶ PRAYER FOR THE WEEKEND ▶

▼▼▼

1 PRAYER FOR THE WEEKEND 4:22
2 THE WORRYING KIND 2:54
3 ABSOLUTELY NO DECORUM 3:45
4 LITTLE DYSFUNK YOU 4:07
5 NEW POLLUTION 4:30
6 THORAZINE CORAZON 3:42
7 I PATHOLOGIZE 3:42
8 DEATH TO THE MARTYRS 2:52
9 ALL I WANT IS YOU 3:52
10 GIMME LOVE TO GIVE 2:56
11 URIEL 5:40

▼

PRAYER FOR THE WEEKEND

THE ARK

Title:
TAHITI 80 -
Wallpaper for the
Soul

Type of Work:
Collage

Year:
2002

Contributed by:
Elisabeth Arkhipoff

Art Direction:
Laurent Fetis

Design:
Elisabeth Arkhipoff

Client:
Atmospherique
France, JVC Japan,
Minty Fresh USA

Musician(s):
TAHITI 80

Description:
CDs, vinyls, post-
ers and promotional
materials for
TAHITI 80's album
'Wallpaper for the
soul.'

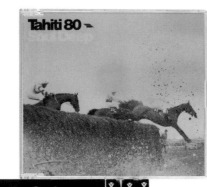

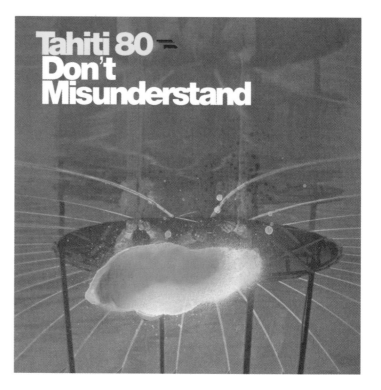

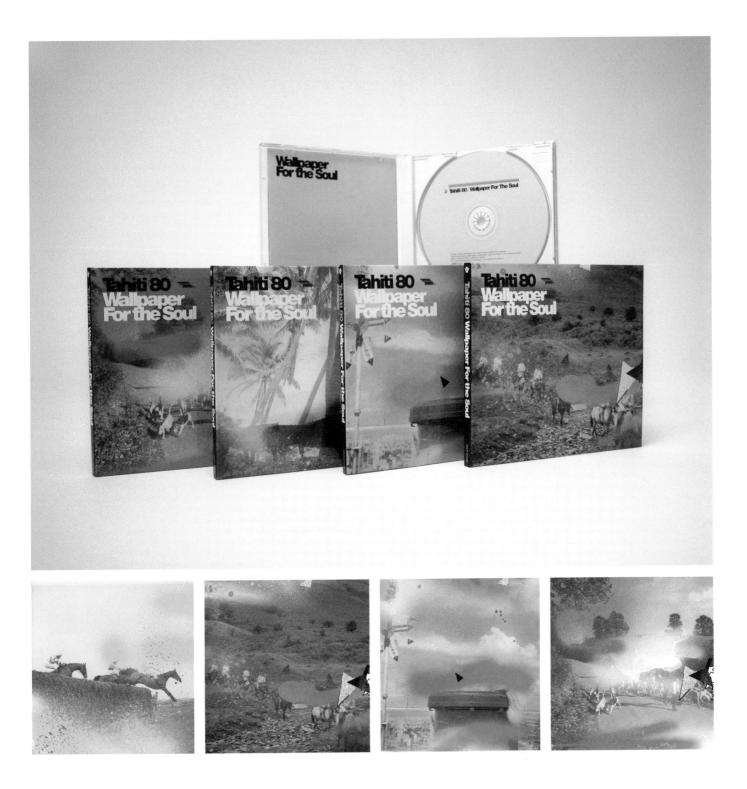

Title:
Working under
Music / Sessions
at *S,C,P,F,...
Factory

Type of Work:
CD packaging

Year:
2002

Contributed by:
*S,C,P,F,...

Art Direction:
Marion Dönneweg

Design:
Marion Dönneweg

Client:
*S,C,P,F,...

Musician(s):
Chop Suey

Description:
One afternoon Chop
Suey came to the
advertising agency
*S,C,P,F,... and
mixed his pre-
ferred music, while
everybody was work-
ing. The agency
is located in an
old factory, that
is why the title
is 'Working under
Music' and the
cover shows old-
fashioned pictures
about factory work-
ers.

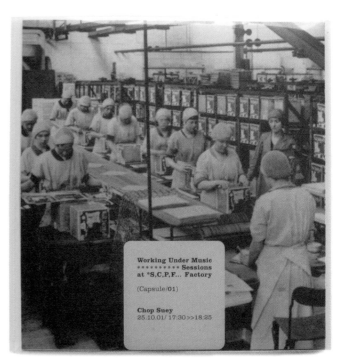

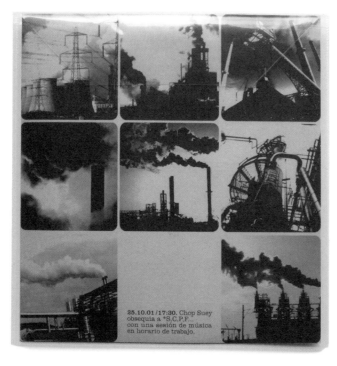

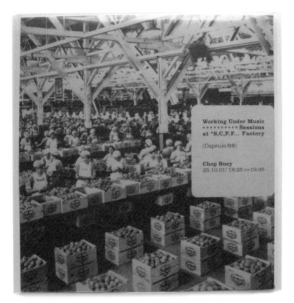

Working Under Music
••••••••• Sessions
at *S,C,P,F... Factory

(Capsule/02)

Chop Suey
25.10.01/ 18:25 >>19:35

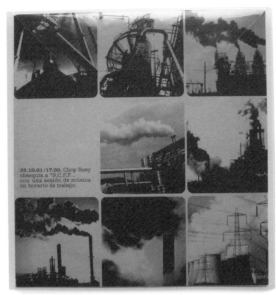

25.10.01 /17:30. Chop Suey
obsequia a *S,C,P,F...
con una sesión de música
en horario de trabajo.

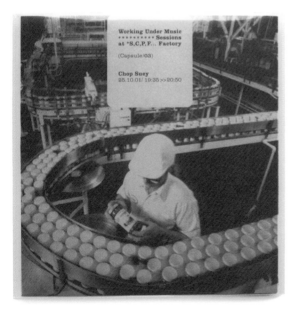

Working Under Music
••••••••• Sessions
at *S,C,P,F... Factory

(Capsule/03)

Chop Suey
25.10.01/ 19:35 >>20:50

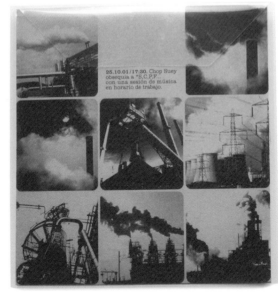

25.10.01 /17:30. Chop Suey
obsequia a *S,C,P,F...
con una sesión de música
en horario de trabajo.

Title:
1. Fujichaku
2. Tokyo City Rhapsody

Type of Work:
CD jacket

Year:
2008

Contributed by:
Enlightenment

Art Direction:
Enlightenment

Design:
Enlightenment

Client:
Warner Music Japan

Musician(s):
Tsubakiya Quartette

Description:
1. For the image of 'TOKYO CITY RHAP-SODY,' Enlighten-ment expressed a feeling of chaos of the town called Tokyo by miscella-neous collages.
2. Enlighten-ment featured the theme of a town called Tokyo as the stage.The stu-dio expressed it so that they could summarize their view of the world.

1

2

The One
Shinichi Osawa

FROM CRESCENT COCOON

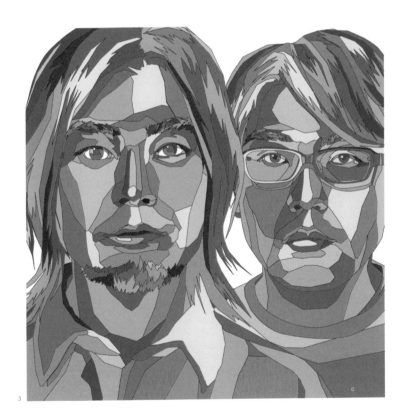

Title:
1. The One
2. Cocoon
3. Dodekagon

Type of Work:
CD jacket

Year:
1. 2007
2, 3. 2006

Contributed by:
Enlightenment

Art Direction:
Enlightenment

Design:
Enlightenment

Client:
1. Avex Entertainment
2. J-wave Music Inc.
3. Columbia Music Entertainment

Musician(s):
1. Shinichi Osawa
2. From Crescent
3. Kirinji

Description:
1. The studio expressed the personality of an artist by original trace.
2. Enlightenment's work was inspired by a CD called 'The Cocoon' and the title of a musical composition and expressed the image of a chrysalis wrapped in a cocoon just before it.
3. Enlightenment imagined the impact of the word Dodekagon, which resulted in a colourful artwork with the faces of the musicians.

Title:
Endless Season

Type of Work:
CD artwork

Year:
2003

Contributed by:
Benjamin Brard

Art Direction:
Benjamin Brard

Design:
Benjamin Brard

Client:
Vorston & Limantell

Musician(s):
Scenario Rock

Description:
For this project Benjamin Brard kept the CD as an object in mind, the jewelcase, totally wrapped up in wallpaper, itself made up of a repeated pattern. It shows on all printed visible part of the artwork, be it the booklet, the inlay or the CD itself.

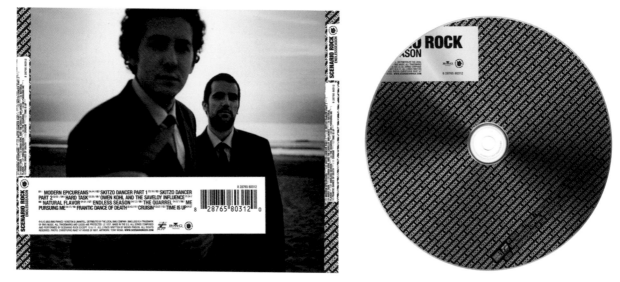

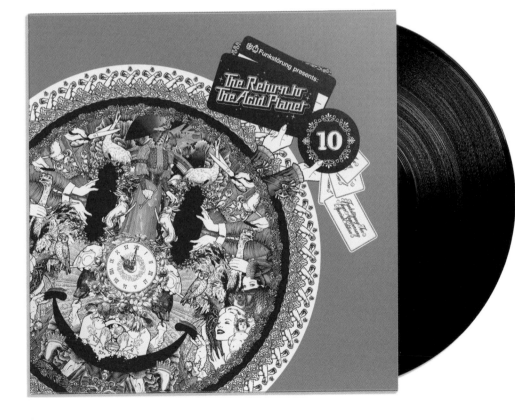

Title:
The Return to The
Acid Planet

Type of Work:
CD packaging

Year:
2005

Contributed by:
Purple Haze Studio

Art Direction:
Clemens Baldermann

Design:
Clemens Baldermann

Client:
!K7 Records

Musician(s):
Funkstorung

Description:
Art direction,
design and title
type design for
music packaging. A
special release for
the 10th anniver-
sary of the elec-
tronica duo Funk-
storung. Printed
in spot colours,
gold metallic ink,
flourescent inks
and fully-embossed
cover.

Title:
Livegig

Type of Work:
Concert key visual

Year:
2007

Contributed by:
Artroom -
Commercial Radio
Production Ltd.

Art Direction:
Chiuyan

Design:
Rico

Client:
Manhattan id

Description:
Commercial Radio
Productions Ltd. and
Manhattan collabo-
rated on a series
of mini concerts.
There are 4 of them
in total and this
one is the first.
The art depart-
ment miraculously
completed the lay-
out and concept in
early February. The
first concert will
take place in sum-
mer, the creative
team is determined
to churn out unique
and colourful visu-
als for each show.

2

1

Title:
Golden10

Type of Work:
Concert key visual

Year:
2006

Contributed by:
Artroom -
Commercial Radio
Production Ltd.

Art Direction:
Chiuyan

Design:
Chiuyan, Rico

Client:
Manhattan id

Description:
People are drawn
to fancy stuff.
Commercial Radio
Productions Ltd.
tries to bring new
elements to every
project. But for
this project, one
of the creative
team members hoped
to go back to the
basics and do a
pure and simple
artwork. Thus the
piece is a simple
yet beautiful one.

Title:
Hit&Fun

Type of Work:
CD jacket

Year:
2007

Contributed by:
Tycoon Graphics

Art Direction:
Tycoon Graphics

Design:
Tycoon Graphics

Client:
Ki/oon Records Inc.

Musician(s):
PUFFY

Description:
CD jacket for
PUFFY.

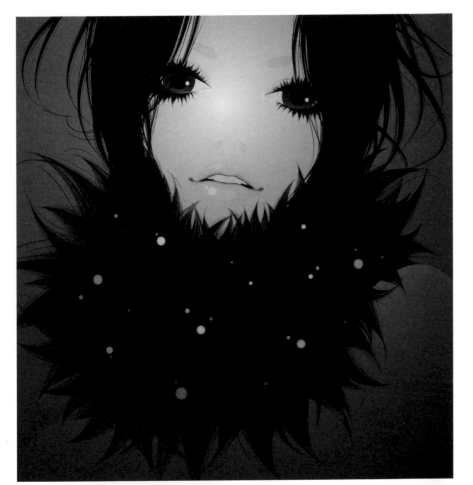

<u>Title:</u>
ena

<u>Contributed by:</u>
ena (digmeout)

<u>Design:</u>
ena

<u>Description:</u>
Design by ena who
is represented by
digmeout.

Title:
Nicholas Tse CD
jacket
Type of Work:
CD jacket
Year:
2005
Contributed by:
SixStation
Art Direction:
Benny Luk
Design:
Benny Luk

Client:
Nicholas Tse
Musician(s):
Nicholas Tse
Description:
CD jacket design
and illustration
for the Hong Kong
musician Nicholas
Tse.

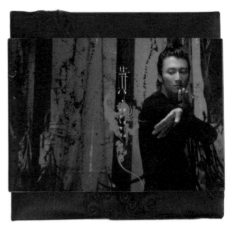

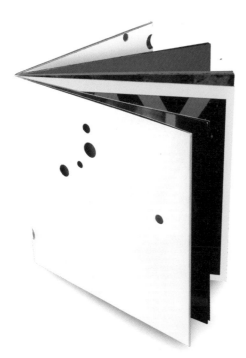

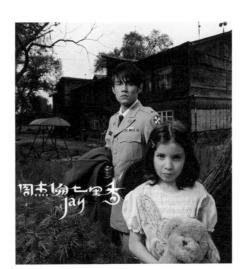

Title:
七里香

Type of Work:
CD package

Year:
2003-05

Contributed by:
Aaron Nieh Workshop

Art Direction:
Aaron Nieh

Design:
Aaron Nieh

Photography:
Kris Shao

Client:
Alfa Music International Co., Ltd.

Musician(s):
Jay Chou

Description:
The lyrics booklet tells a message against the war, which also fits the concept of the album '七里香.' Nieh also used shot hole images, red tones and some monochromes to respond to the story of album.

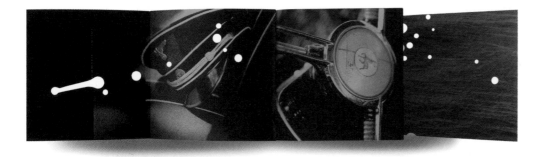

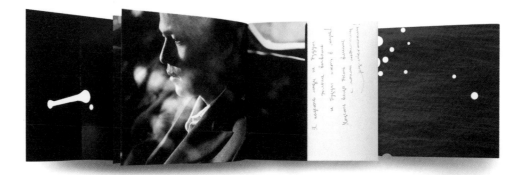

Title:
Playtime is Over

Type of Work:
CD cover, Vinyl
cover

Year:
2007

Contributed by:
Oscar & Ewan

Art Direction:
Oscar & Ewan, Eat
Sleep Work/Play

Design:
Oscar & Ewan, Eat
Sleep Work/Play

Photography:
Per Crepin,
Christopher Peabody
(retouching)

Client:
Big Dada Recordings

Musician(s):
Wiley

Description:
A simple take on
the album's title
removing the
intrinsic primary
colours from a
children's play-
ground.

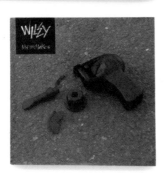

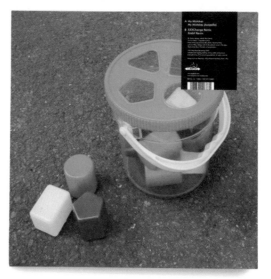

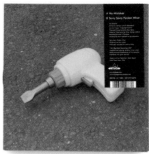

1

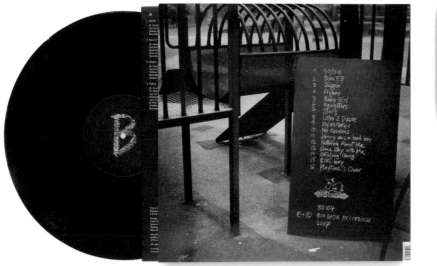

1 50/50
2 Bow E3
3 Slippin
4 Flyboy
5 Gangsters
6 Baby Girl
7 Stars
8 Letter 2 Dizzee
9 My Mistakes
10 No Qualms
11 Johnny was a bad boy
12 Nothing About Me
13 Come Play with Me
14 Gangalong Gang
15 Eski-boy
16 Playtime's Over

BIG DADA

℗+© BIG DADA RECORDINGS
2007

BD104

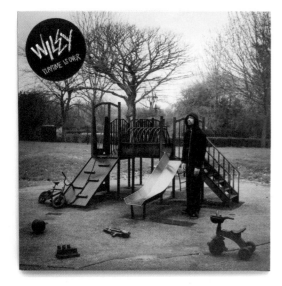

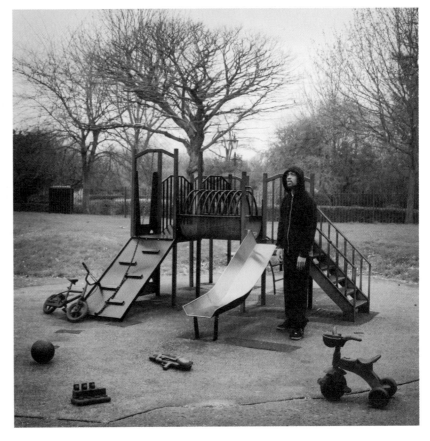

Title:
Clubscene Popscene

Type of Work:
Sleeve, Vinyl

Year:
2006

Contributed by:
Chris Bolton

Art Direction:
Chris Bolton

Design:
Chris Bolton

Client:
Eskimo Recordings,
News NV

Musician(s):
Hiem

Description:
12-inch sleeve
design influenced
by the title of the
track. Typography
custom designed for
the project.

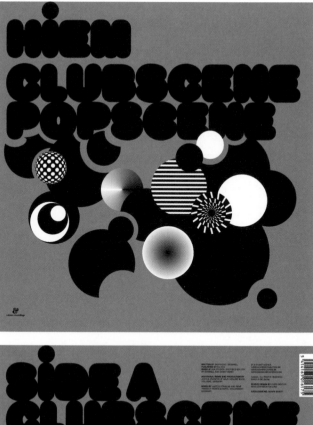

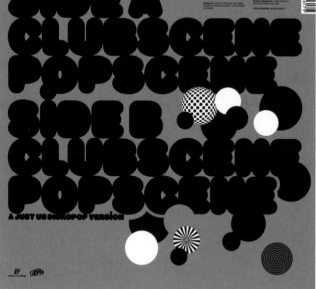

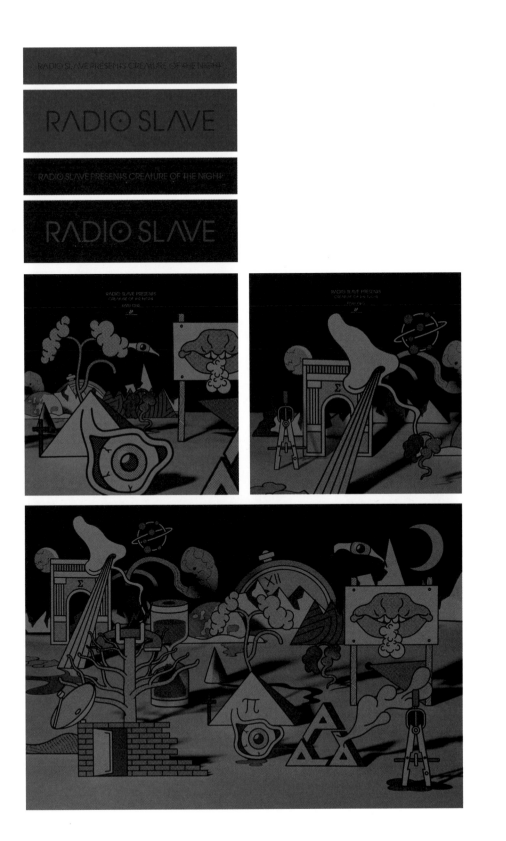

Title:
Creature of the
Night

Type of Work:
Sleeve, Poster,
Typography

Year:
2006

Contributed by:
Chris Bolton

Art Direction:
Chris Bolton

Design:
Chris Bolton

Client:
Eskimo Recordings,
News NV

Musician(s):
Radio Slave

Description:
The idea behind the
imagery for the
sleeve artwork came
from the release
name 'Creature of
the Night,' which
led to a miniature
illustrated set
design of strange
images combined
together to cre-
ate an eerie look-
ing setting. Hard
lighting was used
to extend the shad-
ows and the pres-
ence of darkness.
The typography was
created using reli-
gious/pagan symbol-
ogy and was made
especially for this
release.

Title:
Dose Dozes

Type of Work:
CD cover

Year:
2007

Contributed by:
Mopa

Art Direction:
Mopa

Design:
Mopa

Client:
Siltu

Musician(s):
Siltu

Description:
The cover art tries to reveal some hints about the songs included in the album, putting together elements that bring out the spirit of the band. The CD's name is related to drinking 12 shots (doze doses) and each song comes like a new shot, so Mopa had to make this huge one. Hangover-free!

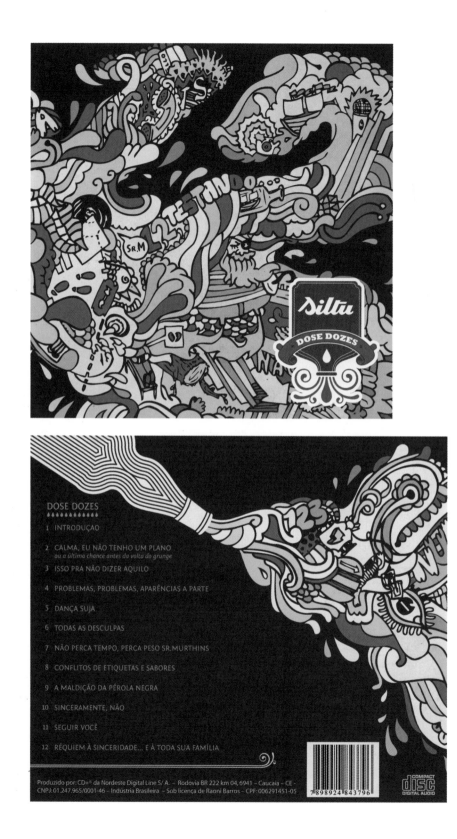

DOSE DOZES

1 INTRODUÇÃO

2 CALMA, EU NÃO TENHO UM PLANO
 ou a última chance antes da volta do grunge

3 ISSO PRA NÃO DIZER AQUILO

4 PROBLEMAS, PROBLEMAS, APARÊNCIAS A PARTE

5 DANÇA SUJA

6 TODAS AS DESCULPAS

7 NÃO PERCA TEMPO, PERCA PESO SR.MURTHINS

8 CONFLITOS DE ETIQUETAS E SABORES

9 A MALDIÇÃO DA PÉROLA NEGRA

10 SINCERAMENTE, NÃO

11 SEGUIR VOCÊ

12 RÉQUIEM À SINCERIDADE... E À TODA SUA FAMÍLIA

Produzido por: CD+® da Nordeste Digital Line S/ A. – Rodovia BR 222 km 04, 6941 – Caucaia – CE – CNPJ: 01.247.965/0001-46 – Indústria Brasileira – Sob licença de Raoni Barros – CPF: 006291451-05

7898924843796

Biographies

*S,C,P,F,...

Marion Dönneweg worked in several Spanish advertising agencies for 12 years. In *S,C,P,F,..., she designed the CD covers 'Working Under Music.' In 2007, she founded her own design company, based in Barcelona, with her 2 partners Mireia Roda and Merche Alcalá, called 'm.'

Page 264-265

Aaron Nieh Workshop

A very small workshop in Taipei which has quite a few important album artworks and publishing design under its belt.

Page 114-117, 275

Aeriform Viscom

Sean Rodwell set up Aeriform Viscom in 1997 as an outlet for his freelance design and illustration works. Since then, it has built a reputation for supplying high impact visual solutions to a varied range of clients. Built on almost 20 years of industry experience, the passion for creativity that founded the company is still at work today. It's this passion that ensures the output is constantly shifting and adapting through experimentation and development. Having worked extensively in the field of image making for advertising, music, fashion and editorial projects, Aeriform's constant state of movement along with occasional collaborations with likeminded creatives allows them to provide the client with the most effective solutions to their visual needs.

Page 075

Airside

Airside is a London-based design company set up in 1999. The people of Airside come from different disciplines, from programming and English literature to textiles, knitting and graphic design, clubs and music (creative director Fred Deakin is one half of a band, Lemon Jelly).

Airside has established itself as a company that approaches design with its tongue firmly in its cheek, and through client works and self-initiated projects has developed a rigorous creative process and strong visual identity. Enjoyment and passion are pre-requisites when Airside makes a work - be it websites, animation, T-shirts or CD sleeves.

Page 056-059, 251

Alex Trochut

Alex Trochut was born and raised in Barcelona. He loves drawing and spent hours drawing as a child.

Alex studied in Elisava, Barcelona and started working with Alexander Branczyk at Xplicit and Moniteurs. After 2 years working in Toormix, Alex worked in Vasava. Right now Alex is freelancing, working for London, New York, Amsterdam etc. and projects for the likes of Nike, as well as some small projects that he enjoys doing. Alex has been working for companies like Non-format or Weiden and Kennedy as a freelancer.

Page 216

Arkétype Création Graphique

Arkétype Création Graphique is a 29-year-old living in Clermont, Ferrand, a town at the centre of France. I've studied arts and image in the E.N.S.A.A. of Bourgogne from 1993 to 1998, and he specializes in graphics and visual communication. After various work experiences, he decided to work in freelance under the name of Arkétype Création Graphique in 2006. He is (modestly) known in his region for his collaborations with indie bands and work for musical events.

Page 080-081

Artroom - Commercial Radio Production Ltd.

In the little Artroom under the Commercial Radio Productions Ltd., 6 fiery designers give their very best in the designs for the Radio (FM881 and FM903) as well as related parties. From 2-dimensional graphic designs, huge settings and stage designs for events and concerts, to miscellaneous designs like event props, stickers and signages, endless design verve makes Artroom@CRP an unforgettable place to create in.

Page 270-271

ATOMIKE STUDIO

Atomike Studio is the 29-year-old Mike Stefanini, who lives in Nantes, France. He studied art history as well as graphic design. After working as a postman, guitar salesman and warehouse man, he understood that graphics remains his calling. He has been a freelance graphic designer for 6 years, and mainly works for the music industry. Atomike Studio has produced around 30 CD packagings, which form the main bulk of his work.

Page 070-071

Benjamin Brard

Brard is a 30-year-old art director, graphic designer and illustrator. He also signs some of his work as Tony Wong because it makes him laugh.

He collaborates with the music industry mainly, be it for major record companies like EMI, Warner, BMG or smaller ones. His work also includes other fields like fashion (Noir Kennedy), cinema posters (Asia Argento's 'Scarlet Diva'), press ('Colette' magazine), visual identity and Internet (institutional sites, NRJ radio, the biggest French commercial radio station).

Page 100-102, 268

Bionic Systems

Bionic Systems is a multi-disciplinary design studio. Located in Düsseldorf, Germany, they are working for global players as well as boutique brands of wide-ranging sectors.

The studio was established in 1999 by designers Doris Fürst and Malte Haust. They are dedicated to inspiring high quality work with a focus on their clients' brief. Whether cutting-edge or classic, they always aim for strong designs with an innovative twist.

Clients include Yamaha, Nike, Carhartt, Red Bull, Universal, Mitsubishi, etc.

Page 120-121, 252-253

Bleed

Working to blur the borders between graphic design, art, technology and commercial brand identity, Bleed has since its inception 7 years ago become a visible force in the world of creativity.

Bleed's work spans art projects and exhibitions, identity work for several international brands as well as a book on young Nordic graphic design and running its own concept store, called One.

The Oslo-based outfit employs 16 people full time, representing a mix of cultures and disciplines to challenge today's conventions around art, visual language, media and identity.

Bleed seeks to add the edge.

Page 162-163

Bluemark Inc.

Bluemark Inc. was set up in 2000 as a conglomerate company consisting of 5 sections - graphic design, web integration, product design, sound design, and publishing.

Their graphic design group handles, for example, brand building for fashion labels, the visual identity of art museums and editorial design of books and magazines. In addition, their web integration group deals with all kinds of Internet-related work such as planning and managing websites.

Since the release of the art book 'NEVERMIND' in 2000, Bluemark Inc.'s publishing section is gradually developing. They released 'Paid Holiday' by KB as their first CD.

Page 156-157

BombTheDot

BombTheDot is a German based studio.

Page 012-013

Bongoût

The Berlin-based Bongoût is Meeloo Gfeller and Anna Hellsgård. Meeloo is French and Anna is Swedish.

Bongoût produces silkscreen artist books and gig posters. They also do commissioned graphic design work for everyone from underground record labels to skateboard brands, from illegal concerts to world music festivals, movie productions, corporate clothing companies and tobacco companies.

Their influences range from contemporary art to outsider art, underground comics culture, Swiss typography, Cuban, Polish and Russian posters. Bongoût try to be as open as they can all the time to new influences that cut across all disciplines of art and culture.

Page 033, 166, 222-223

Brand Nu

Radim Malinic, internationally renowned for his work as a freelance illustrator and designer under the name of Brand Nu. His work has been described as imaginative, sophisticated, sensual and sexy. He creates contemporary visions that are a complex montage of layered photographic, colourful elements and hand drawn additions. His award-winning creations could be, and have been, used in books, magazines, corporate identity, CDs and DVDs, posters, and fine art picture collections. Brand Nu's clients include 02, BBC, Smirnoff, Wall Street Journal, Computer Arts, Mr. Bongo Records, VCCP, Ogilvy and Mather and more.

Page 150-151

C100 Studio

C100 Studio is a multi-disciplinary design studio working on various projects including creative direction, graphic design and illustration for a diverse range of clients. Specialised in delivering inventive and precise visual solutions they approach each project with enthusiasm, dedication, and an individual style which is evident in their works.

Page 035, 038-039, 210-211

chemega

In 2000, the brand Chemega was created to sign the execution of Ricardo Chemega's projects with his own identity, resulting from his ability to deal with the most varied themes.

Page 188-189, 218-219

Chitose Yagi (digmeout)

Born in 1970 in Shiga, she graduated from Kyoto City Art College and taught art classes at a public high school in Shiga. Since 2001, she has become a freelance illustrator. Her theme is 'the gentle air,' using flowers and girls as motifs, they are composed from an authentic technique since the Edo Period, Tarashikomi. Her very beautiful work is loaded with blurred colours.

Page 132

Chris Bolton

Chris Bolton is a British/Canadian educated graphic designer, based in Helsinki.

He is working on music, art, retail, fashion, architecture, advertising and publishing projects worldwide. His thought-provoking work delivers a clear and relevant result, regardless of scale or budget.

Recent clients include Nokia (Finland), Make-Up (Belgium), Skanno (Finland) and Eskimo Recordings (Belgium). He has also worked with Comme Des Garcons (Japan), Escalator Records (Japan) and A-lehdet (Finland) to mention a few.

Page 103, 278-279

Christophe Remy

Christophe Remy is a freelance illustrator based in Brussels, Belgium. He has been running his website under the name of 'Never effect' for about 3 years. His work mainly includes music projects, for instance the Dour festival and he has worked with major brands like Element skateboards, PlayStation and SVSV. Christophe's designs can also be found in magazines like BPM magazine, Modart magazine, etc. He belongs to 2 great collectives: 'No New Enemies' and 'The KDU' where you can find the best artists ever. The designer is also going back to university to study History of Art.

www.nevereffect.com

Page 014-015, 048-049, 054-055

cucumber

Miki Rezai is the art director/graphic designer of cucumber. Having worked for Victor Entertainment, Inc. as a designer for a few years, he started to work as a freelance designer in 'cucumber.' His work ranges from simple and stoic ones to low-fi illustrations. He also produces logo, CD-jacket, book design, editorial design, etc.

Page 027, 152, 238

D412 Architectural Design Group

D412 Architectural Design Group's works mainly include visual concept for web and printed publication as well as CD packaging.

Page 062

Designkönig

Johannes König works as a designer, art-director and graphic design teacher based in Munich. Besides some multimedia projects his main interests are print and graphic design for music and fashion.

Page 154-155

desres design group

Frankfurt-based Desres is a design and consultancy studio and is active in a wide range of projects across a growing variety of media. Projects include concept, design, illustration, interactive design, typography, and art direction along with experience in film, installation, and moving image. Desres works for corporate, cultural, and private clients as well as for advertising and event agencies. The design group also engages in collaboration with other companies and professionals.

Page 064, 220-221

dextro.org

Established in 1995, www.dextro.org engages in abstract graphic experiments, algorithmic animations and interactive animations.

Page 036-037

Elisabeth Arkhipoff

Elisabeth Arkhipoff is an artist and designer who lives and works in Paris and New York. She was born in Ivory Coast in 1973 to a Russian father and an Armenian mother. Graduating from Paris X university with a BA in Contemporary Literature and Philosophy, she started her artistic career in 2000 at the Paris Museum of Modern Art with an experimental free-lending library. Her practice embraces music, painting, sculpture, photography, video, installation and drawing which explores the functioning and selectivity of memory and its building of identity. Among collaborations with designers like Laurent Fétis, she creates designs for music (such as DJ Hell and Tahiti 80), fashion (Anna Sui, Swarovski, Eley Kishimoto, Diesel, etc.) and directs videos and films (for M83, Japanther among others). Her works have been reproduced in several books, catalogues and magazines including: Frieze, Grafik, Gasbook, Süddeutsche Zeitung, Creative Review, IDEA, ZOO, Vogue, Ryuko Tsushin, +81, Self Service, Dazed & Confused, Studio Voice and SHOWstudio.com.

Page 008, 149, 262-263

ena (digmeout)

Draws monochromatic female images that use clean, delicate lines and daring compositions. She carefully details hairstyle and costumes. She has done many projects such as a cash card illustration for RISONA Bank,

CD sleeves for a Japanese musician called 'mink,' visual image for Eclat De Mode's Bijorhca exhibition, and an illustration series for Yasuharu Konishi's column at MACPOWER magazine.

Page 273

Enlightenment

Enlightenment was founded by Hiro Sugiyama in 1997. Members include Hiro Sugiyama, Akiyoshi Mishima, Shigeru Suzuki and Kaname Yamaguchi.

Recent exhibitions include The Borderline, HIROMI YOSHII in Tokyo in 2006 and the After the Reality, Deitch Projects in New York in 2006.

Page 028, 061, 230, 234-235, 266-267

Géraldine Georges

After the 'Académie royale des beaux arts de bruxelles' Georges worked for 7 years in various advertising agencies in Belgium and Luxemburg. Georges started freelancing in 2006.

Page 164

Giottographica

It was established by Yoshihiro Inoue + yukinko in 2002.

Its work includes art direction, photography, graphic design, illustration, CD jacket, logo, fashion catalogues and advertisement.

Page 110-111, 225, 231, 236-237, 254-255

Grandpeople

Grandpeople is a Norwegian design studio. It consists of Magnus Voll Mathiassen, Magnus Helgesen and Christian Bergheim who met at art school where they started to work together. Grandpeople has been a full-time studio since 2005. They work with small-scale and large-scale clients in the fields of advertising, art, fashion, music and exhibition mostly.

Page 010, 153, 176-177

Graphic Design Studio 3group

Established in 2007, Graphic Design Studio 3Group is a young design studio collaborating mosty with freelance graphic designers.

Page 198

HANDIEDAN

Hanneke Treffers studied photographic design at the Academy of Arts and Design in the Netherlands. She specializes in illustrations and (web)design as a independent learner. Now she works as a self-employed illustrator, photographer, art director and artist under the name HANDIEDAN.

The layered universes she creates are accessible, playful and full of different little stories.

www.handiedan.com

Page 076-079

Herburg Weiland

HERBURG WEILAND was founded by Tom Ising, Martin Fengel and Judith Grubinger in 2000. Since then the studio has specialized in consulting as well as the relaunch and redesign of magazines, newspapers and books.

Herburg Weiland are convinced that only an agency which succeeds in combining the interests of its customers with prevailing artistic and aesthetic standards can produce comprehensible, high-quality design and advertisement. This is why they work closely with a variety of artists, illustrators, photographers, writers, journalists, architects, web designers and other specialists.

Tom Ising is art director at Herburg Weiland. In addition to his creative work for magazines, books and international companies he also teaches magazine design at the Deutsche Journalistenschule.

Page 144-145

Hvass&Hannibal

Hvass&Hannibal is a young Danish design duo comprising of the 2 childhood friends Nan Na Hvass and Sofie Hannibal. Pronounced in their native tongue, their company name sounds like 'What's up Hannibal?' and the answer to this particular question is 'A lot!' Over the last 2 years Hvass&Hannibal have crafted critically acclaimed record sleeves, a collection of limited and sought after hand printed T-shirts and posters, a psychedelic art-installation, photographs and photo-art, a gigantic vivid mural at the popular Copenhagen venue VEGA and numerous flyers and posters for different parties and events. The future will bring more of the same, but also music videos and clothings and in a few years they will graduate from Denmark's School of Design.

Page 053, 168-169

IKKAKUIKKA Co.,Ltd

The award-winning IKKAKUIKKA CO., LTD has held 2 solo exhibitions: 'FOREST' at Diesel Gallery, New York, and 'K' at Transplant Gallery, New York. It has also participated in the Hello Kitty secrethouse exhibition which was held in Hong Kong in 2006.

Page 044-045, 098-099

Ippei Gyoubu

Ippei Gyoubu is an illustrator. His artwork was featured on Sony Walkman special limited edition Ippei Gyoubu model, Dr Pepper package, Adidas Japan advertising campaign. He

has published the comic works 'Planet of the Fusion' and 'Spunky a Go-Go.'

He is currently creatively helming the character design of TV animation Akihabara Deep,' produced by Nickelodeon.

His clients include Adidas, Sony, Nike, Coca-Cola, Play Station, Big Magazine, Konami, Cartoon Network, MTV, and Nickelodeon, among others.

Page 086-087

Irana Douer

Irana Douer is an artist from Buenos Aires, Argentina. Her work usually represents women and their emotions in a very feminine way. Sadness and loneliness are some of the feelings she likes to work on the most. She works as a freelance artist and has appeared in several art magazines and books.

Book cover, Page 052

Jawa and Midwich

Jawa and Midwich is an award-winning graphic design studio providing a design, illustration and art direction service for a wide variety of projects and clients that include music, branding culture and film.

Page 170-175

Joel Lardner

Lardner's work is informed by the collision between reality and fantasy. Appropriating imagery from history and reforming it into fantastical and sinister worlds. He investigates his own imagination, exploring the boundaries between contemporary music and the subconscious worlds of fantasy that the sound evokes.

Page 184-185

Johanna Lundberg

Originally from Sweden but London and the UK has been her base for several years since studying graphic design at the London College of Communication. She had the opportunity to do a year in industry in 2006/2007 where she worked for GH, a visual agency in NYC, Syrup Helsinki in Finland and Neue Gestaltung in Berlin.

Page 165

Julien Pacaud

In 2002 the Paris-based Pacaud started to engage in graphic design and illustration.

His first commisioned work was a CD cover illustration for the French musician Arman Méliès in 2004.

In 2006, his series '66 Polaroïds that Never Existed' was exhibited at Deluxe Gallery in Halifax, Canada.

Later in 2006, Julien joined the newly created illustrator agency Talkie Walkie (www.talkiewalkie.tw) and he's now working full-time as an illustrator.

Page 072-074

Kabo

Born in Tokyo, Kabo is noted for her strong signature style and is highly sought after in both Japan and Hong Kong. Her works can be found in all leading fashion magazines. A passionate photographer, she hopes you can enjoy her work as much as she does.

Page 024-025, 096-097

Kai and Sunny

Design team Kai and Sunny work in illustration and art direction within advertising, publishing, exhibitions, fashion and music. Their work has been nominated for a silver D&AD award and includes international advertising campaigns for Apple, Toyota, Honda, Ford, Vodafone, British Telecom, British Airways, Chevron, Seeds of Change, Sun Silk, Method, Kiehls, Becks, Miller, Observer, CND, EA Sports, Playstation 3 and Levis. Design for publishing clients includes Penguin, Harper Collins, Faber & Faber, Hodder & Stoughton, Scholastic and Dazed and Confused. The design duo has worked for various divisions of Nike including White Label, ACG, Nike ID and Michael Jordan. Design work for other fashion labels include Reebok and Maharishi.

Page 204-205

KARBORN

East London artist John Leigh aka KARBORN is one of the UK's most prolific young artists and creators, having notched up an outstanding client list from the likes of Nike, Polydor, Playlouder, Nibus Clothing and Talib Kweli. From ongoing live VJ stints at The Big Chill and Festival, with Akira the Don and John Foxx. He also operates as part of the KDU family between NY, London and world-wide. KARBORN approaches industries as diverse as art and design, copywriting, video, film, interactive, production and fashion. His ethos of embracing multiple fields of creation is reflective in his work, moving smoothly between artistic styles, each pushing the boundaries of originality.

Page 066

Karpa™

David Carvalho is a Portuguese artist and designer that has been producing work in many design disciplines for the past years.

He has been interested in design since he was a kid and simply dedicated his life to

1 of his biggest passions: creativity. Since then, he has worked for many design studios in Portugal. In 2003 started his own design company where he stayed for 3 years, named Pkage Design.

Carvalho was also the Founder and Fashion Editor for the Online Lifestyle magazine Rua de Baixo, since 2003, where he has also engaged in writing and photography.

Page 256-257

KATRIN OLINA

Katrin Olina Petursdottir, born in Iceland, is a designer and artist whose work has been commissioned, produced and published by the National Gallery in Oslo, Print Magazine, Die Gestalten Verlag, Rosenthal, Fornarina, Michael Young, Mr. Teruo Kurasaki, Dupont Corian(R), Montreux Jazz Festival and 100% Design Tokyo, among others.

A graduate of product design at the E.S.D.I. in Paris, she worked for Philippe Starck's studio in Paris and Ross Lovegrove's studio in London, before joining the studio of her husband Michael Young in 1998. Since then, Katrin Olina and Young have actively collaborated on high-profile design projects.

Page 067

Kazuko Taniguchi (digmeout)

Born in 1981 and lives in Okayama. Started working as an illustrator while she was in college. She launched her illustration career by designing CD sleeves, flyers, cut illustrations for magazines, and postcard designs. She likes to draw cute and slim girls dressed in traditional Japanese kimoonos as well as anything shiny or floral. Her detailed illustrations are highly original, and stand out amongst many 'cute' illustrations.

Page 133

Ken Meier

Ken is rarely without an opinion yet often misunderstood, which probably speaks volumes about his ability as a communicator. The founding member of the Chicago-based Interrupt Media Group and Subsystence magazine, he spends most of his time thinking about all the work he should be doing. Lately, he's been fond of sincerity, Steve Coogan, Maker's Mark, and pouting, though not necessarily in that order.

Page 063

Khaki Creative & Design

Born and raised in Northeastern China, Nod Young gave up his factory job 7 years ago to move to Beijing and pursue his dream to incorporate art into his life.

Today Nod is the Creative Director and Co-Founder of his own creative group, Khaki Creative & Design. Based in Beijing, Khaki

Creative focuses on creative branding services for clients in China, the US, Japan and the UK as they look to explore the rest of the world.

Nod's personal works have been displayed in exhibitions in the UK, Germany, Japan, Mainland China, and Taiwan.

Page 084-085, 226-227

Kimberly Dulaney

Growing up in Washington State, Kimberly Dulaney studied at California Institute of the Arts (CalArts) in Santa Clarity Valley for a BFA in Graphic Design. She moved to New York after graduation. Now she has been in the motion and print business for about 3 years. She is currently working for Psyop Inc. in the lower East side of Manhattan, New York. My position at the moment is Senior Designer and Art Director. I have just gone full-time in July 2007 after freelancing for 2 months. Before working at Psyop she has freelanced for Umeric, Loyal Kasper, Hunter Gatherer, Stilletto, and from 2005 to March 2007 full-tme at Stardust in New York.

Page 011

King Trash

Michael DeForge was born in 1987. He lives in Toronto. He makes comics and likes Lee Hazlewood.

Page 090-091

Kustaa Saksi (Unit CMA)

Kustaa Saksi's illustrations are a syrupy disarray of elements: playful, paradoxical, often over-glossy, inviting, troubling, messy, and yet strangely clear. The Paris-based illustrator combines organic touches and viscous shapes into new world pyschedelia. Saksi has been working with various clients in the world of fashion, music and entertainment. His unique imagination with strict Scandinavian design roots illustrates the world of surrealistic landscapes, beautifully strange characters and very strong atmosphere.

Page 088-089, 167

Lucha Design

Founded in 2005 and located in New York, Lucha Design is an independent collective of creative professionals who assemble to produce art and design projects.

Page 130-131, 250

Madebymade

Made aka madebymade is a graphic design company based in Oslo, Norway.

Page 082-083, 217

Maija Louekari

Maija Louekari graduated from the University of Art and Design in 2004, and she is now a textile print designer and illustrator. She has been designing prints for Marimekko in Finland since 2003.

Page 050

Marcos Chin

Marcos Chin graduated from the Ontario College of Art and Design in 1999, in Toronto, Canada. Since then, his work has appeared on book covers, advertisements, CD covers, fashion catalogues and magazines, such as Time, Rolling Stone and Sports Illustrated. He has received a gold medal from the Society of Illustrators Los Angeles, and has had his work published in award annuals such as Communication Arts and American Illustration. Perhaps most recognizable amidst his portfolio are the illustrations which he has done for Lavalife's international advertising campaign, appearing on subways, billboards, print and online. Marcos currently lives in New York City and teaches Fashion Illustration at New York's School of Visual Arts.

Page 051

Michael Perry

Michael Perry works in Brooklyn, NY, where he works on books, magazines, clothings, etc. He is currently curating 2 new books. He also recently started a magazine called Untitled a..., which explores his current interests. Doodling away night and day, Perry creates new typefaces and sundry graphics that inevitably evolve into his new work, exercising the great belief that the generating of piles is the sincerest form of creative process.

Page 032

Misprinted Type

Eduardo Recife is an artist/illustrator and designer from Brazil.

Page 030, 041

Mopa

Mopa is an illustration and graphic design studio, which was founded in 2006, in Brasília - Brazil. They value the personal development in the studio, resulting in many styles and visual resources, fitting each new project perfectly. Mopa try to develop their projects in a more humane way, making the design more suitable for people. Mopa's main concern always lies on the social aspect of their work.

Page 280

Mr. Bowlegs

Mr Bowlegs is graphic designer and illustrator Jeffrey Bowman. Established in 2006 in the UK, he is now working from and living in Holland. Mr Bowlegs came about through his time spent at the University of Huddersfield while freelancing for the local music and skate scene. It's a name he acquired and stuck with to front his design practice. With a love for weird science, space exploration, grids, Helvetica, CMYK, diet coke, collaboration, instillations, wall art, naivety and all things print; this is the world of Mr. Bowlegs.

Page 182-183

Natasha Jen

Natasha was born in Taipei, Taiwan. She travelled to New York in 1998 and received her Bachelor of Arts with distinction in Graphic Design from the School of Visual Arts in 2002. In 2006, she joined the design team at 2x4 in Manhattan. At 2x4, her recent projects include the exhibition about the Cultural District in Abu Dhabi for the Guggenheim Museum; a mega-book on urbanism in Lagos, Nigeria for Harvard Project on the City; identity for a new hair-care product line and other publications and branding campaigns.

She is one of the recipients of the 2004 Young Guns from the Art Directors Club in New York. Other awards include the Type Director's Club in New York, D&AD, and Graphis.

Her personal work has been published in several publications including Metropolis Magazine, Young Guns 2004, and Rosebud Magazine.

Page 190

ngdesign.it

Lines, blots, photos, press clippings, reminders, smiles, phrases, words, perfect clean ups. Nazario Graziano likes to play with these elements to create his art. No rules, no limits to communication, no keys, no alarms.

His art is full of irony. Hybrid and non-conformist, Nazario Graziano absorbs and evolves and uses various styles and techniques to create his artworks and his personal style. Nazario creates artworks (posters, flyers, branding, websites, clubs) for agencies, events, bands, and every project that inspires him.

Page 191-195

Nicole Jacek

Nicole Jacek is a German designer currently based in Sheffield where she is working with The Designers Republic. She works on a range of projects including art direction and design for the music industry, arts and culture, architecture and fashion clients. Before she moved to Sheffield, she was also working with Stefan Sagmeister and Karlssonwilker in NYC and Springer&Jacoby in Hamburg. Nicole loves design.

Page 202-203

Nitrocorpz

Established in 2003, the Nitrocorpz Studio has managed to work in a broad range of communication fields, such as print, illustration, branding, animation and interactive projects.

They conquered respect and admiration from their clients, thanks to the efficiency and consistency of the design solutions they presented.

Page 232

No Days Off

No Days Off is a creative studio specializing in graphic design and art direction. The studio works on a diverse range of projects, including design for the music industry, art direction for magazines and fashion clients, independent publishing, book design and corporate identity.

Page 199-201

Oscar & Ewan

Born in 1985, Ewan Robertson graduated from BA (Hons) Graphic Design at Central Saint Martins in 2007. He is currently working freelance on a wide range of design projects in London.

Page 243, 276-277

PMKFA

Micke Thorsby aka PMKFA now resides in Tokyo after spending the first half of this decade in Copenhagen and London.

PMKFA creates graphic artwork and design for music, packaging, garments, magazines and books for clients such as Universal Music, Uniqlo, Atlantic records, Nudie Jeans, WESC, Beams T, Knee High Media, Ubiquity records, Arkitip, Lo-Fi-Fnk and Kocky.

Once heavily focused on music graphics, PMKFA's last 2 years can be seen as the expanded adventure into new fields. Since 2006, he has become an art director of the Swedish furniture newcomer VujjTM, participating in creating 2 critically acclaimed exhibitions in London and Milan. He is also known as the co-founder/designer of the clothing label It's Our Thing that has created a stir in the graphic garments business since its launch in 2006.

Page 026, 031

Purple Haze Studio

Purple Haze is a multidisciplinary graphic design studio based in Munich, Germany. Working for miscellaneous public and private clients on a variety of national and international projects including expertise in conception, art direction, typography, design and illustration. Producing intelligent and progressive communication solutions for print / packaging, brand applications, publishing, exhibitions and websites. Most recently Purple Haze has won the Type Directors Club New York Typographic Excellence award (2007).

Page 060, 140-141, 146-147, 269

Qian Qian

Qian Qian is a multi-disciplinary designer, illustrator and art director from China, now living and working in NYC. One of the '20 under 30 New Visual Artists' by Print magazine, he has worked with some of the top clients and agencies, including Nike, Panasonic, Motorola, One Show, Ogilvy One, and Wieden + Kennedy.

Page 094-095

RADIO

Yoshi Tajima graduated from the Commercial Art Department of the American Intercontinental University in London, BA in Commercial Art 1995, and started his career as a freelance graphic designer after that. RADIO is his studio. He is currently working as a director, graphic designer and illustrator.

Page 016-019, 186-187

R-one

R-One is Ming-yuan, who does graphic design for music and fashion.

Page 212-215

Rune Mortensen Design Studio

Rune Mortensen was born and raised in Flekkefjord, a small town in the south of Norway. After high school he moved to Oslo and started his education to become an art director. After graduating he spent 2 years working for Norwegian pioneer designer Egil Haraldsen, doing mainly book sleeves and film posters. He next worked in advertising at DDB Oslo. He started designing sleeves and posters for friends and slowly built up a network of contacts. After 2 years at DDB he left to concentrate on his own work. In 2000 he started his own studio focusing on the music and publishing industry.

Page 138-139, 142-143

S E I Z

Gui Seiz is a Portuguese graphic designer based in London. An avid screenprinter and typographer, he is happily making work that makes people happy.

Page 065, 136-137

Sam Weber

Born in Alaska, Weber grew up in Deep River Ontario, Canada. After attending the Alberta College of Art and Design in Calgary, he moved to New York to pursue illustration and attend graduate school at The School of Visual Arts.

Page 128-129

Sanna Annukka (Big Active)

Sanna Annukka is a half Finnish, half English illustrator and printmaker with a refreshing love of nature and folklore. Having spent her childhood summers in the nightless Lapland wilderness, the forests, lakes and wildlife of the region have formed and infused her work. In 2006 her work was spotted by the British group Keane which led to a remarkable collaboration on their second million selling album, 'Under the Iron Sea.' Since this first commercial adventure, her talent has been in constant demand. She now divides her time between commissioned work and her ever expanding range of self-styled products.

www.bigactive.com

Page 206-209

Santos&Karlovich™

Santos&KarlovichTM is a multimedia, experimental, design studio based in NYC. The founders, Virgilio Santos and Nedjelco-Michel Karlovich, met while working as designers at ATTIK. Within the last year they'd gathered all of the work that they had done together experimentally and formed their own studio.

Page 020-023

SEA

Established in 1997 by Bryan Edmondson and John Simpson, SEA is an independent, multi-disciplinary and award-winning design agency based in London.

Page 148

Seripop

Seripop consists of 2 people who do graphics and printmaking in Montreal, Canada.

Their aesthetic is maximalist, their approach free and cathartic and their philosophy is that of Get in The Van' - the seminal book of life on the road with hardcore pioneers Black Flag by Henry Rollins.

Like Black Flag, Seripop believe that life is made for creativity and total immersion is key. Every moment of every day should be spent on one's output and no amount of discomfort should get in the way. The tribe of like-minded folks who live and breathe the new basement art/design/music/literary scene are called lifeforce warriors.

When not working on new designs or drawing the 2 can be found in the van with their noise-punk bands AIDS Wolf and Hamborghinni.

Page 196-197

SixStation

Founded by Benny Luk, a 28-year-old graphic, web, font designer and illustrator. Sixstation first started as a personal experimental website in 2000. Design style is mainly mixed with modern contemporary and rich traditional Asian culture.

From 2004 to the present Benny has changed into a soho style freelancer. He mainly works with international clients such as Nike Asia, MTV Asia and SonyXLevis.

Page 092-093, 274

Sopp

Sopp is a design studio based in Sydney and London. They have over the last 8 years been producing new and innovative design for the music scene in Australia and Europe.

Their multi-disciplinary skills have enabled them to produce not just album artwork for bands but also music videos, visuals and interactive installations.

They thrive on experimenting with various processes, production methods and design styles in order to explore new routes of visual communication.

Page 122-125, 134-135

Studio8 Design

Studio8 Design is an award-winning independent graphic design studio with a reputation for delivering intelligent and engaging creative solutions. Based in central London, Studio8 was established in 2005 by Matt Willey and Zoë Bather, formerly Creative Directors at Frost Design London. Working with clients both large and small, in the UK and overseas, Studio8 produces a diverse range of work across multiple disciplines. With over 15 years of industry experience between them, Matt and Zoë bring a wealth of knowledge and enthusiasm to every new project and offer a scope of capabilities that includes editorial, exhibition, signage, corporate literature, websites, and brand identities.

Page 258-259

SUNDAY VISION

SUNDAY VISION works mainly on graphic design, motion graphics, web design and apparel design. Apart from working with clients, SUNDAY VISION designs and publishes its works in many locations. Shinsuke Koshio, the director of SUNDAY VISION, is responsible for art direction as well as illustration.

Page 112-113

Takeshi Hamada Office

Born in 1970, Takeshi Hamada is a graphic designer and art director.

In 2003, he started working as a freelance graphic designer. He mainly designs printed works such as CD packages, editorial, posters and fashion catalogs. He has also been working on the screen magazine Tiger. He is a member of the Tokyo Type Directors Club.

Page 042

Tetsuya Nagato

The award-winning Artist, art director and graphic designer Tetsuya Nagato was born in 1970 in Tokyo. He move to the United States after graduating from high school and returned to Japan in 1996. He then began working on digital photo-collage /collage and illustrations.

He is currently working on visual production for magazines and the advertising, fashion and music industries.

Page 009, 029, 043, 158-161

Tragiklab

Dhanank Pambayun is a digital artist who lives in Yogyakarta Indonesia and is the principal of Tragiklabs.com, a small illustration studio which focuses on digital illustration and art direction.

Tragiklab artworks are characterized by a dark, creepy and psychedelic look. Their clients boast the likes of Leo Burnett, Dailey Ad & Association, Computer Arts, Concept Magazine, YODI Studio, Idea Magazine, Die Gestalten Books, Overspray Magazine etc.

Page 180-181

Tycoon Graphics

In 1991, Yuichi Miyashi and Naoyuki Suzuki established Tycoon Graphics.

The company is committed to art direction and graphic design for advertisements, corporate identities, package designs, and editorials, mainly in the field of music, fashion, and cosmetics.

In addition, Tycoon Graphics conducts a broad range of activities including brand development, architectural graphics, and moving picture direction. As for the history of awards, they won the gold prize of 'BIG MAGAZINE' at the 78th New York ADC, and the silver prize of 'BOYCOTT MOVIE.'

Page 239, 272

UFG (Unidentified Flying Graphics) Inc.

Born in 1958, Tokyo, Keiji Ito is the President of Unidentified Flying Graphics.

Ito received a Tokyo ADC Award in 2001. Not only has he held numerous solo exhibits, but he also has taken part in international and domestic shows. His latest publication 'FUTURE DAYS' is now available. The artist's interest includes art direction and visual production as well.

Page 228-229

Urbancowboy

Acknowledged as one of the most influential designers by WebDesign Magazine, Patrick Boyer began his career as a Designer/ Art Director in 1998 through 'UrbanCowboy,' an internationally acclaimed creative design identity. With a strong background in Marketing and Communication, Patrick has used his distinctive style and knowledge of the industry to develop a growing reputation as 'one of the hottest designers around' (Digital Creative Arts).

Page 178-179

Vasava

Vasava is a communication studio established in Barcelona in 1997. It consists of 16 young people from various fields and disciplines. Vasava has a new way of dealing with the creative process based on experiment and commitment, and the search for new communication values, trends and fresh ideas is what inspires them.

Vasava uses a single criterion and objective to take on different directions, working the same idea in all its possibilities and formats, capturing the most excitement they can and generating outputs.

Page 126-127

Voegeli JTV

The award-winning Voegeli JTV focuses on different editorial projects. Specializing in book design and corporate design, their works always have a strong visual impact. Voegeli JTV is based in Zurich and their clients include the likes of Zurich University of the Arts.

Page 046-047

Xavier Brunet

Xavier Brunet aka deesk is a graphic designer from France. Lately, he is working for an architecture agency but his main hobby is music.

He does some VJ-ing with the Depth Affect band and makes artworks for their label named autres directions in music.

He also creates illustrations for different clothing brands.

He is fascinated by violent pictures in different media, and he often mixes cult movies and videoclips. His style is dark versus touches of colours.

Page 224, 233

Yellow Brain Co., LTD

Kouki Tange creatively helms Yellow Brain Co., LTD, which was established in 1999 after he finished staying in NYC as a fellowship student from the Agency for Cultural Affairs.

He has directed numerous music videos, and is the recipient of several prizes in this category.

In recent years, he has also worked in graphic art direction.

Page 034, 040, 240-242, 244-249

Yuko Shimizu

Yuko Shimizu is a Japanese illustrator living and working in NYC. She is also a part time instructor at the School of Visual Arts where she teaches illustration. She works with a diverse range of clients such as advertising campaigns for Microsoft, MTV, Pepsi, Nike and MTV, editorial illustrations for TIME, The New York Times, Rolling Stone, and Playboy. The awards she has amassed over the years include Yellow Pencil Award D & AD, Gold and Silver Medals Society of Illustrators, Silver Award Spectrum, Magazine of the Year Award Society of Publication Designers, etc.

Page 104-109

Zion Graphics

Zion Graphics is a multifaceted design agency based in Stockholm, Sweden. Founded by Ricky Tillblad in 2002, Zion's work crosses over vast disciplines including corporate identity, fashion, interactive media, packaging and print. Their clients include J. Lindeberg, Sony BMG, Universal Music, EMI Music, Pee&Poo, Peak Performance and more.

Page 068-069, 118-119, 260-261

Acknowledgement

We would like to thank Irana Douer for the
cover illustration and all the designers and
companies who made significant contributions to
the compilation of this book. Without them this
project would not be able to be accomplished.
We would also like to thank all the producers
for their invaluable assistance throughout this
entire proposal. The successful completion also
owes a great deal to many professionals in the
creative industry who have given us precious
insights and comments. We are also very grateful
to many other people whose names did not appear
on the credits but have made specific input and
continuous support the whole time.

Viction:ary

Future Editions

If you would like to contribute to the next
edition of Victionary, please email us your
details to submit@victionary.com